CREATIVE
ILLUSTRATION
WORKSHOP
for Mixed-Media Artists

QUARRY

"Every artist was first an amateur."
—Ralph Waldo Emerson

CREATIVE ILLUSTRATION WORKSHOP

for Mixed-Media Artists

BEVERLY MASSACHUSETTS

QUARRY BOOKS

SEEING, SKETCHING, STORYTELLING, AND USING FOUND MATERIALS

Katherine Dunn

First published in the United States of America by
Quarry Books, a member of
Quayside Publishing Group
100 Cummings Center
Suite 406-L
Beverly, Massachusetts 01915-6101
Telephone: (978) 282-9590
Fax: (978) 283-2742
www.quarrybooks.com
Visit www.Craftside.Typepad.com for a behind-the-scenes peek at our crafty world!

Library of Congress Cataloging-in-Publication Data available

ISBN-13 978-1-59253-636-8
ISBN-10: 1-59253-636-0

10 9 8 7 6 5 4 3 2 1

Design: Nancy Ide Bradham, www.bradhamdesign.com
All art and photography © Katherine Dunn

Printed in China

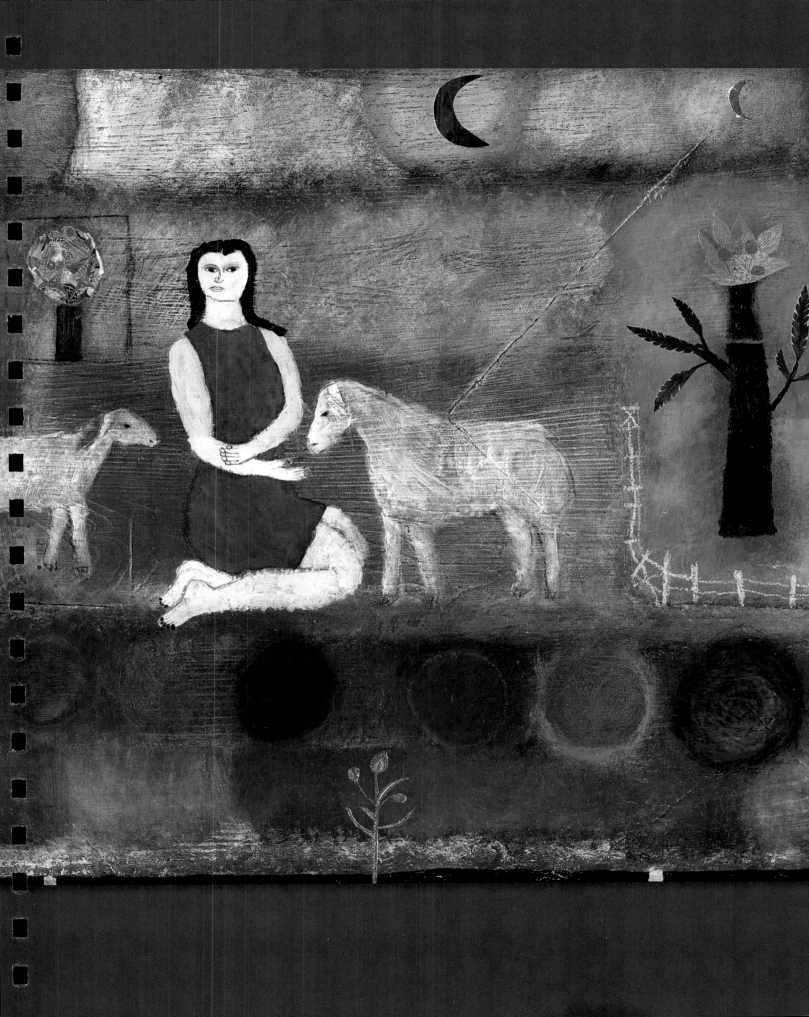

C O N T

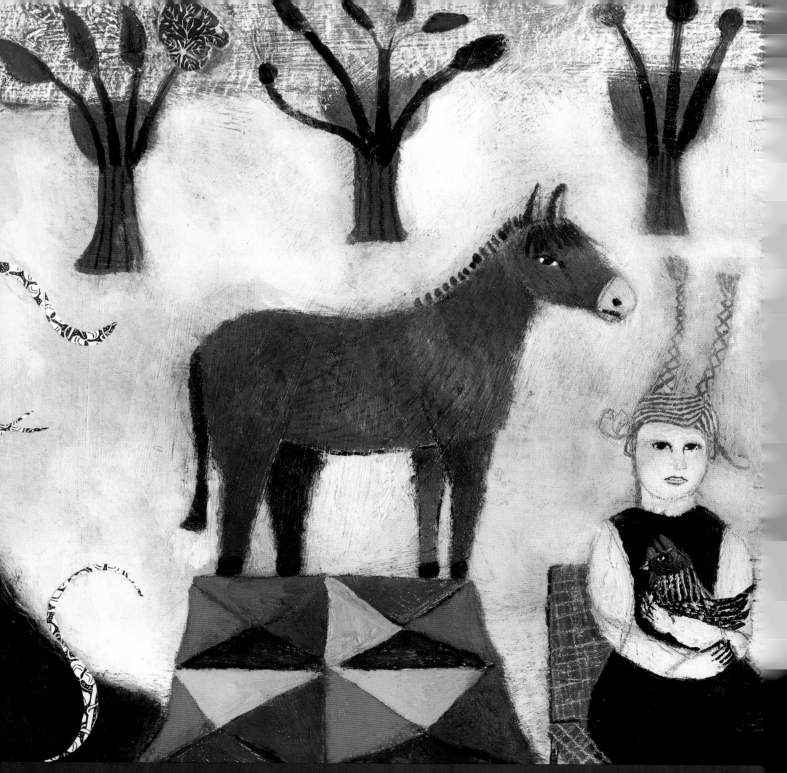

And Then the Wind Blew In, acrylic/collage on pine board.

"Primarily, what we carry around with us is a memory of childhood, back when each day held the magic of discovering the world." —Isamu Noguchi

Introduction

On any given day there are stories all around you, and as an illustrator and artist, you get to decide which ones to explore and possibly share with the world. An apple falling from a tree, a child skipping down the road, an old man sitting in a park—all these visual moments can lead to your next illustration.

Let's face it: Since the dawn of mankind, humans have illustrated their stories and feelings through drawing, whether on a cave wall or the ceiling of a chapel. As children we drew all the time, sharing our fears and joys or stories of imaginary friends. As adults that joy of expressing ourselves seems to get pushed aside. I often hear people say, "I can't draw." One of the goals of this book is to allow you, no matter what your level of drawing skill, to open your mind to drawing as a way to share a story, a feeling, or an inspiration. Why? Because stories entertain, teach, communicate, inspire, and heal. Not only the artist is transformed—so is the viewer. An illustration can be as simple as a beautiful drawing of a bowl of fruit or as detailed as a full-bleed image from a short story—but both came from some visual inspiration. As you read this book, I hope you begin to take more joy in the fact that your daily world is a giant library of visual inspirations.

While many mediums can "illustrate" a concept or feeling, this book will focus on illustrating ideas through traditional drawing and painting mediums. I do address the use of computer programs to enhance illustrations, since I use this technique in much of my commercial work. It is a wonderful tool to have in your bag of tricks as you develop your style.

Everyone has their own style and voice. My work has always been heartfelt and emotive, both in color and subject. We'll look at simple techniques to capture the initial essence of an inspired moment, so you can save it for a later time when you are back at the studio. We'll look at the many sources of inspiration from our own backyards as well as books, people, muses, and simple objects.

Illustration not only tells a story, it can create a visual answer to your own internal mysteries. One of the chapters in this book presents an exercise in which you can explore a personal life experience through a series of illustrations created from one piece of paper. It allows you to focus on the fluid process of creation instead of focusing on the end result. Like life, it's the journey that matters as much as the destination.

You will also be encouraged to think about simple, everyday items as visual and textural resources for techniques and illustrations. Sometimes all we need is a fresh perspective on the ordinary to make us see how "extra" ordinary it really is.

Appreciating your surroundings as a library of color, texture, and emotion is an inspiring way to go through life. Creating illustrations from that inspiration is a rewarding way to share your feelings, stories, and observations of the world. I hope that by reading this book, you'll be inspired to look at the magic in your own world and translate it into an illustration.

Chapter 1

Basic

MATERIALS

In addition to experimenting with quality papers, canvas, and paints, be open to working with what some might tell you are second-rate materials—such as newsprint. Working with an open mind about everything, from materials to subject matter, can lead to fresh techniques and discoveries for your work. Your choice of surface and material should reflect you and your lifestyle at the moment. If you are in a confined area, then smaller, more intimate surfaces might hold more appeal. Certain moods and experiences might push you to paint or draw on large surfaces. Or you might like the idea of using the interior pages of an old book as an art surface to tell a story.

Don't hold yourself back from trying new surfaces and sizes. When I first started out, I was intimidated by large canvases. But eventually I just had to work big, and I still go back and forth between small, intimate pieces and large canvases, depending on my mood and the project at hand.

Physical limitations might also affect what surfaces and materials work best for you. Large surfaces require a more physical style of working. Smaller pieces allow you to be very quiet and intimate with your subject. There is no right or wrong ... it's your vision and expression.

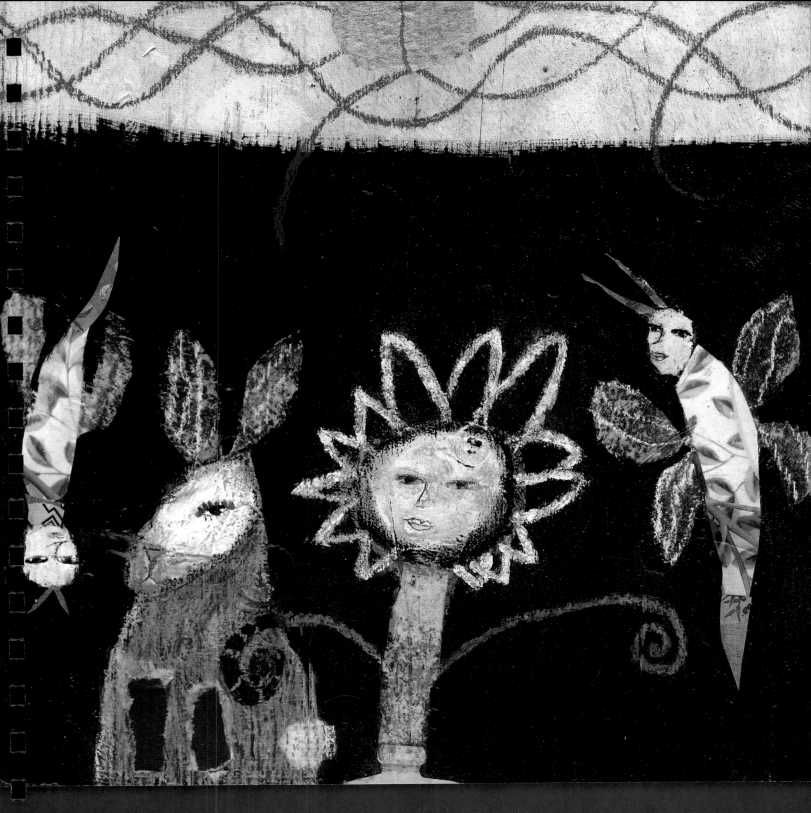

"I work in whatever medium
likes me at the moment."
—Marc Chagall

SURFACES

A surface is anything you can paint or draw on, including canvas, paper, Masonite, or a pine board. You can also paint on a paper bag or an old door. Each surface takes each medium differently, so you will need to experiment to suit your taste and your budget.

Acrylic and pastel on 36-inch (1 m) stretched canvas. Stretched canvas is durable and well-suited to painting in a physical manner, which is usually the technique for large abstracts. Experiment with the different types of canvas—cotton, linen, and so on—to find one that suits your taste and materials.

Acrylic and inks on newsprint | The hazy green circles were achieved by applying a white gesso wash over the acrylic painting. Note how the black ink is bleeding due to the newsprint surface.

TIP Instead of recycling your old phone book, you can staple about ten pages together, gesso the top layer, and use it as a drawing surface for pen and ink pencil illustrations. The text can show through in areas, adding context and texture to your work.

Paul Klee painted on newsprint throughout the war, as it was all he had.

WOOD, PAPER, CANVAS

THE FOLLOWING SURFACES ARE SHOWN IN THIS BOOK:

Pine board can be purchased at local home and garden stores in board lengths and then cut to size. The surface is porous and takes acrylics wonderfully. It is also great for collage. Wood pieces can be hung without framing, saving you or an art buyer some money. It's also sturdy and easy to move around in your studio.

Newsprint bought at an arts and crafts store or your local newspaper can take inks, pastel, pencil, and paint (although the number of layers you can use is limited because the paper cannot withstand too much moisture). Newspaper makes good collage material and is useful for adding words to another surface. It is very inexpensive, readily available, and for these reasons, also good for practicing since it's not "special."

Watercolor paper is durable and takes acrylic well. It can be repainted many times. You can also embellish and alter paper with sewing and collage. The thickness of a sheet of watercolor paper is indicated by its weight, measured by either grams per square meter (gsm) or pounds per 500-sheet ream (lb): the greater the weight, the thicker the sheet. For acrylics and other mediums, consider 140 lb (300 gsm) as a minimum for using multiple paint layers. If you plan on doing lots of layers and rough application techniques, 300 lb (640 gsm) paper is probably preferable. Visit your art supply store and get a feel for the different textures and weights.

Canvas is durable and resilient, and it comes in a variety of sizes. I suggest you purchase prestretched and gessoed frames for ease. Many types of canvas are available, such as cotton and linen, and each has its own qualities and price ranges. Canvas allows you to work large and doesn't require a frame for hanging. It also allows you to repaint the surface many, many times. I have repainted some canvases years later.

Drafting paper works well with pencil, ink, conté, and pastel. It is wonderful for layered illustrations, which are described in chapter 5.

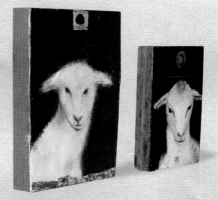

These acrylic portraits were done on old wood beams from the artist's barn. Consider using recycled wood as a surface. Shop at antique or salvage yards for old doors and shelves that can be painted on. Another benefit is that they don't require frames.

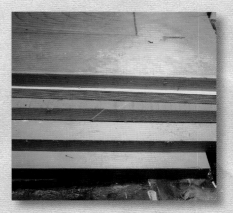

Pine board is durable and easy to ship. Purchase it in board lengths and have it cut to the size you want. The way pine takes paint, inks, and pastels is texturally appealing to many artists.

DRAWING MEDIUMS

This book focuses on working with acrylic paint, inks, ballpoint pens, pencil, pastel, and collage. Some watercolor is also used. These mediums can all be incorporated into one piece or used individually, depending on your needs and vision. I say this often, but it deserves repeating: Experiment! Every brand is slightly different. Your needs and personality will lead you to materials that are right for you.

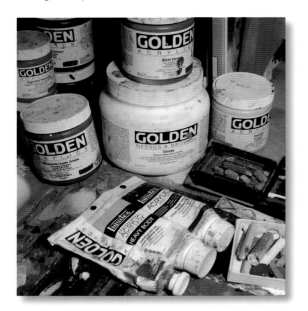

Here is an array of paints and pastels on the artist's (messy) desk. Remember that acrylics dry quickly, and are well suited to painting in many layers. They also are water-based and can be washed up with soap and water.

TIP Consider incorporating latex house paint into your work. It is especially useful when you work on large surfaces. In addition, you can mix acrylic color into the paint. Apply the latex paint onto your surface, dab an acrylic paint color onto the latex/surface, and rub it in with a cloth to provide a wonderful "hazy," ethereal quality to the image.

PAINTS

Acrylic paint dries quickly, making it perfect for layering techniques and collage. It also allows you to make many changes more quickly than with oil paint. Since it's water soluble, you don't need solvents for thinning or cleanup. Solvents and turpentines can be dangerous to use without proper ventilation. (Any of the exercises in this book can be done with oil paints if that is your preferred medium.)

Acrylic gesso is usually applied on the surface before a painting is begun; it is a "ground," and it fixes the surface so other paint and materials will adhere better. White gesso can also be used as a white color to mix in with your acrylic paints to lighten their value. You can also purchase black gesso.

Many acrylic brands are available. I work with Golden and Liquitex. Heavier bonded acrylics come in tubes or jars and can be mixed with water to create washes. You'll find that the same color can vary slightly from brand to brand, so you will need to experiment and find your preferences. I purchase the base colors that I use most often—such as cream, black, Payne's gray, white, browns, and olives—in wide-mouth jars, which allow me to dip my brush right in to get more paint. I purchase the smaller tubes for pricier colors and for the ones I use in accents, such as cadmium reds.

TIP Acrylic paint dries quickly, so try keeping some small plastic bags at your work area. You can place one over the open jar to save the time and energy of repeatedly putting the lids back on. You can also lay the plastic bags over paint you've spread out on a palette to mix.

I also have a variety of Winsor & Newton watercolor tubes on hand. These can be used as washes or mixed over acrylic for unusual effects.

You can also experiment with very inexpensive paints, such as children's poster paint and cheaper brands. You'll find these useful for processes such as washing a large area with an initial color, but you'll also discover that cheaper paints often don't mix well or react oddly with varnishes and other mediums.

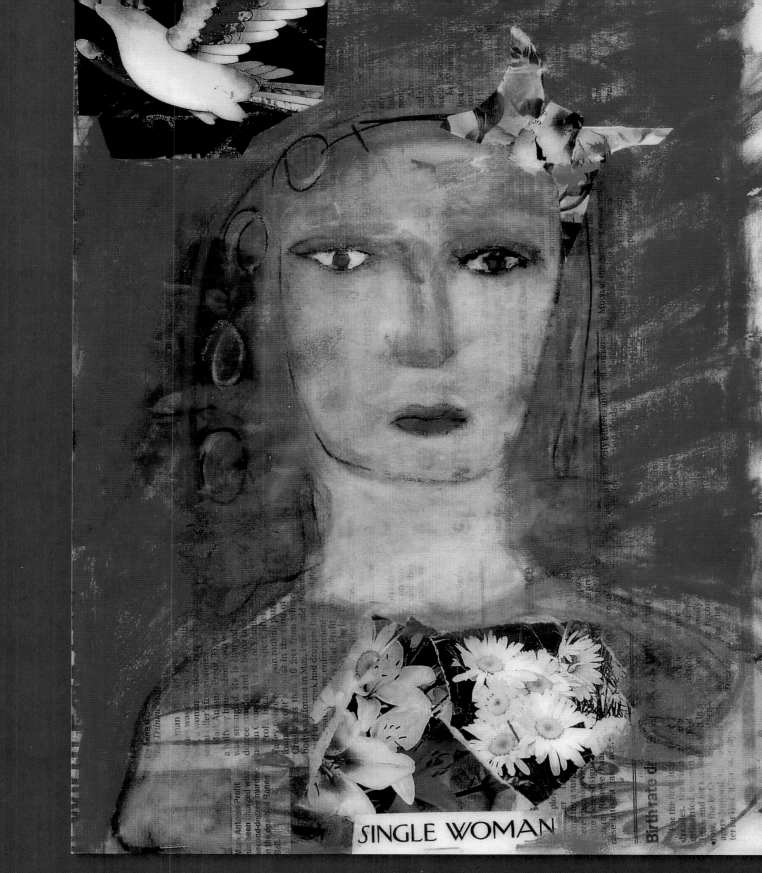

SINGLE WOMAN

Acrylic and pastel, collage on folded city newspaper | Note how the text of the paper shows through in areas.
Newspaper doesn't last hundreds of years like canvas might, but its soft, absorbent quality is appealing to many.

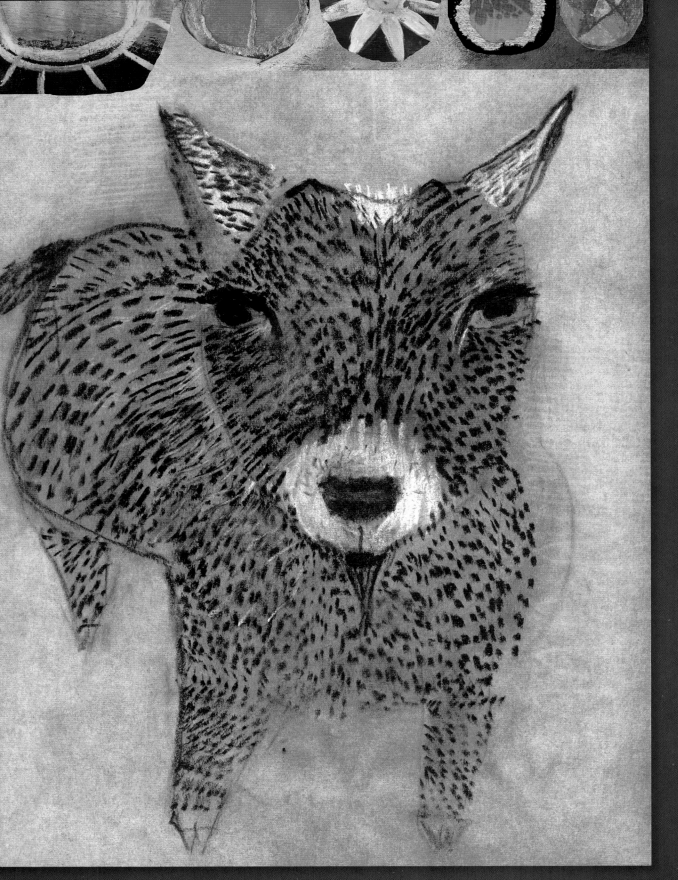

Acrylic wash over tissue paper | The hairs of the goat were created with watercolor sticks and pastel. The top border is made with collaged elements. When working on tissue paper, you have to work quickly and are limited to how much waterbased medium you can apply.

PENCILS, PASTELS, INKS

A myriad of pencils, pastels, and inks are available. If you plan to incorporate them into your work and are using acrylic, you will need to seek out waterproof varieties—unless you are open to bleeding and chance textures, which you might desire in abstract pieces.

You can read all the books in the world on materials, but the best way to learn what works is to buy a variety of mediums and experiment. Books will tell you that non-oil-based pastel won't work well over acrylic, especially if varnish is applied, but I do this all the time by adding light varnish sprays onto the chalk/pastel, letting it dry, and then adding a light coat of varnish again. I repeat this until I have the desired effect, such as on the goat image you see here. So experiment and find the brands and materials you can manipulate to your advantage.

Pastels, inks, and pencil can add detail, color, line, shading, tonal ranges, washes, or words. Certain inks and pencils will bleed more, which might be a welcome result or not. Oil pastels can be used over acrylic to paint words, bold lines, or shapes. Watercolor sticks used over acrylic or directly on paper can create a watercolor effect with some control for line. Try creating your initial drawing with just oil sticks or pencil, let it dry, and then add subtle washes of watered-down ink or acrylic over it. Experiment! I like to follow the philosophy of, "Who says?" When someone states an opinion or what appears to be a fact, I ask myself, "Who says?" What works for me might be frustrating for you and vice versa.

For more detailed parts of an illustration, pens or pastel pencils can clarify finite details, like an eyebrow or fingernail. I always have a variety of pens around, including basic Sharpies, for detailed work.

TIP A variety of sharp objects at your desk can be handy for writing or carving words into your piece. I keep a box of nails and pins at my working table to use for inscribing into a light layer of acrylic, showing off a darker layer underneath. You'll be surprised at the difference in lines between different-size nails, so keep a variety available. Other good and inexpensive word inscribers are knife tips, pushpins, and sewing and knitting needles.

Different mediums produce different results. Experiment! Test your medium to see if it is waterproof by dabbing a bit of water on it. Sometimes you might welcome the smudging that occurs if it's not water soluble.

TIP Dab a small amount of Liquitex varnish over ink or pencil to give it a protective coating, allowing you to proceed with the next layer of the painting.

A wine label for a distributor was created on magazine scrap paper with acrylic, ink, and pastel. The client liked the torn edges, feeling them to be "earthy" and raw, like the earth the grapes came from. This is a good example of incorporating nonwaterproof ink into an acrylic painting; I lightly varnished the ink before I proceeded so it wouldn't bleed too much.

ADHESIVES FOR COLLAGE AND PROTECTIVE COATINGS

Acrylic adhesives attach material to your working surface. All the pieces in this book use Liquitex semigloss varnish for collage elements and protective coatings. You can also get a very heavy gel adhesive with texture added, such as pumice, which creates a gritty quality. Or you can buy varnish in a spray adhesive. I try very hard not to use this, as it is bad for the environment and my lungs. If you do use it, wear a mask and be sure you have good ventilation. Sometimes I have to use it to spray a tiny amount of protective coating over a small element so it won't smudge—usually pastel.

Liquid varnish comes in manageable squeeze bottles. Apply with fingers or a brush. A handheld size might be more comfortable and easier to use than a large jar of varnish. The hardware store has a variety of inexpensive 1-inch-wide (2.5 cm) paintbrushes. They're great for applying varnish, saving your more expensive brushes from too much abuse.

TIP If you do a lot of spraying with fixatives, consider investing in a spray booth, but still wear a mask. Consider using Liquitex gloss varnish in the bottle as much as possible instead of spray varnish. Spray cans should never be thrown out unless totally empty.

Liquid varnish comes in a squeeze bottle, making it easy to adjust the amount of varnish you require. A 12-ounce (340 g) bottle can last a long time. Varnishes come in matte or gloss finishes. You can also purchase varnishes in large gallon (3.8 L) buckets, helpful for using large brushes to apply items to large canvases.

TIP For collage, apply varnish with a brush or finger to the working surface where you want to place scrap. Place scrap on the varnished spot and press lightly until it stops moving. Some papers might wrinkle, tear, or change values, but often this element is welcome in the finished art.

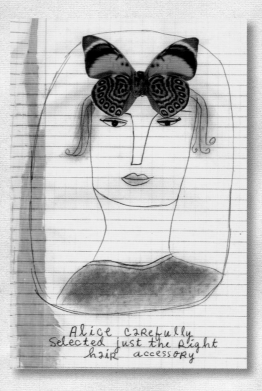

This piece is a series of portraits created for a fundraiser event. The butterfly is magazine scrap varnished down to the notebook paper. The purple dress is shoe polish, another unique medium to experiment with color and "sheen."

If you use acrylic, I recommend that you apply varnish over your finished pieces no matter what surface you're working on. Since acrylics dry slightly duller than their wet state, the varnish saturates the final color and also protects the painting. A heavy application can create a milky appearance, so you will need to experiment to determine the amount you need.

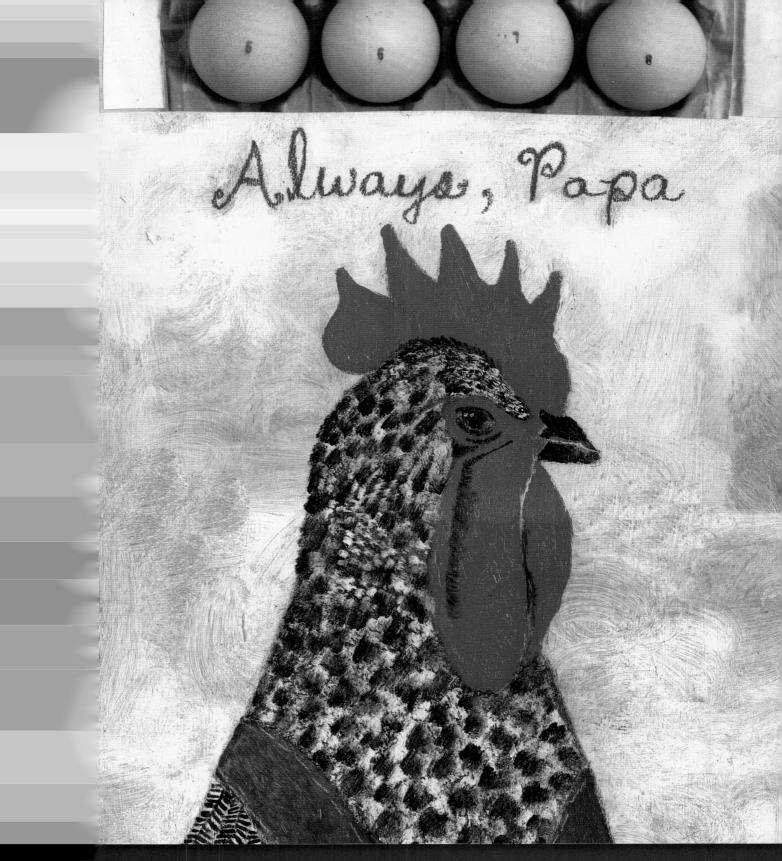

Always, Papa

Acrylic. Collage and pastel on wood | The words "Always, Papa" were applied over the acrylic background and then dabbed with a finger with acrylic varnish. That way, when I brushed on the final varnish coating, the letters wouldn't smear.

Chapter 2

Illustration as

STORYTELLING

Every picture tells a story; every face has a history. Every tree has a beginning and an end. Drawing and painting your world is a wonderful way to share your stories or explore stories you didn't know existed until you sat down to find them. Characters, plots, and scenes are everywhere. Come along and explore.

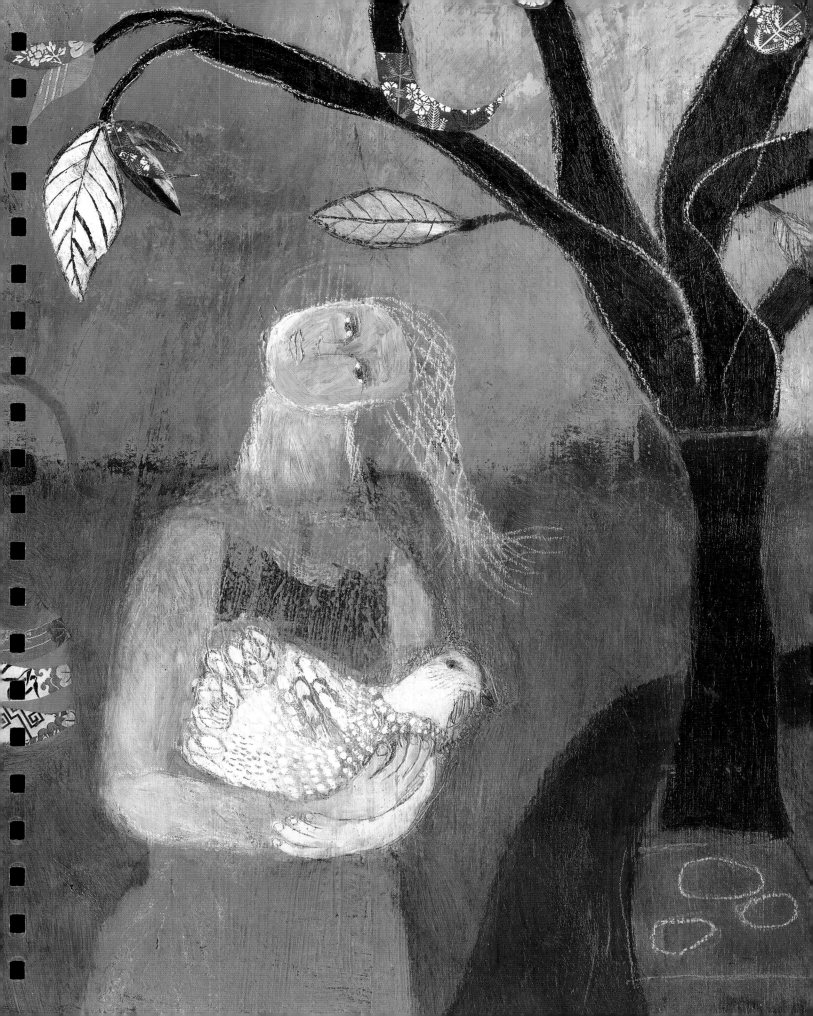

CAPTURING THE ESSENCE

**es·sence [es-uhns]
—noun**

1. the individual, real, or ultimate nature of a thing especially as opposed to its existence: *A painting that captures the essence of the land.*

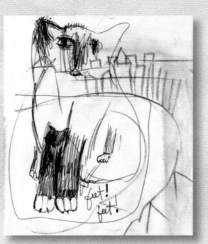

STAGE 1:
Commission of a cat.

For starters, let's take the mystique out of finding that initial idea. The blank page can create panic in some artists, novice or otherwise, but if you look at the world right at your feet as a library of images, ripe with stories, then you can be confident that the ideas are always there for you. The trick is to notice when you are inspired and make note of it: somehow, somewhere. You want to capture the essence of your inspiration and not necessarily the whole story that comes with that essence.

In this commission of a cat, it was all about her attitude but also her white feet. Later when I sat down to do the actual painting (seen on the opposite page), I surrounded her in mirrors, since she was very beautiful and knew it. When you do your next pet portrait, write out a sentence for yourself that captures the personality of that animal before you begin.

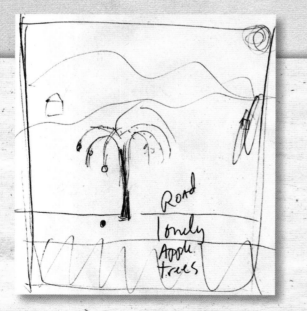

STAGE 1:
A lonely apple tree.

This was caught quickly in my car—a lonely apple tree on the country road.

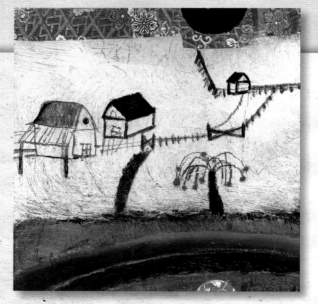

STAGE 2:
A lonely apple tree.

Later in my studio, the lonely apple tree gets a farm to feel less lonely. But the essence and personality of the tree remain.

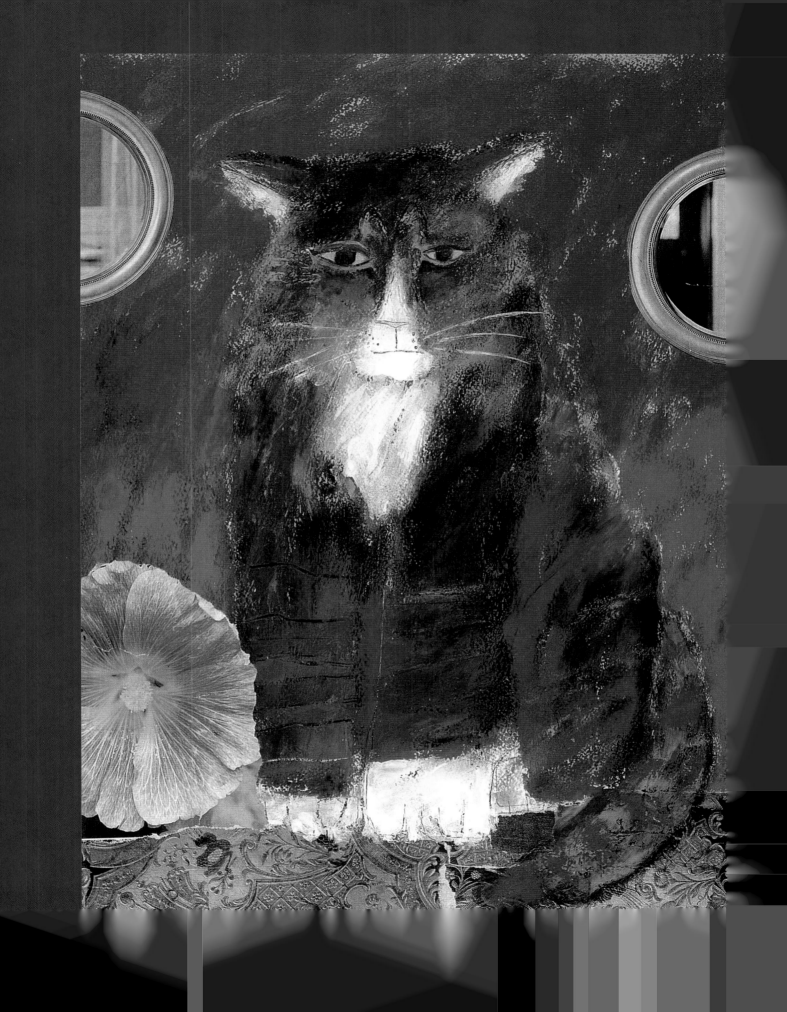

Not all your sketches or doodles will end up as final illustrations. Certain details of a rough may end up in a final piece of art days or weeks later.

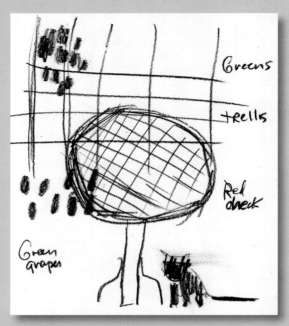

STAGE 1:

Crude sketch of first inspiration.

My studio is surrounded by doors and windows, so I can look out at nature and animals all day long. I can walk out onto a front courtyard, with grapevines and trelliswork, where cats often lounge. The first stage shows the initial crude notes I took. The second image shows an intermediate color sketch. It is still crude, but it's a little more developed than the first sketch.

That sketch never made it to a final stage, but you can see the lush leaves, the cat, the grapes all merged into one in the piece on the final. I don't know the time span between these, but I think inspiration soaks into you and can be brought to the surface at any time—especially when you sit down to paint or draw.

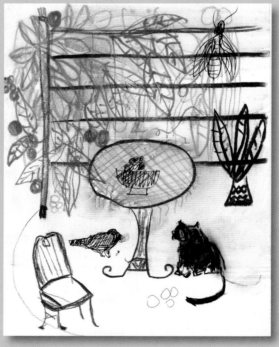

STAGE 2:

Intermediate color sketch for layout | You can choose how much detail you want these initial sketch ideas to have. I like to get to the actual painting quickly, since my work is so inspired by color.

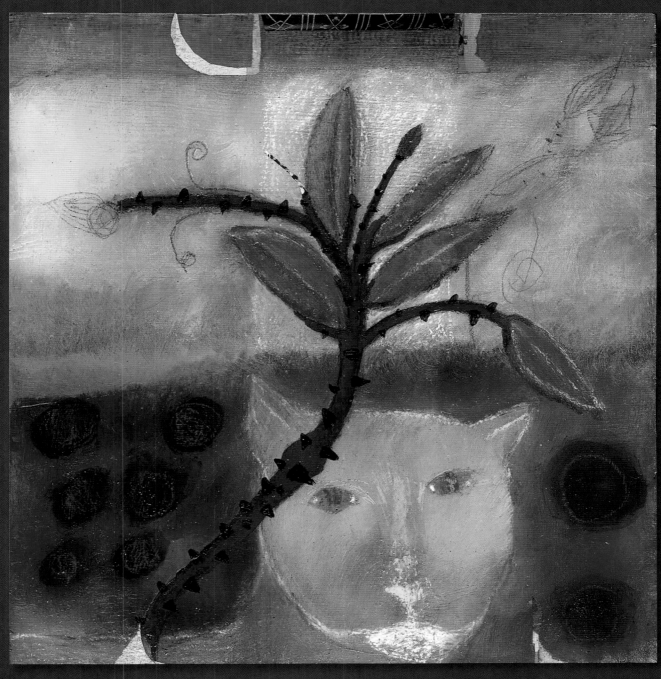

STAGE 3: FINAL
Cat, acrylic/mixed media on wood.

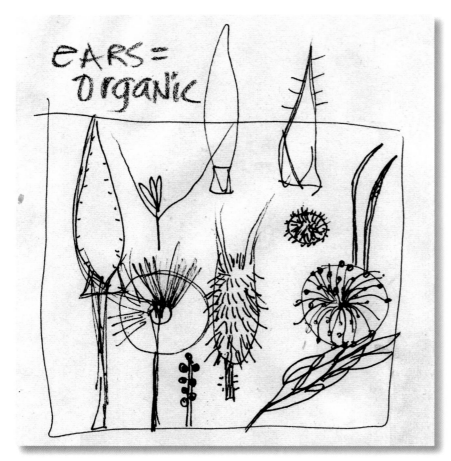

EARS = organic

Initial crude line images of various weed forms in the garden, on scrap paper with ink

STAGE 2: (Opposite)

As I continued, I noticed the donkeys in the background. I can't help but see their ears as organic creatures, just like a plant or weed. I began to see their ears as negative and positive shapes.

Turn the page to see how these initial sketch inspirations turned out. Do you see shapes around you that become spatial patterns rather than objects? Can you incorporate them into one of your pieces?

The initial idea capture is just that: initial. Don't get bogged down in details at this stage. Capture the essence of what you are seeing and focus on the details of the illustration later.

Get a word down on a pad of paper or get a line image down on a sketch pad—whatever it takes to jog your memory back at your studio when you can focus on the idea in depth. Maybe you see a woman in a black dress holding red flowers. The image inspires you somehow, but you don't know why. Jot it down: black dress and red flowers. Back at your drawing table days or weeks later, you can read the note and work through the idea in greater detail, from memory and from the feeling, or essence, of why that image initially grabbed your eye and heart.

Here I set out to just capture the beauty of the various shapes of the garden, including my beloved weed friends. The donkeys of our farm were in the background.

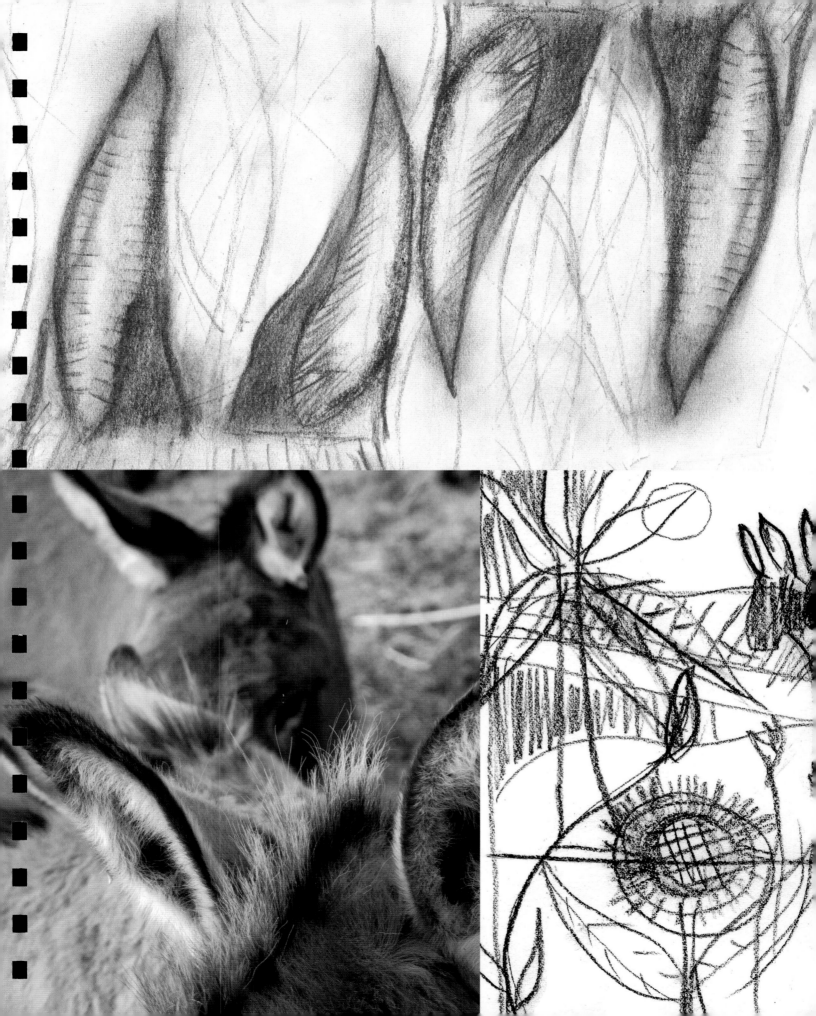

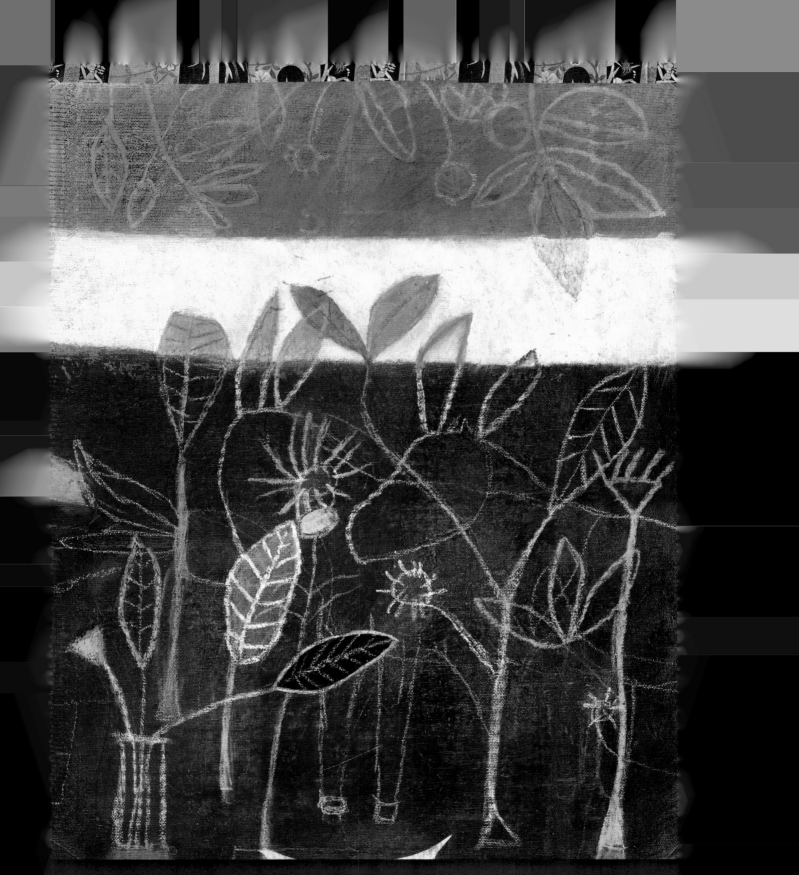

STAGE 3A:

Fully developed illustration.

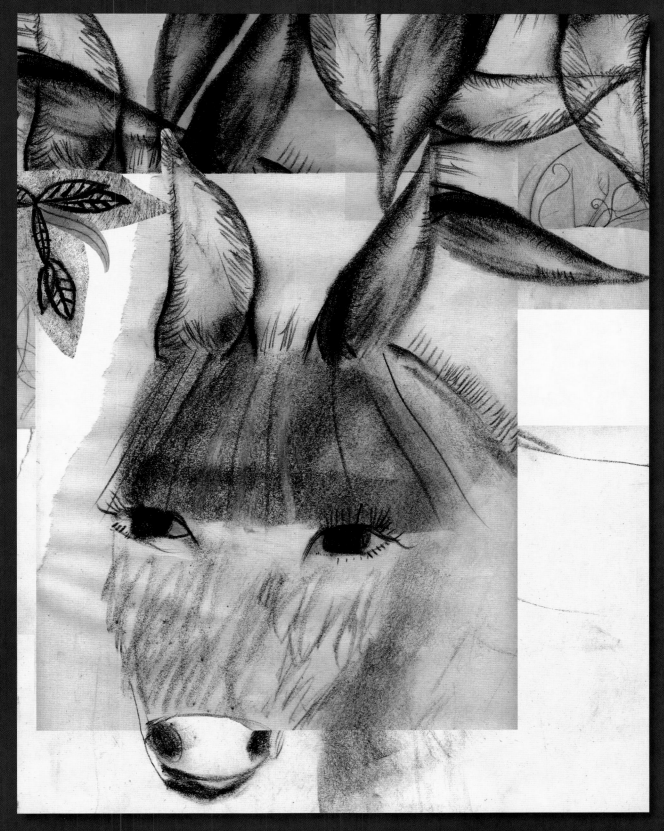

STAGE 3B:
Fully developed illustration.

Words are powerful memory joggers. Jot down a word versus a sketch.

OWL – LIT BY MOON
OBJECTS = LEAVES

STAGE 1:
A moonlit owl in the upper hayloft inspires me to jot a note down in the studio.

MAKE NOTE TAKING EASY

Just like you take a twenty-minute walk to keep your mind and heart alive, take twenty minutes to observe, sketch, or take notes. It will become part of your routine, and it will hone your senses the more you do it. Seeing, as well as drawing and painting, is a discipline.

Make it easy to capture your inspirations. A small digital camera is a real asset for any artist to document ideas anywhere and anytime. And of course, with many cell phones, a picture is at your fingertips.

I have a variety of note pads in all sizes around the studio and in my car. Some are tiny palm-size pads that fit in my pocket—perfect for when I'm walking or in the car on the go.

Scrap Box

Keep a scrap box full of thoughts that come to you throughout the day. Keep a pad of sticky notes at your desk and in your car for spontaneous encounters. Attach a pencil to a series of notepads so you're never without a way to take notes. I am notorious for writing words on my wrist for later reference!

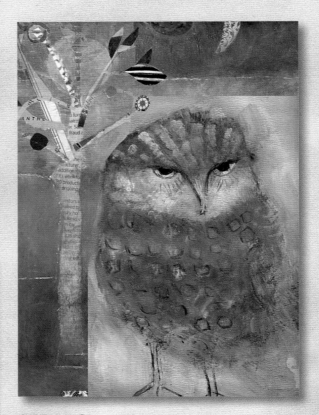

STAGE 2:
Soon after, I created this piece but placed the owl next to a tree instead of the barn loft. The leaves must have been very inspiring to me that night.

Name one thing today that sticks in your head. Was it inspiring enough to sketch or draw?

STAGE 1: (Left)

This is from one of the mini notepads in my car. On this day I was touched by the youth of a bird and also by the tiny young tree it sat next to. They both seemed so vulnerable but hopeful.

STAGE 2: (Bottom)

The note taking above led to a series of pieces, including this one. I never did any more sketches on this—just went right to the final. It was all in my head ... and heart. Sometimes an inspired moment is ongoing and leads to a series of images. Sometimes it flutters and goes away but comes back days or months later. I think the important thing is to recognize it as a moment of inspiration and do your best, at that time, to honor it somehow and share it in art.

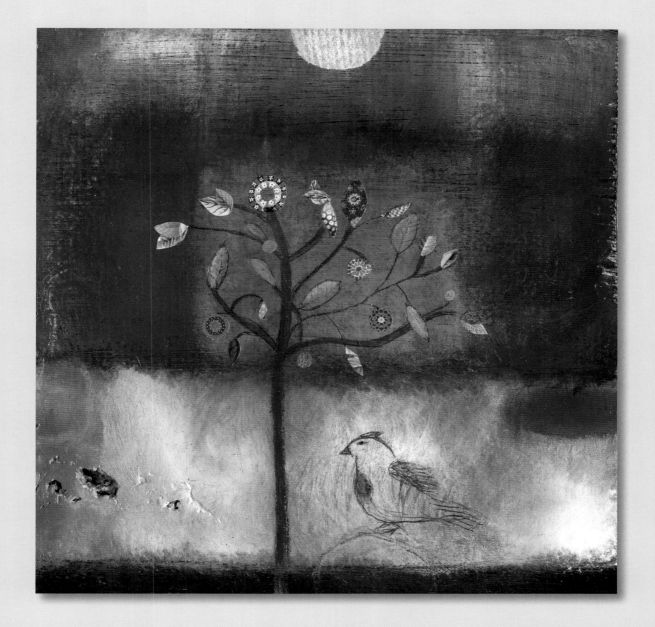

IDEAS FROM OUT THERE AND IN THERE

Just two of the many sketches from the artist's pile of inspirations that have never been made into final art ... yet.

My life is on a farm, where I interact daily with nature and a cast of animal muses. Land, fog, and working in the fields are part of my inner and outer skin here. But I've also lived in large cities and studied and traveled abroad. Each environment brought a new palette of sounds, textures, and objects. How we each react to these environments and put them on paper becomes ours and ours alone. We will go into other inspirations in later chapters, but for now, I want to emphasize that cities, apartments, tiny houses, bookstores, gas stations, farms, rivers, mountains, high rises, and basements all have stories for us.

A jotted-down word or sketch can be like a conversation with another person. You can't necessarily know the outcome. You can guide it, but you often learn things you weren't planning on. Sometimes an idea pops into your head from what seems like nowhere, and when you revisit that idea at your desk, it takes a path you hadn't really planned. This is the magic! Let it flow and see what develops. You do, after all, have your own inner mysteries and thoughts that are going to interact with that initial idea. That's your voice.

Some people are more comfortable just sitting down and starting with an inspiring idea that came to them "out of the blue." I have learned not to think too hard about where some ideas come from but to recognize them as wonderful little internal stories that I needed to tell—for myself as well as a viewer.

While we've been focusing on finding inspiration by going out and observing and sketching or documenting, many of your inspired moments just get soaked up into your own essence, and later—days, weeks, or months—an idea that has been unconsciously percolating in you spouts. This is the beauty and the mystery of creating.

I've had ideas in piles that years later moved me to do a drawing.

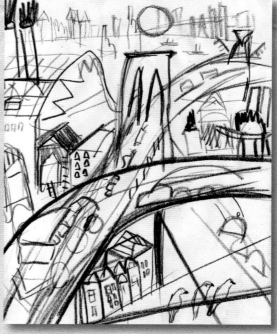

After a trip to the city, I made this crude sketch, trying to capture the chaos and activity I felt on that particular day. Note the two birds in the lower right; always, my homage to nature ends up somewhere, somehow. Do you live in the city? Maybe a trip to the country would inspire drawings outside of your comfort zone.

Inspired by a Swedish friend and memories of my travels there over twenty years ago, this illustration is about Saint Lucia Festival of Lights. The white snow circles were made by layer upon layer of collaged white tissue paper.

A piece inspired by urban growth boundaries.

Mining for Ideas

Retrace your day in your head. What things happened that left a visual impact on you? Jot those ideas down. Add them to your idea box or notebook for later reference. Here a collage of images on the facing page shows how simple daily activities are ripe with emotion and initial sketch ideas.

- Sit and watch faces on the morning commute. What emotions or stories do you see?
- A face at the coffee shop intrigues you—why? Was it color, texture, expression, or memory?
- A pair of red high heels in a store window takes you way back to a childhood memory.
- What shapes and textures do you respond to?
- You hear a story on the radio or read an article that inspires you.
- People are talking on the elevator, and you're listening in.
- You're on a plane, and it makes you wonder what a bird sees in flight.

Not all inspired moments become full-blown drawings or illustrations. I think you sometimes have to let inspired moments gestate and evolve on their own time. On the other hand, you should look at drawing and art as a discipline and practice sketching, painting, and creating. Then if the idea needs to percolate and be reborn days or months later, it will. But first you should exercise that idea by drawing it out, playing with it, and exploring it.

TOOK 10 MINUTES FOR BUG TO LEAVE

The artist sits at her farm observing the natural world. While one person's daily stories might be in nature, another's might be in the city.

worried
couple

child
worried
about
pumpkin

LET THE IDEA BLOSSOM

L et's take a sketch idea and see how it progresses from start to finish. I'll start with some basic notes and sketches and show how they evolve on paper and in my head and heart.

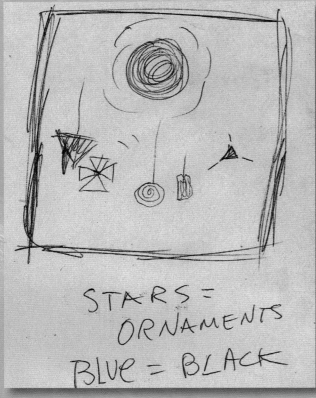

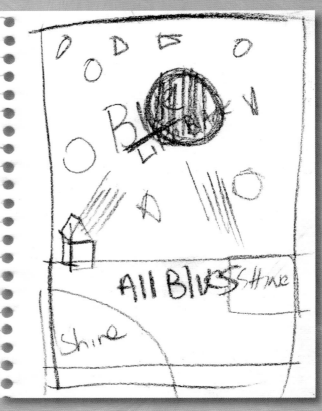

STAGE 1:
Initial inspiration written in a crude note in an artist's pad.

STAGE 2:
Months later, I revisited the idea, perhaps reinspired by another starry nightscape.

I like to call the initial phase of drawing the flow stage, as the idea starts like a little twig at the top of a stream and flows along collecting debris, dropping debris, and losing a bit of itself here and there until somewhere it comes to rest.

Living out in the country, I see a movie in the sky every night. Certain nights just grab me harder than others, and this was one of those winter nights when the sky was so black it was blue or vice versa. I remember making a note of it quickly after returning to the studio.

This crudely written note sat for several months before I had time to revisit it. Perhaps another night had come along and reminded me, "The stars are like ornaments tonight," inspiring me to finally sit down and paint.

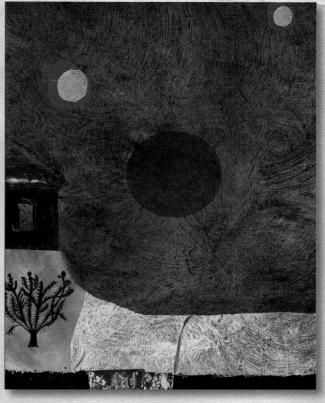

STAGE 3:

I began by covering the board in paint. I always cover my surface with a color. Not only does it give me a starting point, but the motion of adding a wash of color is like a "warm-up."

This initial layer is not only a ground, but it frees me from thinking of the painting as too precious. Once I get the initial color down, I don't feel like I'm going to ruin anything. This is strictly psychological for me; you might not need to do that.

STAGE 4:

Figuring out the initial composition | The idea is at a fluid stage at this point, and I don't have a strict sketch that I stick to. I'm thinking of that huge moon and the blue. I play with shapes by cutting them out of scrap to see how shapes might work, or I use pastel to draw figures before applying them in paint.

I wanted to capture the bigness of the sky and how it felt almost like shiny blue. Objects were lit by the stars and moon. Note the black stripe at the bottom, another recurring symbol in my work. I feel it grounds me and the painting, like roots of a tree or like the frame around a work of art. I've added a few stars and a giant moon to show you how the painting was progressing early on.

TIP The computer can be a like a vacuum cleaner sucking your creative juices clean. Trust me, I know! Turn off any sound alerts for incoming email and create a noncomputer area just for art and writing. I find staying away from the computer is like any discipline: I need to make a conscious decision to do it, and then I need to practice it daily, just like getting exercise.

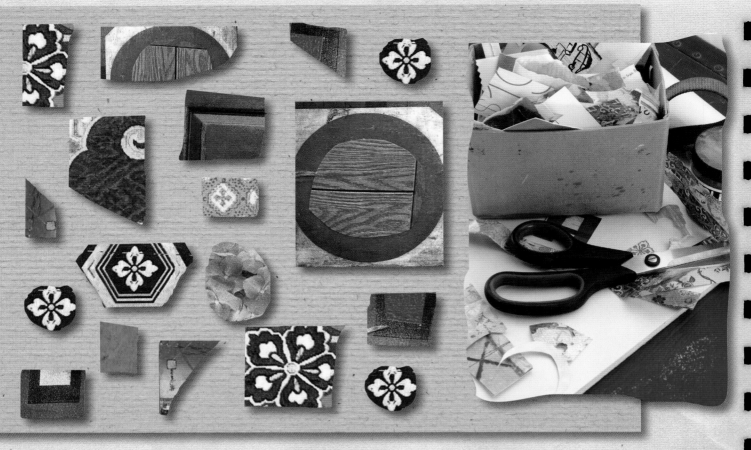

STAGE 5:

I often incorporate collage bits into my pieces. I keep cutouts of colors from magazines, bits of fabric scraps, stamps, or whatever inspires me. I keep a box on my painting table and play with the shapes and colors as I work out the image.

This stage is where you need to plow ahead and really focus without interruption on your task. Even if you feel stuck, just keep moving forward and thinking. The creative process can be mysterious, but if your hands are moving, sooner or later things develop. Another tip is to use tracing paper and play with the composition at this stage. Get up and move away from the piece if you're having trouble.

Speaking from experience, there are many times when I feel an idea is going nowhere, but after a while, something pops and reminds me of something or looks like something, helping me add new details to the picture that is forming. If after a couple of hours nothing is flowing, and I mean *nothing*, I walk away from it, take a walk, or work on something else and come back to it later that day. Or I go pet the donkeys, and that always helps!

As I continued thinking about and playing with this piece, I realized I wanted the stars to be abstract and magical. I began to add collage bits.

Fresh Perspective

If you get to a certain stage in the composition and you just can't pinpoint what is wrong with the actual composition, try turning it upside down. Sometimes this helps you see shapes and spaces. Another trick is to place the piece in various locations in the house and walk away from it; work on something else for an hour. Return to it and often you see the next steps you want to take.

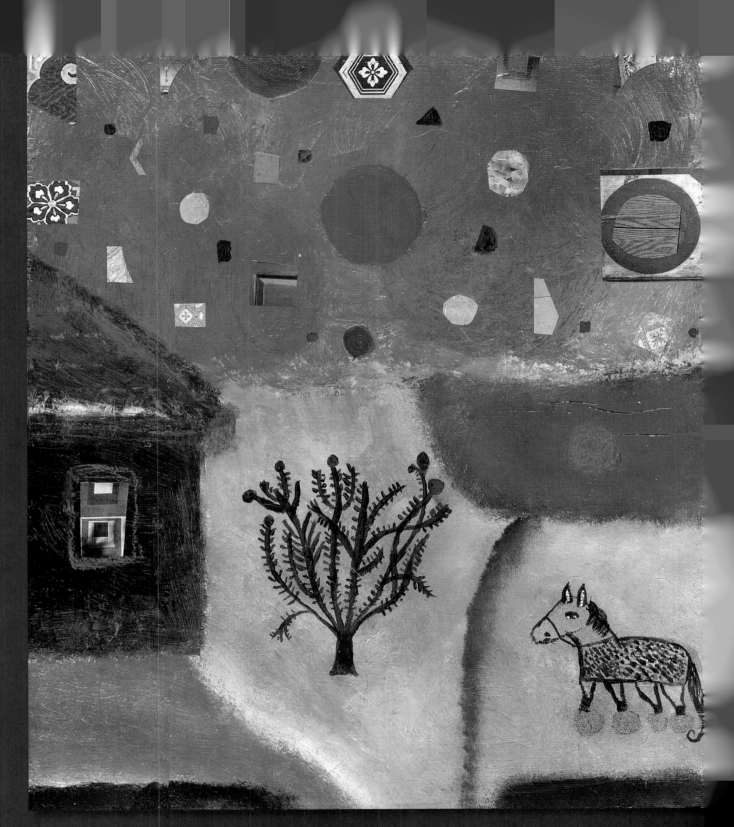

STAGE 6:

The final piece | I added more foreground and changed the composition slightly from the initial layout. And I added a donkey. Or is it a toy donkey? The red circles under the donkey are a mystery to me, but I chose to leave them in. And I wonder, what is the donkey seeing in that window? That's a different story for some other time.

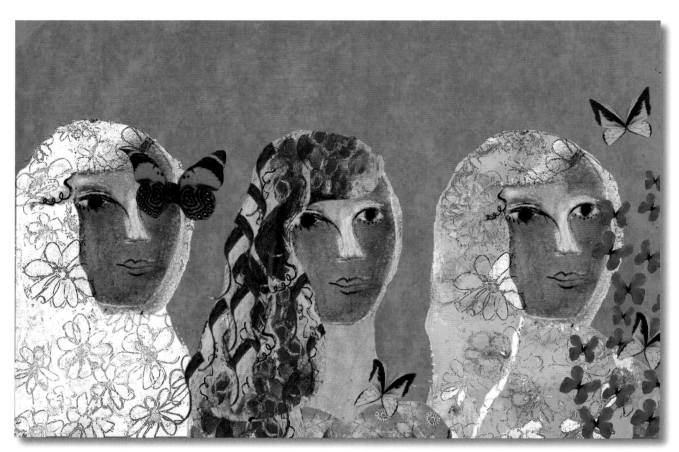

This piece was inspired by the struggle of a Muslim woman who felt trapped between cultures, yearning to combine elements of each and be free. It was created with digital layers of scanned images, a technique that will be discussed in chapter 5.

HERE, THERE, AND EVERYWHERE

So there are stories all around me, and you. Your stories will be uniquely yours and may be inspired by city sounds or nighttime outings in noisy gathering spots. Maybe a dream inspires an idea. Watching a movie, listening to music, reading—ideas can blossom from all of these experiences. Wherever you live, work, or dream, you need only look, listen, and feel to have a whole library of stories to tell.

Let me show you just a small sampling of pieces in my illustration portfolio and what inspired each.

"There is life in everything. Why didn't I paint it long ago?"
—Ludwig Bemelmans

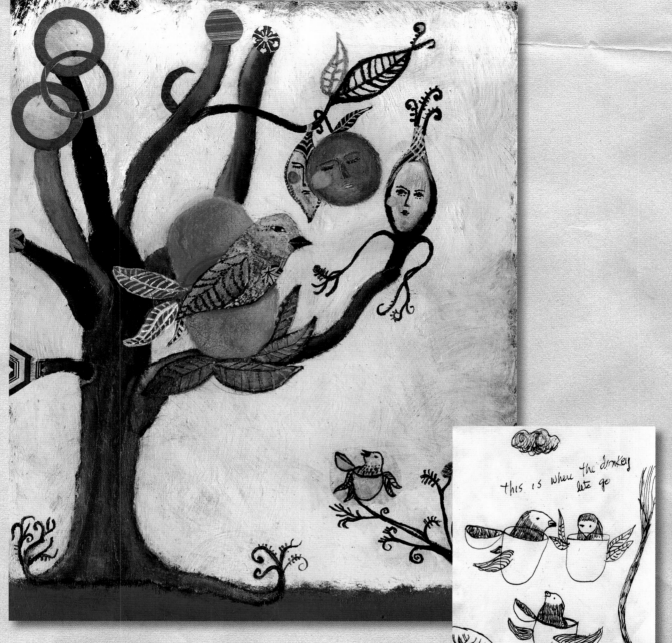

this is where the donkey lets go

FUN EXERCISE

Try writing a short story of fifty words. Then divide it into illustrations but leave the words out. Did your pictures tell the story? Or pick one sentence out of a book and illustrate it. Look for ways to show what you feel and show what you see in your mind as you read that sentence. A bird sings from the rooftop ... but what does the bird see? Where is the house—in a park or a city?

What experience did you witness that upset you?
Can you create a fanciful illustration where everything
turned out okay in the end?

I found a beautiful blue egg on the road and brought it to my garden, where I set it in a planter to enjoy its beauty and give it a respectful place to rest safely. Weeks later, a visitor to our farm saw it, picked it up, and broke it. I created a whole series of pieces about where baby birds go if they aren't born. I fantasized how their little eggs became living rooms that could fly them to safety and to visit other friends.

How would you illustrate the feeling of safety in a drawing or painting?

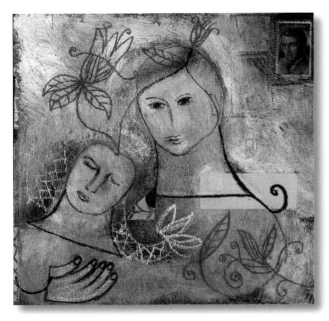

The intent here was to illustrate the feeling of mother as safe harbor. This piece was painted on a box, with the interior lined in vintage wallpaper. I placed locks of hair and some trinkets inside the box, each symbolizing mother love. The piece was part of a group show raising awareness for a charity that worked to combat abuse in families. The organic leaves symbolize growth and fertile grounds.

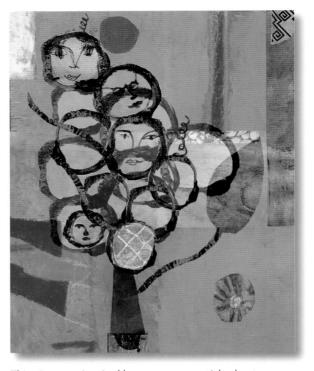

This piece was inspired by a newspaper article about a woman who found comfort adding life to earth by planting trees, after experiencing multiple losses of loved ones. It is an example of "layers" of drawings and collage pieces that are later scanned and "sandwiched together" to make one final digital original. Read more about this technique in chapter 5.

Let Go of the Outcome

To keep yourself from getting too "attached to the outcome," try having several pieces going at the same time. This might not work for everyone, but it can help make you less afraid to add or subtract something in the piece for fear you might ruin it. Taping your work to Masonite boards is a benefit because you can move the boards around and bring a new piece onto your work area easily.

Different Perspectives

If you're looking at one of your in-process works and you can't quite figure out what is wrong with the composition of the piece, try turning it upside down or 90 degrees. This can allow you to see shapes at different angles and perspectives, helping you improve the overall balance and design of the image.

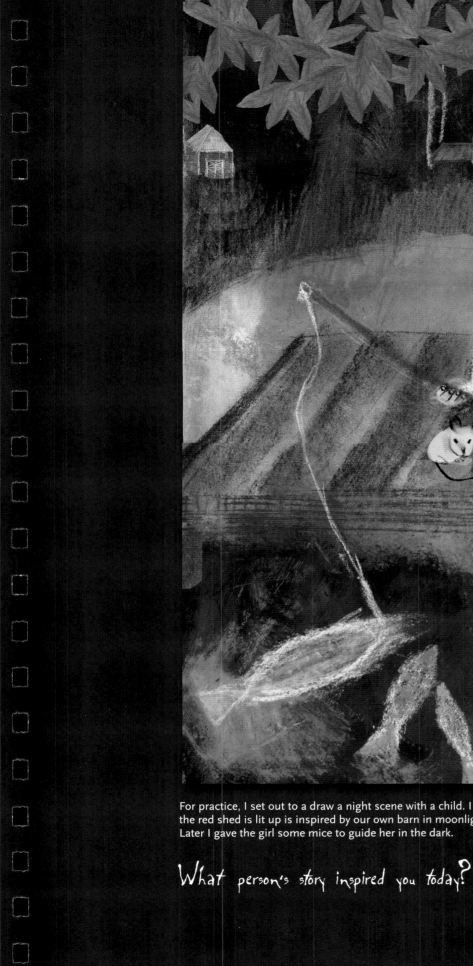

For practice, I set out to a draw a night scene with a child. I love the night's darkness, as well as its mystery. The way the red shed is lit up is inspired by our own barn in moonlight. After I finished, I set the piece down for a few days. Later I gave the girl some mice to guide her in the dark.

What person's story inspired you today?

An
EXERCISE

Go now and look with the eyes of a child, but look like it's your last day. Tell that story in drawings.

March 25 ... Today I left my shoes in my bedroom and put on my favorite hat. I didn't need shoes because I wanted to feel my grass friends. I went outside and walked all over the grasses, but I tried to tiptoe so I wouldn't hurt them too much. They said, "Thank you for tiptoeing!" My toes felt free and happy in the grass. I saw so many things on the ground and in the air. Some were bright and shiny, some were soft. I saw a bird on a tree. The tree was little like me. I think the bird liked my hat because it sang a song to me and my hat. When I was in my bed, my mother was going to read to me. But I had to tell her my story about walking in the grasses. And I wore my hat to bed too and sang the bird song.

when WORMS geT CUT IN TWO

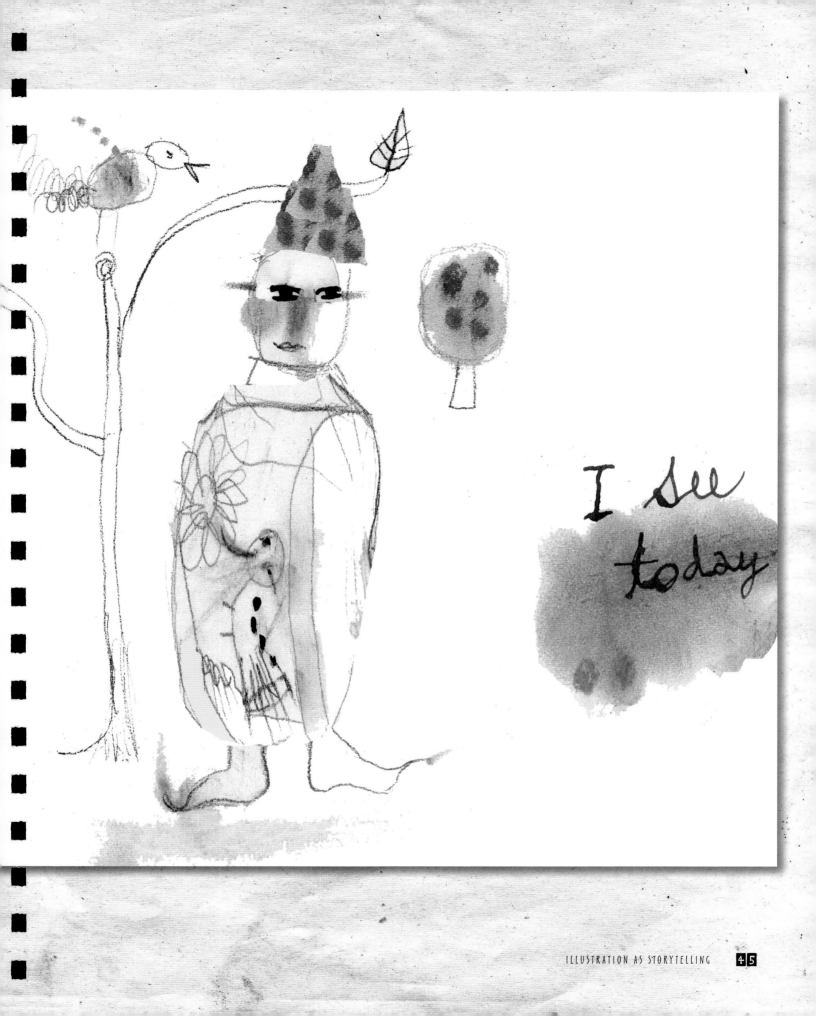

I see today

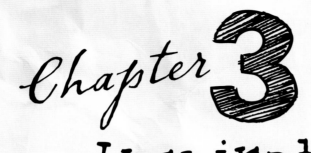

Chapter 3

Inspiration:

DRAW WHAT YOU LOVE

With your new waking day full of stories to be told, which ones do you pick to capture on paper?

I have a very simple answer. Choose the subjects you love. If you love them, you'll want to explore them, feel them, live within them, and then nurture them into an illustration. Our eyes see a myriad of images, textures, and colors each day. We hear conversations, music, wind, and rain and experience joy, sadness, fear, and pain— sometimes all in one day. The experiences we've had in our ongoing lives give each of us a unique way to examine the world. From examination comes learning and insight that can be shared in story: visually, with words, or both.

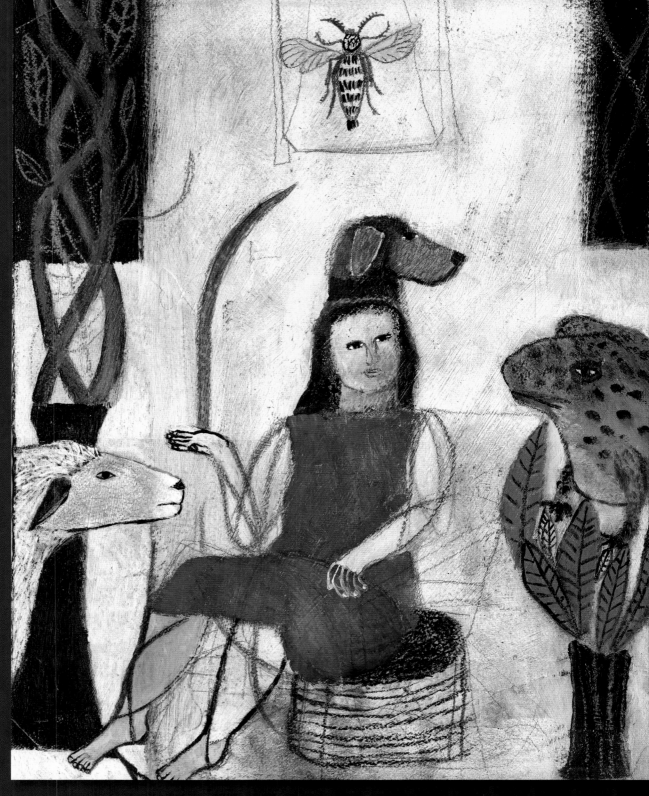

"When you start a painting, it is something outside you. At the conclusion, you seem to move inside the painting." —Fernando Botero

HONOR YOUR MUSES

Here on the farm, I'm surrounded by my favorite muses ... animals. Some are four legged, some have wings that glitter in moonlight, and some are old and barely walking. We all have muses, be they animals, children, funny friends, or famous musicians. But each muse can be a collaborator in your illustrations, giving you a voice you might not have tapped into on your own.

The muse-artist relationship is just that: a relationship providing an abundance of entertaining and inspirational moments. Look at your muse as a dance partner—the give and take from each partner makes the dance come alive. The energy, joy, or insight you receive from a muse sinks into your heart, and someday it comes out in an illustration that in turn goes out into the world and inspires or touches another person.

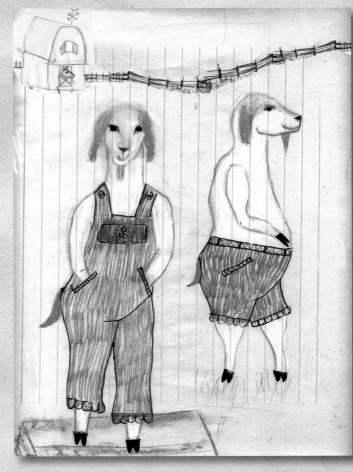

Stella and Iris provide a daily supply of humorous stories, often involving their uncanny ability to escape fenced pastures. Goats will stand on two feet to reach high branches, and I often look out to the pasture and see my illustrations coming to life!

(Opposite)
A beautiful stray cat wandered onto our farm. He was very theatrical, so I named him Phineas T. Barnum after the great circus man. His theatrics in the barnyard inspired a short story in which animals gathered to hear him recite poems.

CIVIL DISCUSSIONS ON HEALTH REFORM 5¢

PLEASE READ PROPOSAL FIRST

5¢

Is your muse an animal? Close your eyes and envision having a conversation with that animal. What does its voice sound like?

June 12, '09

I've taken to carrying a tamborine. It alerts the bugs so I step on as few as possible.

A muse can act as the conscious voice for something your subconscious already knows. It often feels safer to express certain things through a muse in an illustration. My donkey Pino is a perfect example of this. His calm demeanor translates into poetic thoughts and inspiring anecdotes. When the world seems a little crazy, little Pino helps me put things in proper perspective.

A muse can help you feel braver or wiser. Schulz spoke through Snoopy; I often speak through Pino. And you can speak through your muse too.

(Top and left)
Donkey Diary is an ongoing series starring Pino the donkey. Through him, I can address current issues as well as personal conflicts I might have—all with some humor and heart.

(Right)
Pastels and pencil on tissue paper | After a walk with Pino to visit an elderly neighbor, I drew this scene.

SING ELANOR'S TRAVEL SONG:
"GO, GO, GO WE'RE GOING FAR AWAY,
FAR FAR FAR AWAY, hmm-mmm-mmm"
SING 2nd time LOUDER than FIRST

the TRiP was STill two months away, but ELaNoR insisted on WEaRiNG her new SWiMSuit to BeD EVERY NiGHt.

I once lived next door to a little five-year-old girl named Elanor. With her constant chattering and humming outside my window, she became an instant muse for me. My images of her were a combination of her antics and personality with my imagination.

Muses are just like the imaginary friends we had as children. We can share secrets with them or cling to them after a sad experience. Maybe your muse is "imaginary" in that it is a character you've invented in your head. I won't tell anyone! The main point is to respect your muse by listening to it and conversing with it. Those dialogues will often generate inspirations for stories and illustrations.

Throughout life, your muses will change. The muses of your twenties might not satisfy you in your fifties. For just as you evolve, so do your muses. Rather than fight it, be open to new muses that appear in each new chapter of life. Muses have a way of presenting themselves when you need them the most—giving you hope in a hard time, making you laugh in a lonely time, or cheering you on in an exciting time.

"Let your muse find the child in your adult body."

Who makes you chuckle or grabs your heart? Who irritates you, yet you are still drawn to them? Who inspires you through their actions? There's your muse.

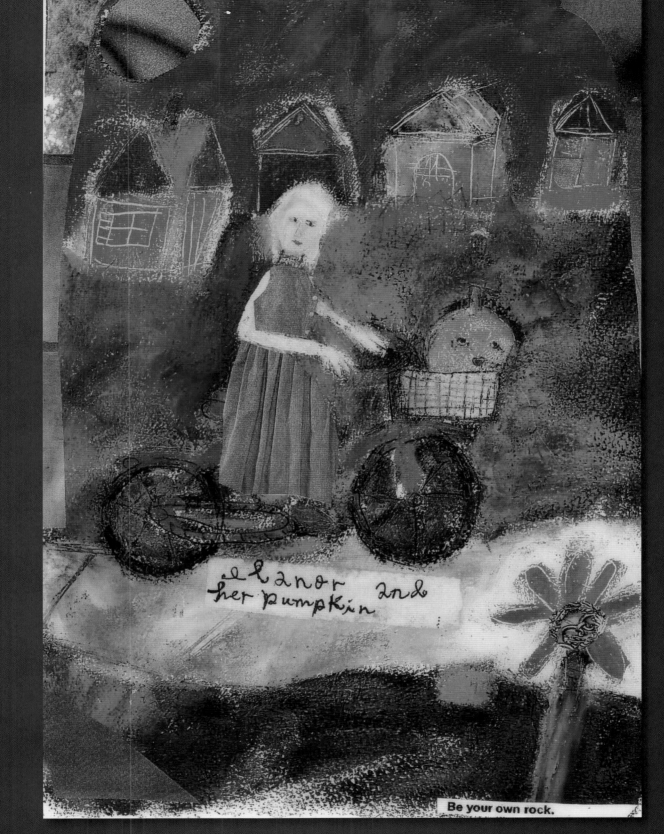

On the day Elanor learned to ride a two-wheel bike, I watched from my window. Soon she was a pro, and she was always so happy on that red bike. I gave her a pumpkin to carry in her basket.

At this stage I'm just feeling what the character looks like in my head. Consider a book you really love. Then keep it as an ongoing project on your desktop—one to pick up and work on when you feel stuck on something else.

INSPIRED BY FICTION

Books are a huge source of inspiration, loaded with characters, landscapes, drama, and plots—all just waiting to be illustrated.

One challenging but fun thing to do is pick one of your favorite stories and create a variety of images about it. If you love people, focus on doing portraits of the main characters. Maybe landscapes inspire you—so illustrate a scene in the story that incorporates some of your vision of the landscape.

Working in a series like this will challenge you to illustrate characters consistently through a series of settings. As you read, take note of the visual images, scenery, and fashion.

My favorite story of all time is *The Wizard of Oz*. Here are some rough sketches I did just to get a "feeling" of the characters—in other words, it's back to capturing the essence again.

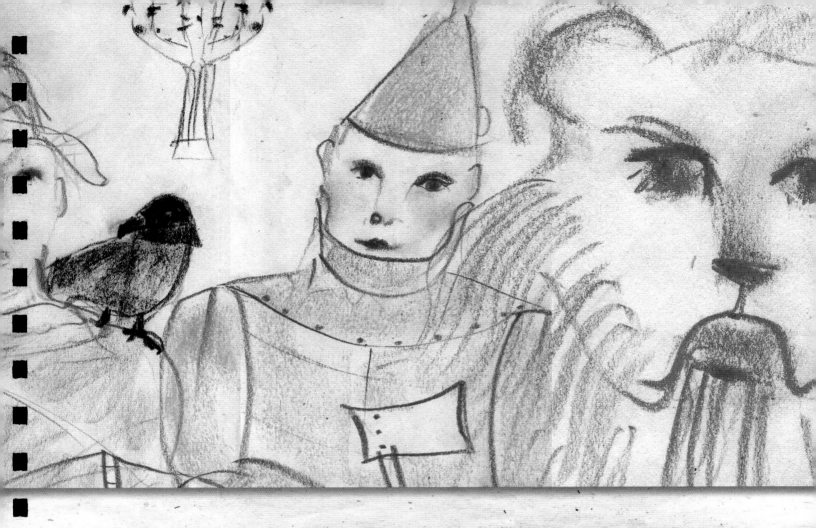

Since this book was also a movie, there are plenty of visual aids, but I want to make the characters in my own style. Here is a cropped image where the characters have a childlike style. Turn the page to see how I treated the entire scene of this illustration and how I envisioned the Lion.

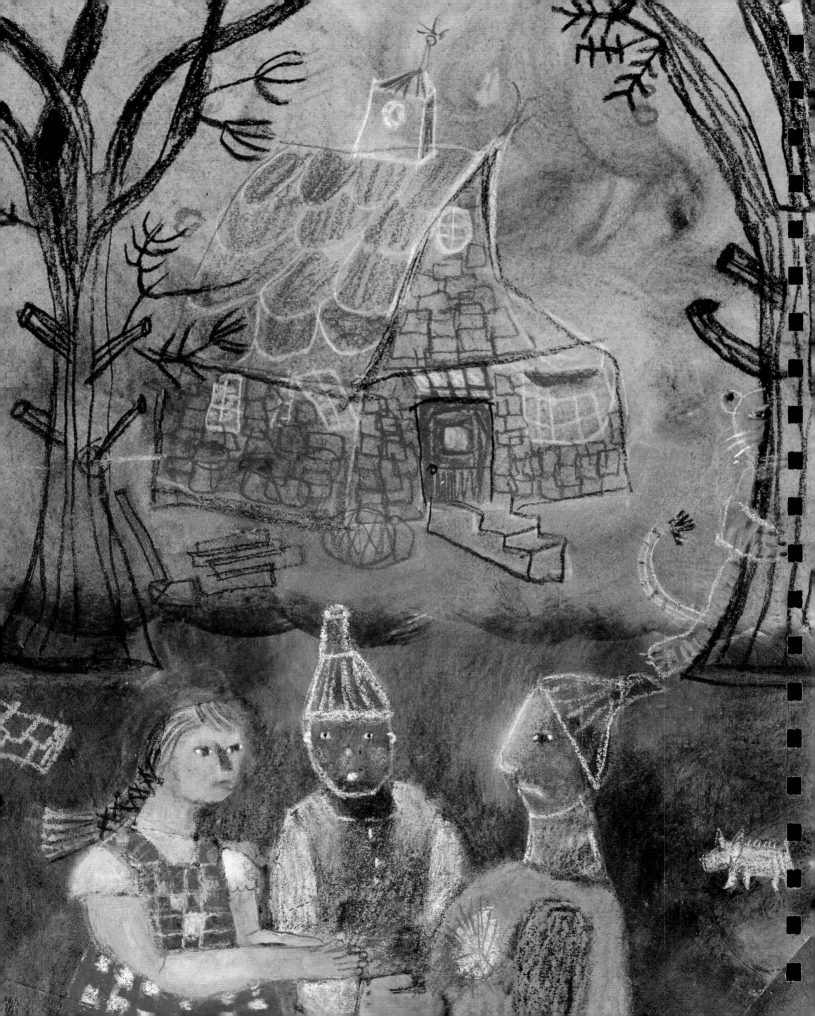

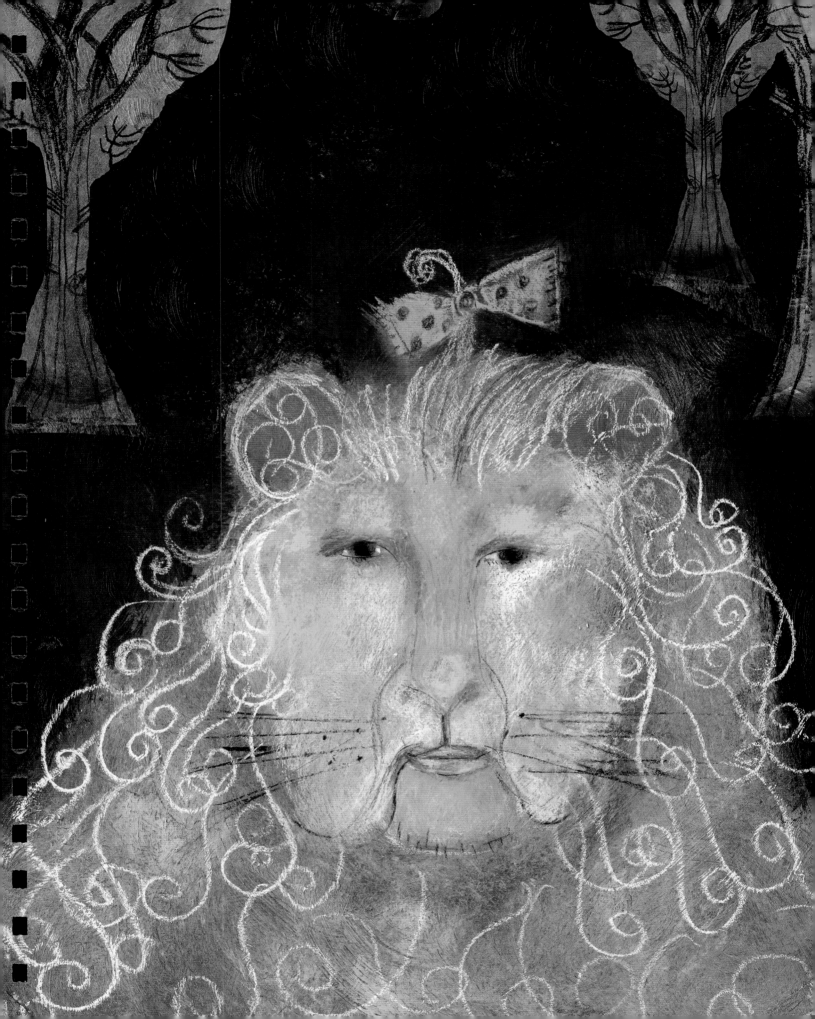

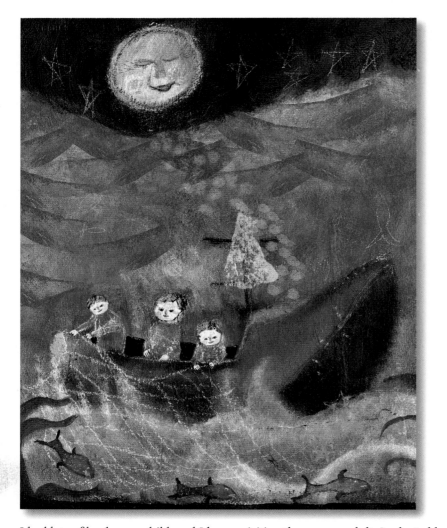

(Opposite)
As a child, I remember being fascinated with images I saw in "There was an Old Woman Who Lived in a Shoe." Upon rereading it, I realized the woman was taking a switch and sending the children off to bed. I wanted this illustration to reflect that and be more European in flavor.

I had lots of books as a child, and I love revisiting them as an adult. Look at old fairy tales or children's poems and illustrate the ones you love, but illustrate them in your own voice and style. Poetry is another wonderful source of imagery. Since poems rely on very concise words to convey an idea, look at each word as a possible source of imagery.

Visit online reviews of books you remember enjoying. Then create an illustration. Or read a synopsis of a current bestseller and pretend you were hired to illustrate that synopsis.

"The old moon laughed and sang a song,
As they rocked in the wooden shoe,
And the wind that sped them all night long
Ruffled the waves of dew."
—Wynken, Blynken, and Nod

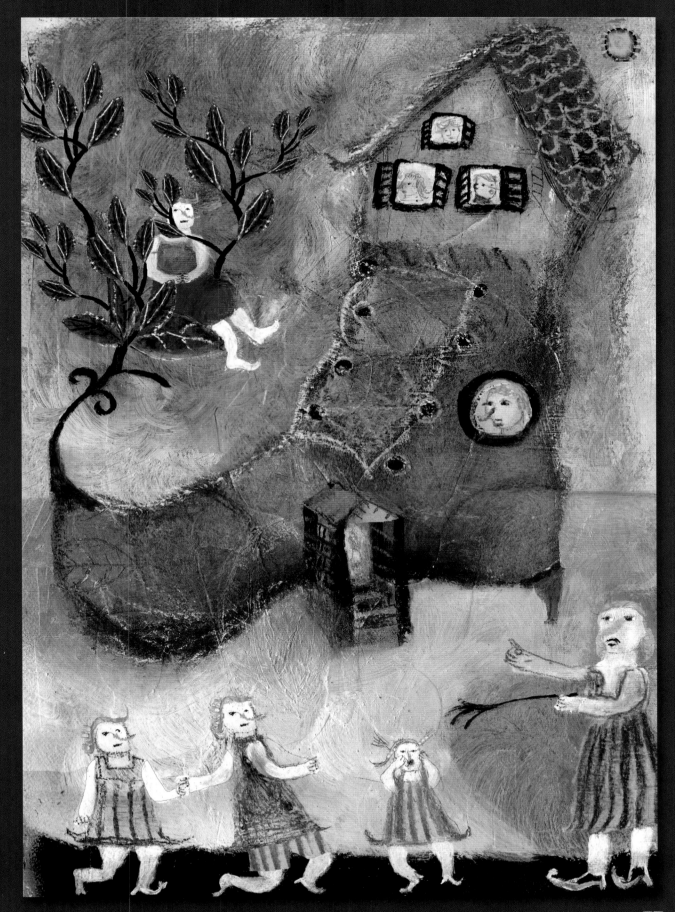

Challenge Yourself

If you always draw women, draw men and vice versa. Draw people of different ages and ethnic groups. Show different moods—happy, sad, and pensive.

Biographies and interviews are good sources of inspiration. Life stories are rich with visual imagery, complete with drama, death, anger, love, and shame. After you find a person who inspires you, search for online pictures of them as a visual aid for an illustration. Choose symbols or objects to help illustrate the person's life story.

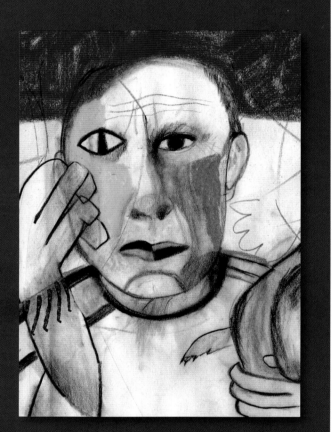

The intensity of Picasso's face made to look like one of his Cubist paintings.

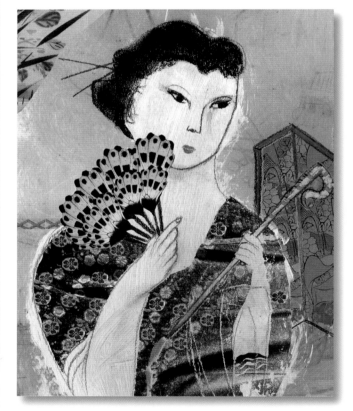

The fashions and patterns in this piece are appropriate to the Japanese setting for a piece on Madame Butterfly.

(Opposite)

Don't overlook the faces of the elderly. Look into those "lines of life" embedded in their skin. What story does each line hold? An article about a dying man in hospice who felt he was becoming the tree outside his window inspired this illustration.

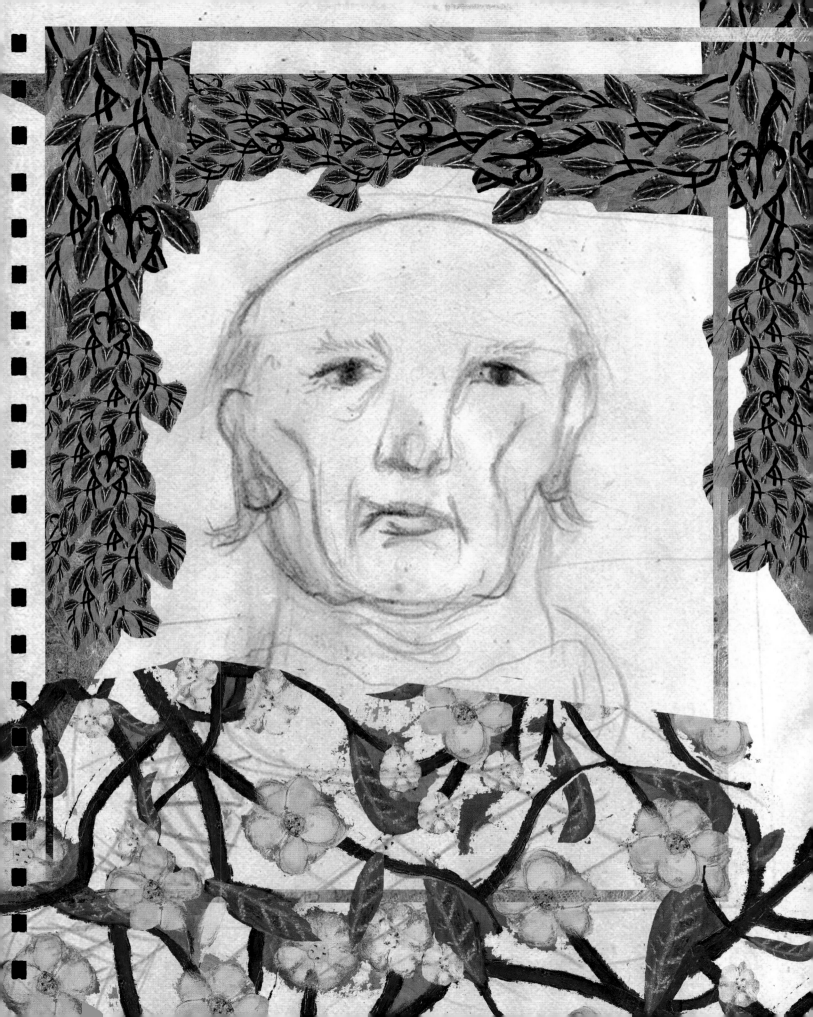

INSPIRED BY SIMPLE THINGS

T he inspiration for an illustration doesn't have to be a novel, a beautiful animal, or famous person. It might be as simple as … a jar of mustard. One of my favorite colors is mustard yellow, and one day I just felt inclined to paint a simple ode to the little mustard jar in my fridge.

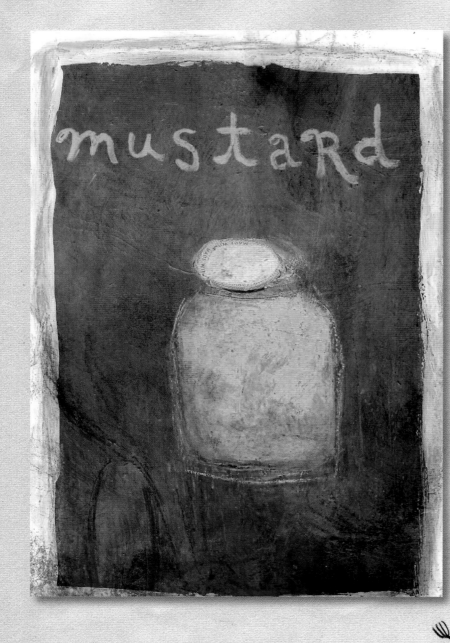

FUN EXERCISE

Look inside your fridge.

Is there a bottle or can label that inspires you?

Do certain vegetables have personal attributes?

Capture the colors, texture, or personality of these items in drawings.

Let the personalities of the items and food you've picked "play" and show you ideas. You will see the results of my experiment in the example on the facing page.

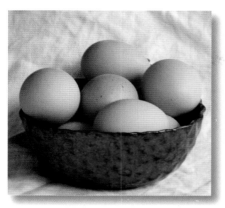

STEP 1:

I open my fridge to find fresh farm eggs and arranged some in a blue bowl I like.

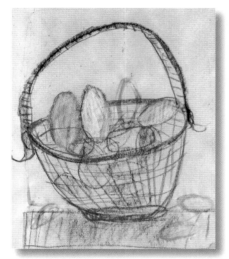

STEP 2:

The blue bowl makes me eager for our new hens to start laying—because they will lay blue eggs. I decide to draw some blue eggs in a gathering basket instead.

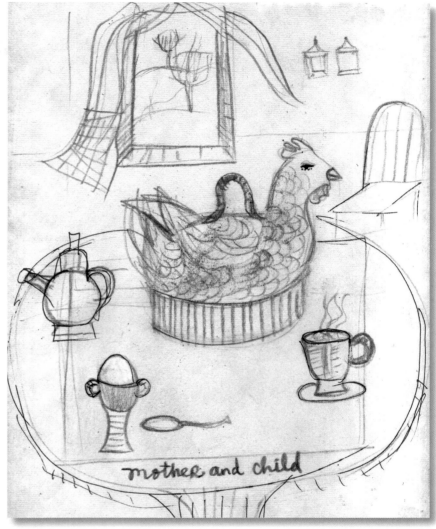

mother and child

STEP 3:

My imagination takes over. Thinking of blue eggs reminds me of a blue ceramic hen my mother had that sat on the kitchen table, and the sketch turns into an ode to motherhood and a childhood memory of soft-boiled eggs.

FUN EXERCISE

Your closet is full of items you love. Each item has an entire history with you and a unique style and personality of its own.

Pick something in your closet and create a whimsical homage to it. Even more fun, interview that item. Yes, that's right, interview your favorite item. I guarantee stories will evolve from that interview!

Here's a bit of an interview I had with my shoes and a series of drawings it inspired, which I later turned into a promo for myself.

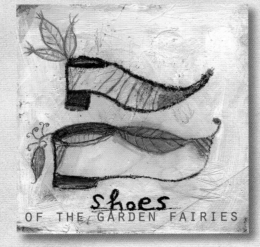

shoes
OF THE GARDEN FAIRIES

"Hello, shoes. Where did you come from?" I ask politely. "Out in the forest, living with fairies. Fairies like shiny red things," my red shoes said. "I see. That explains why I can't always find you."

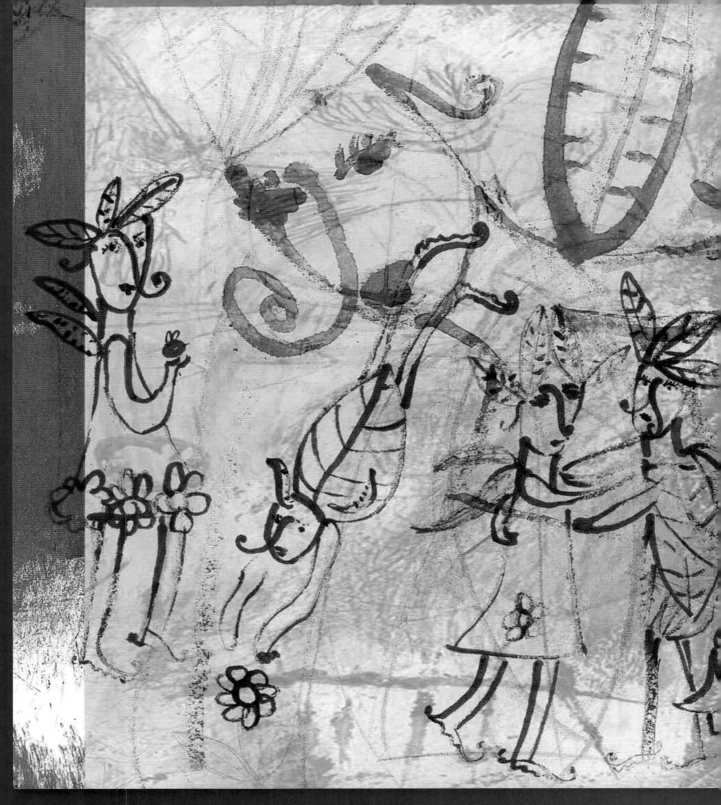

YOUR OWN DREAM SYMBOLS

Dreams can be a wonderful source of imagery. Some dreams, more than others, will resonate with you upon waking and might deserve some attention. Dreams are also rich in our own internal symbols, many of which we haven't explored, but you might notice them popping up in your art. For me, gates and fences are important.

EXERCISE

What are your muses saying today? Illustrate that conversation.

I was busy doing barn chores and thought I heard voices, but the only one within eyesight was the horse. "Hmmm," I thought. "Must be hearing voices from the valley down below."

But the voices continued, and I went out to look around the barnyard. And there was one of my chickens chatting with one of our newest farm members, our little donkey Lucia.

"How old are you, donkey?" the chicken asked.

"I'm one, and my name is Lucia."

I stood somewhat out of sight, thinking my presence might stop the free flow of their chat.

But they saw me, and I'm quite pleased to tell you they invited me over.

"I suppose you already know this is Lucia," said the chicken.

"Well, yes, I do," I said. "I thought she would be a wonderful addition to our barnyard family."

Soon other creatures appeared. Some I knew by name, but some I had not officially met, like the little chipmunk who stood at his house door watching with curiosity. The grasses all chimed in, "Hello, Lucia, nice to meet you. Please don't eat us."

And as I returned to the barn to finish chores, I saw the chicken's children rushing over to meet Lucia.

"We really like your big ears!" the young chicks said.

Chapter 4

Sharing Emotions

through

PERSONAL STORIES

Drawing and painting are cathartic ways to journey through upheaval. In the course of a lifetime we all face challenges, large and small. The feelings that surround these ups and downs can be fueled into opportunities for creative output. In this chapter, I'll share an exercise where you can process ideas and emotions that arise during such times.

Always remember that you have art as a gift to yourself; it can serve as a friend, therapist, or devil's advocate. The beauty of all art is twofold—it is personal expression you can savor for yourself, and if you choose, you can release it to the world for others to experience, engage in, learn from, or simply enjoy.

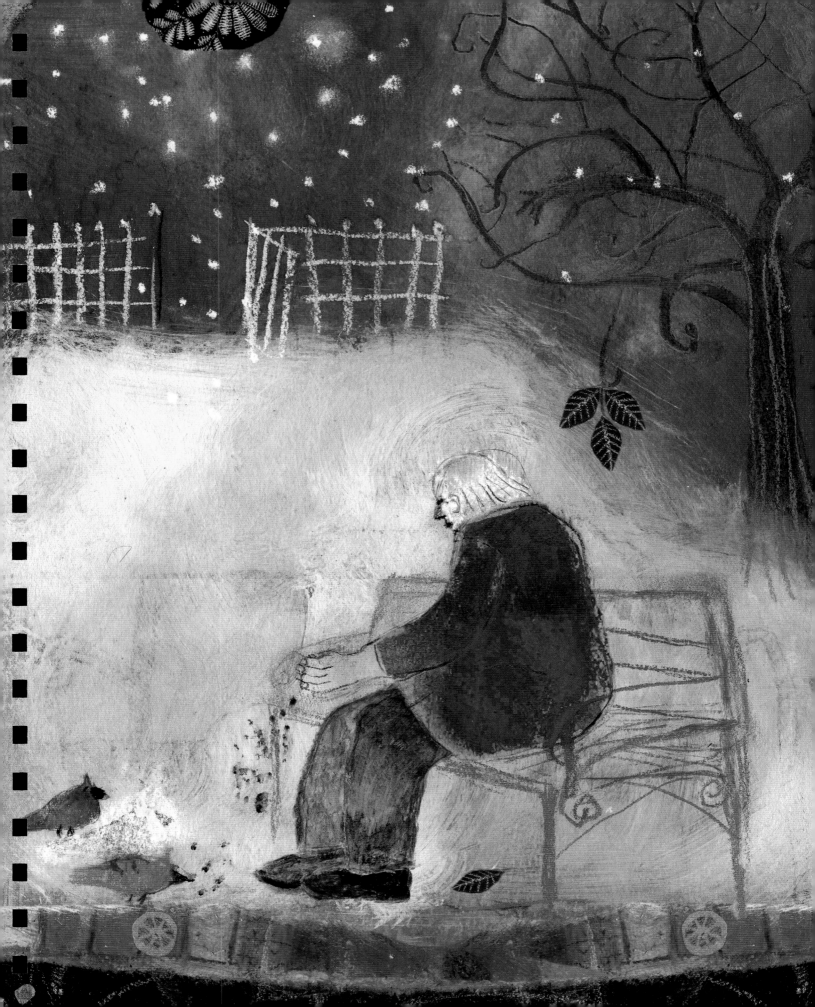

FROM THE HEART TO PAPER

Sometimes life sends you on an internal roller-coaster ride, tossing all sorts of emotions around. The death of a loved one, the ravaging illness of a friend, the loss of a pet, or changes at home or in a job can all trigger an array of raw emotions: stress, fear, anger, or hopelessness. The goal of this exercise is to let the making of art be a cathartic venue for those raw feelings. The journey you take in your head and heart is what's important not the art itself. You will begin to work on an image. While developing your work, you can continue to add to this surface, or when an image feels complete, you may want to move on to a new surface.

The concept for this exercise came to me when I was dealing with the impending death of my own father. It dawned on me that each photograph of him held a long story or memory within my heart, and it was the experience of remembering that was so vital, not the actual photo. During this exercise, as I worked on my surface, I got to a point where I decided I wanted to completely cover over my image and start a new work on top. By doing this, I felt like I was symbolically "letting go" of the past and moving on, just as I had to eventually accept this difficult loss and continue to live my life.

In any life, pictures hold memories, but it is your mind and heart that relive them. The photograph is less important than the journey you were on when you made the photograph. The photograph or postcard you send from vacation is not as important as the experience you had making the photograph.

"I paint in order not to cry." —Paul Klee

Note how I have taped the corners of the paper to a Masonite board. This allows me to move the piece around easily and also move it off my table if I need to.

PROCESSING EMOTION EXERCISE

Choose your preferred surface, either heavy paper, wood, or canvas. You might also want to gather pastels, collage scrap, adhesive, and a pair of scissors. You also need the following:

- One or multiple painting surfaces (more on this in next steps)
- White or black gesso
- Acrylic paint and any materials you choose

STEP 1:

Choose a working surface that can withstand multiple layers of paint and possibly rough handling. I suggest a heavy 150 or 300 lb (320 or 640 gsm) watercolor paper or a wood surface such as a pine board. Feel free to work on a larger surface such as a stretched canvas, as it is very physical to work on large surfaces. (Note: In this demonstration, I am working on 8-inch [20.3 cm] 150 lb [320 gsm] paper.)

Start by laying a "ground" on your surface. This can be white or black gesso or it can simply be a solid paint color of any kind. Note: I work with acrylic, which dries much faster than oil, and for this exercise will allow you to speed up the intervals between steps.

STEP 2:

Develop your surface with two colors of paint. In my example, I paint the entire surface with green acrylic. After about twenty minutes, I paint black acrylic over the entire surface. I often do this because now I can take white pastel and doodle or draw on the black surface. Having black over the green allows some color to come through, adding texture. It's just the way I always start any piece.

Consider using your fingertips as brushes. Not only can it lead to interesting shapes and textures, it is very sensual and healing to feel the paint on your fingers.

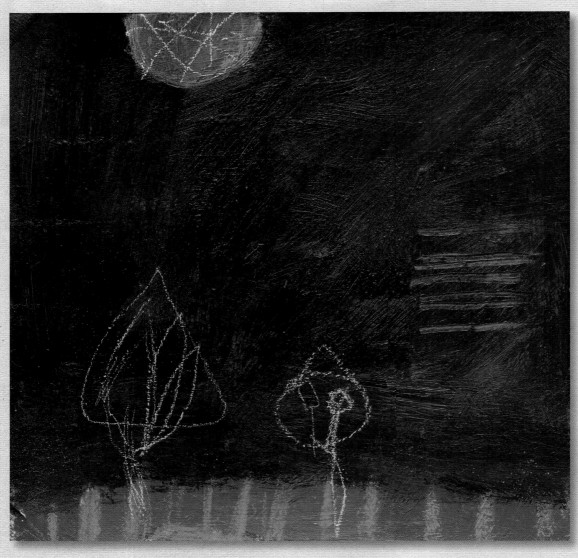

Allow abstract shapes to emerge on that surface. Here I've not only scribbled lightly with white pastel, I've also added a blue circle. This is a recurring symbol for me—be open to what shapes recur in your work as symbols. You can also see an area of rough scratches on the right of the surface; I created these with a nail.

STEP 3:

Draw what you feel. At this early stage, it's a very abstract process. In my example, I start with pastel and draw whatever I feel. You might even try closing your eyes so you aren't overthinking what you see on the paper. Just be loose and keep moving your hand, even if it seems clumsy or "silly."

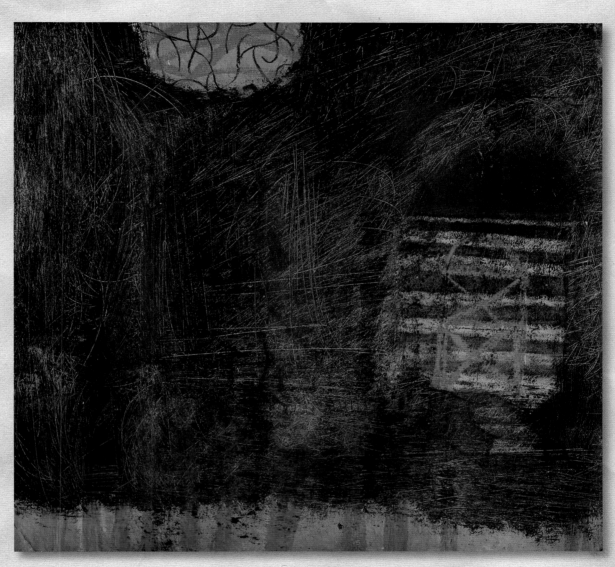

STEP 4:

As I progress through this abstract stage, I enhance the circle shape and adjust the pastel blue to be more somber. I notice something in the scratch-mark area on the right and adjust it to be an abstract red shape (using red pastel), which I read as a symbolic "opening" or door. I've also wiped the white shapes slightly away—a benefit of using pastel. During this stage, stop. Look for any shapes or areas that draw your eye in. Focus on those areas but don't try to figure out what they mean. It's still very abstract. Work with adding some color or more definition in those areas. Explore them with an open mind, and try not to get tied to "what does this mean?"

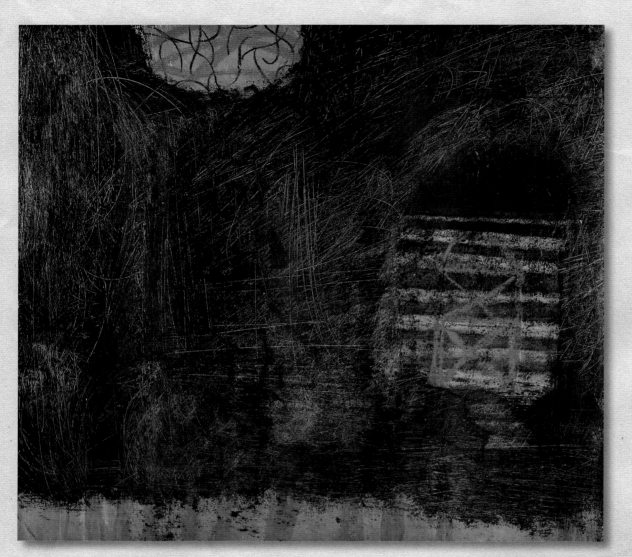

Image in progress, ready for next step.

STEP 5:

Your mind will be percolating as you work at this abstract stage—let it.

The event or issue in your life that has you trying this exercise will be on your mind as you work away at this abstract stage. As your mind rewinds old memories or thoughts, continue to draw and paint.

As I was working, the white shapes I had erased, along with the green area at the painting's bottom, reminded me of my father's love of his gardens. Even though I erased the white area, I am thinking of his gardens.

before she was born

Because I'm also a writer, I chose to write words down for each finished image. I scanned the words, along with the art, and kept it in a journal for myself. Feel free to incorporate words in your exercise.

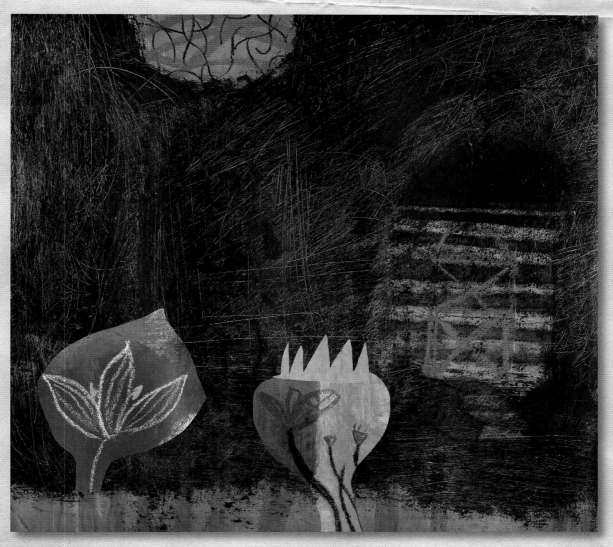

Finished image #1 | I take a break and document this image for myself with the scanner.

STEP 6:

As I think of my father's early gardens, I begin cutting out color shapes from scrap and painting or drawing on top of them. I decide one needs a crown. Again, this is a subconscious decision to place a crown on a flower.

Even though the image is still very abstract, I feel it is a finished piece, especially after the words "before he was born" come into my head.

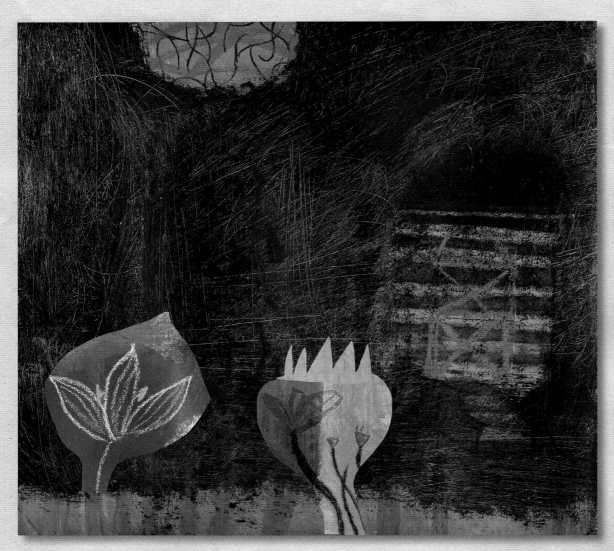

This is the previous image, which I will now paint over.

STEP 7:

Begin a new image, either by covering up the old surface or starting on a new surface.

Note: In this exercise, I am choosing to cover up each image I create and repaint a new image on the same surface. This is cathartic for me and very symbolic of "letting go." But you can choose to start the next piece on a new surface, maintaining each image as an original.

In the last step, I had noticed the floral quality of some of the abstract shapes. I notice the green area at the bottom of the piece and consciously decide to make it grass blades.

He must have stalked to the grasses

The grass blades make me think that my 84-year-old father was once a little child, playing in grass, far from death. I wondered what his child activities were, and many words and images came to me, but these words resonated within me and provoked this image to develop.

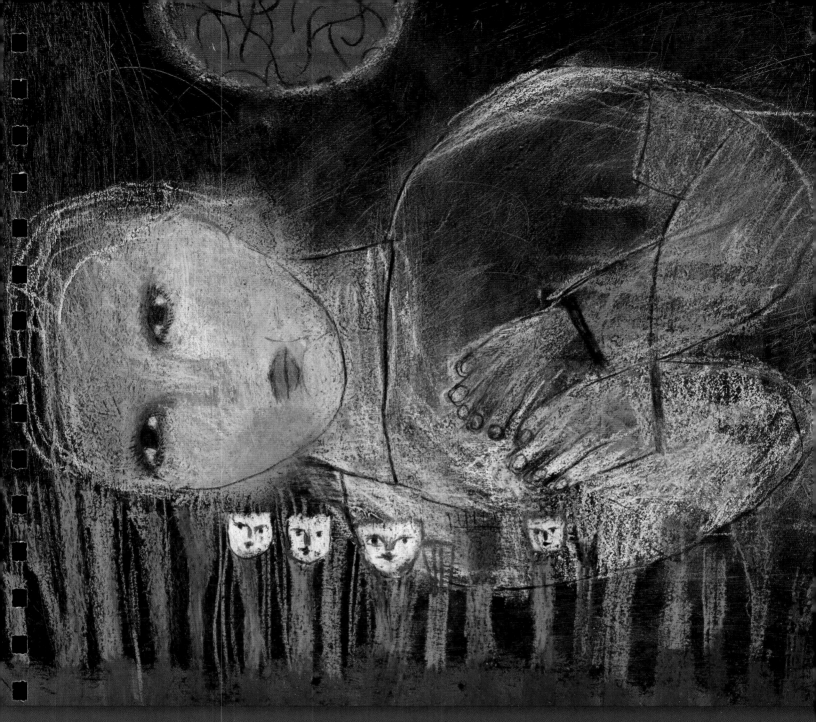

FINISHED IMAGE #2

Note how the orange structure has been covered up from the last piece, but I've allowed it to stay as a ghostly image here. After I completed this image, I made a scan of it and then covered the surface again to hide most of the original.

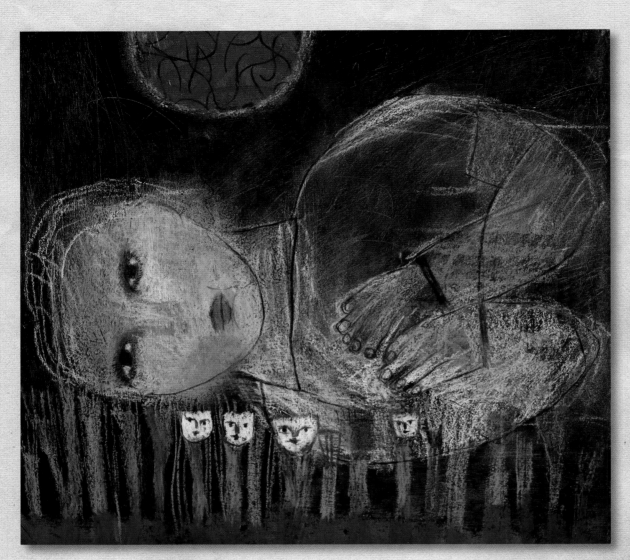

This is the pevious image that I will now cover.

STEP 8:

A few days pass before I begin this new image. Take as much time as you need between steps. I once watched an old, grainy movie of my father as a child floating little cardboard boats in city gutters with his brothers. I watched it in the presence of my then-84-year-old father, and that movie and the memory it held, made him emotional. Those thoughts were with me as I sat down to start a new piece in the exercise.

He played in streams in the strat with cardboard boats

These words resonated with me as I worked, so I wrote them down.

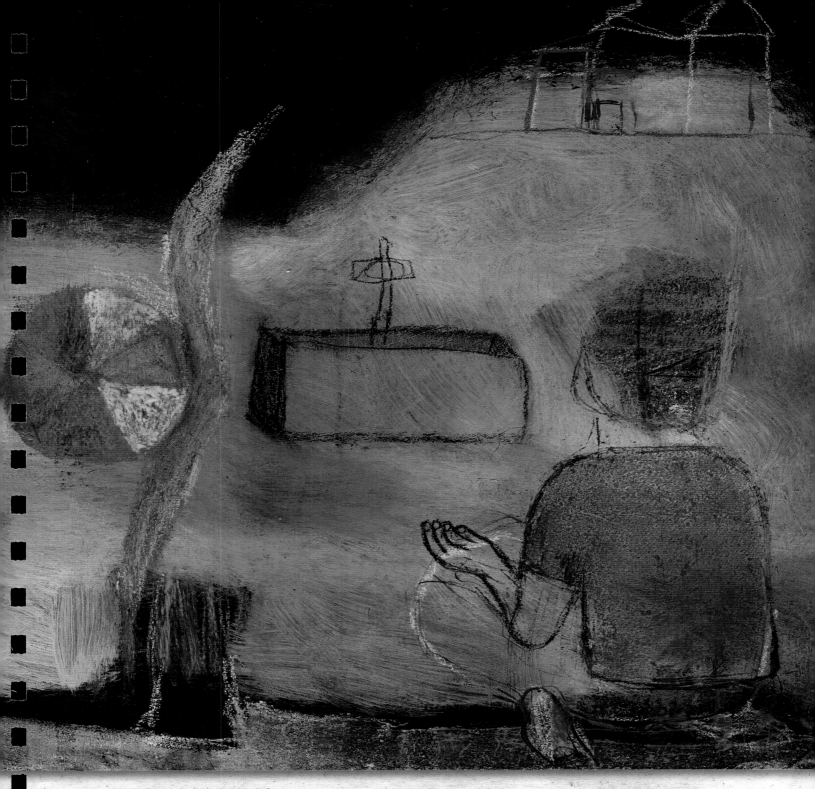

FINISHED IMAGE #3:

Notice how the dark area in the previous image has now been painted over with blue. And note there is still a ghostlike image in the child's head on this new piece, a remnant from the previous piece. Only a small amount of the former painting is left in the bottom left corner, where you see some remnants of yellow.

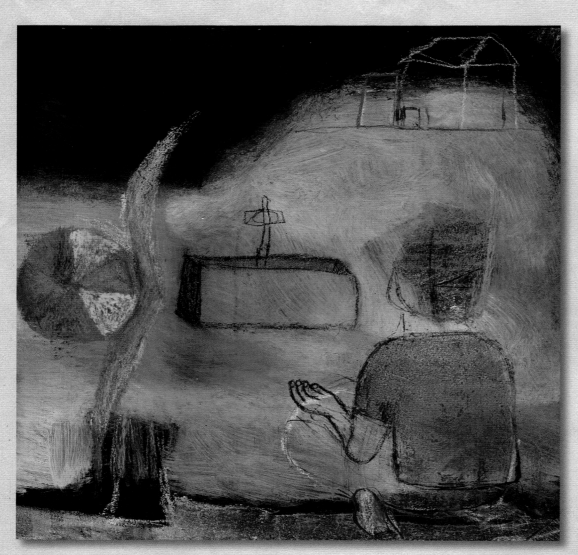

This is the previous image that I will now cover up.

STEP 9:

Several weeks pass before I begin this new piece. I remember not really wanting to cover this piece up but knew it was a symbolic letting go. By covering up each piece, you are letting go of a tangible object and surrendering yourself to the experience of art itself.

Once again I cover most of the surface, with a bold red. Note that the ball shape of the previous image has been covered, but an abstract reminder of it is there. The blue is still partially there too, as is a sliver of yellow on the right.

Letting a memory come out in the open

If you have chosen to do this exercise by making individual paintings and are not covering up each one, the process is still cathartic. As you relive a memory and paint it, you are letting it out into the open, leaving your energy free to focus on present and future events.

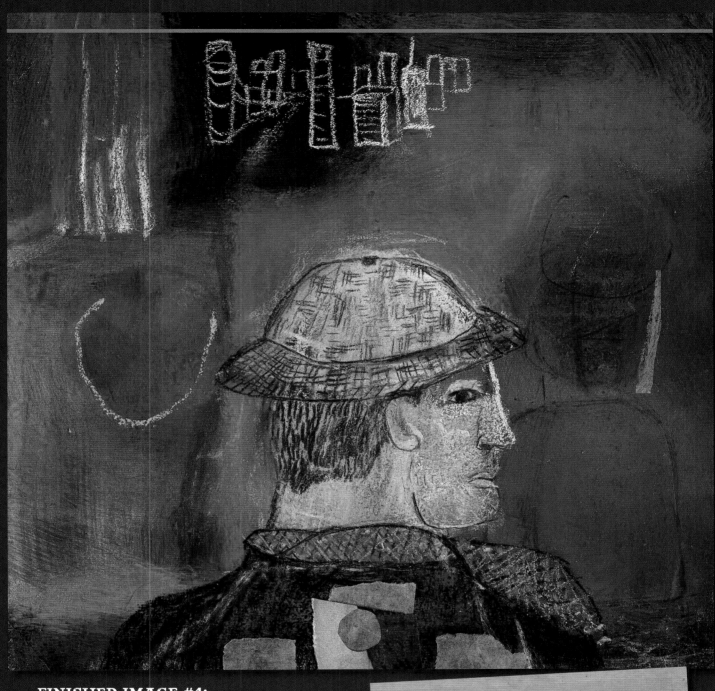

FINISHED IMAGE #4:

As a young, self-absorbed teen, my father went off to work each day. I didn't give it much thought. But as his death approached, I yearned for pictures of him doing everyday things, like walking to work. He always wore a tie and a tweed hat and scarf.

Where was I when he stood here?

Again, these words resonated as I painted. Even if you aren't a writer, listen to the words in your head while you paint.

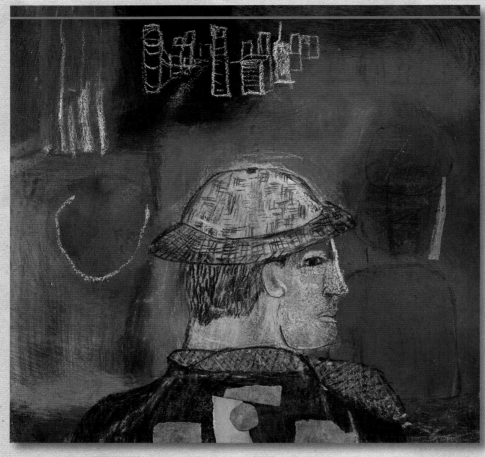

This is the previous image that I will now cover up | Note how the bottom textures of his coat still can be seen in the final image on the right.

FINAL STEPS:

Weeks pass between steps. Once again I painted over the previous image with white gesso, and then I began redrawing a new image on the same surface. I did not choose colors consciously, and as somber as these are, I find them very beautiful and raw.

It's up to you how many images you create. As you go through each step, your emotions will be expressed in your own inner textures, colors, words, and shapes.

Maybe a day of creating two to four images will be enough for you. For myself, I reached a point after a few weeks where it felt natural and okay to stop. This final piece felt very much like a "good-bye" to me, like the ending of a love song.

Don't attach yourself to the outcome.

Elements of this exercise can be applied to your daily art projects. How? It's easy to get "attached" to what you want the piece to look like. You struggle along for a day and feel like you're getting nowhere. Rather than hanging on to what you think the image should be, try covering 50 percent of the image with gesso and leaving some elements you feel in tune with. Most of the time, you'll end up with a stronger piece. And if you don't, start over.

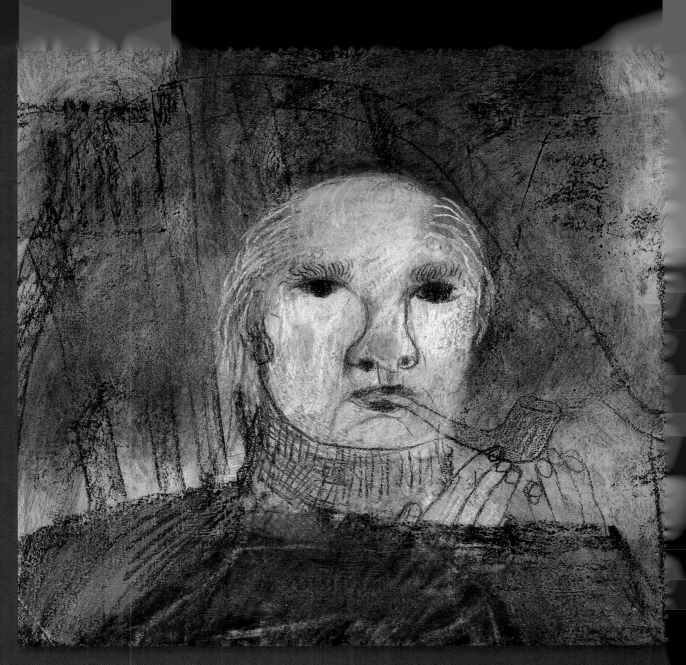

FINAL IMAGE IN SERIES.

I remember exactly what I was thinking while creating this piece—that it seemed like yesterday when he was sitting in his favorite chair, smoking his favorite pipe. I was feeling the textures of a rough wool sweater and remembering his gray, bushy eyebrows, which I exaggerate here for my own pleasure.

At this stage, I felt it was a natural place to end the exercise and painted the image over in black. I stuck it in a pile to be reused for future projects.

"There's a bit of magic in everything,
and loss to even things out."
—Lou Reed

MORE EXAMPLES OF CATHARTIC WORKS OF ART

No matter what life throws at you, drawing and painting are physical, cathartic exercises to help you through your journey. The ride might be bumpy, but the physical act of drawing can soothe the heart, purge some fears, and help you move on to the next level.

(Left)

If you fear it, draw it. I respect bats and their purpose, but I admit getting anxious when they fly over my head. I started drawing bats and soon began to see them as mice with wings. Since I'm not afraid of mice, this has helped me immensely.

This piece is about changes and moving on. When I moved from a well-loved home, I experienced a grieving for the many things I would leave behind in my yard. I painted pictures of the trees and plants I loved as a way to say thank you.

cow heaven

Memorialize a Lost Friend | A painting is a cathartic way to put a friend to rest. This was a memorial for a dairy cow. I thought she deserved a cold glass of milk.

An
EXERCISE

Are you on a roller-coaster ride of emotion?

Express it. Draw it. Paint it. Do it for yourself.

The feelings that came from the death of our beloved sheep, Rosie, were intense and blanketed me in mourning for some time. Not knowing she was carrying triplets, I had adjusted her feed portion inaccurately, and she died from nutrition imbalance. I walked around doing barnyard chores for many days in a cloud of sadness. At some point, I began drawing my many animal muses again, but what came out on paper was a sea of crying animals. This was art's gift to me—it allowed me to feel camaraderie with my daily companions. I needed to feel that the entire farm understood my sadness.

Chapter 5

Incorporating

TEXTURES

&

FOUND MATERIALS

On any given day as you walk around your world, there are fabrics to be touched, odd buttons with tarnished patinas sitting in boxes, and items from the natural world that beg to be picked up. Look at the objects in your world as gifts for your art. They can enhance an illustration with texture, color layers, and patterns, not to mention whim.

This chapter will show you ideas for using found objects, along with collage, in your work. I'll also briefly demonstrate a "layered" technique using the computer to scan and incorporate textures and found objects.

Keep an open mind and eye as you go about your day. Next time you find yourself in an antiques store, look for old magazines, newspapers, boxes (which often have wonderful imagery and type), or postcards to incorporate into your work. Not only will you find the type from past eras is unique, but often the worn materials add a unique texture or ambiance to your art.

Another fun source for textures and color is vintage fabrics. You can cut and collage them into pieces or scan them and then incorporate them into a digital version of the illustration. Old books can also be scanned for interesting type and shapes that appeal to you.

Chicken feathers found in the barn topped off a hat of green fabric, with silk ribbon added to create a head of whimsical hair.

"You will have to experiment and try things out for yourself, and you will not be sure of what you are doing. That's all right; you are feeling your way into the thing." —Emily Carr

BE OPEN TO THE UNUSUAL

O ften an item can add just the right "touch" as you finish an illustration, or it might inspire additional ideas that have gone unearthed. Once again your daily world becomes a library of inspirations for your art. Be open to experimentation. For example, paste fabric on paper and paint over it, adding texture.

Try looking at objects you might normally dismiss. A dying rose or its petals, a weed, a blade of grass—play with incorporating these items into your work.

If you work on paper, try sewing fabrics, papers, and items down to the surface. Working on wood allows you to hammer items into the surface, such as nails, buttons, or tin. Not only will this add dimension and texture to the piece, it might give you shapes, colors, or symbols that you hadn't thought of before.

Some of the examples in this chapter use a computer layering technique with Photoshop and scanning. I will demonstrate that at the end of the chapter.

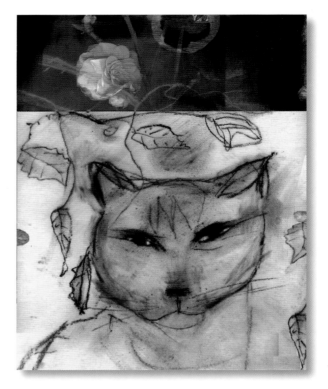

Here are two examples of flowers and weeds used in an image. The image above incorporates a photo of a decaying rose. On the left, Queen Anne's lace is placed under tissue paper and then the borders are sewn with invisible thread to hold it in the final piece.

Consider found objects as one more source of texture and color.

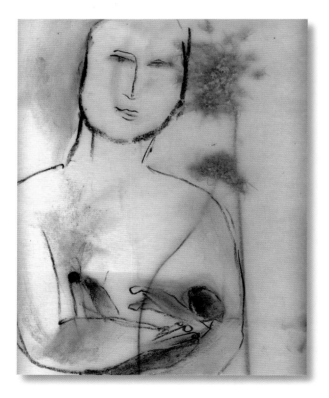

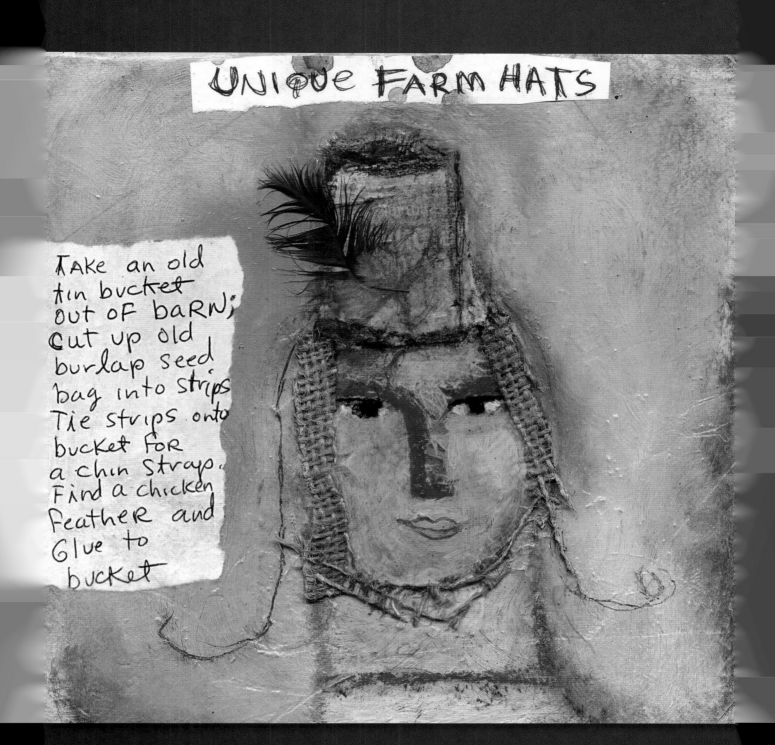

UNIQUE FARM HATS

Take an old tin bucket out of barn; Cut up old burlap seed bag into strips. Tie strips onto bucket for a chin strap. Find a chicken feather and Glue to bucket

Burlap scrap from old seed bags and feathers from the barn inspired this silly collage piece, created on watercolor paper. I love hats, so I am always inspired to create creatures in hats. Here, the instructions for making the hat are included as a text element collaged to the surface.

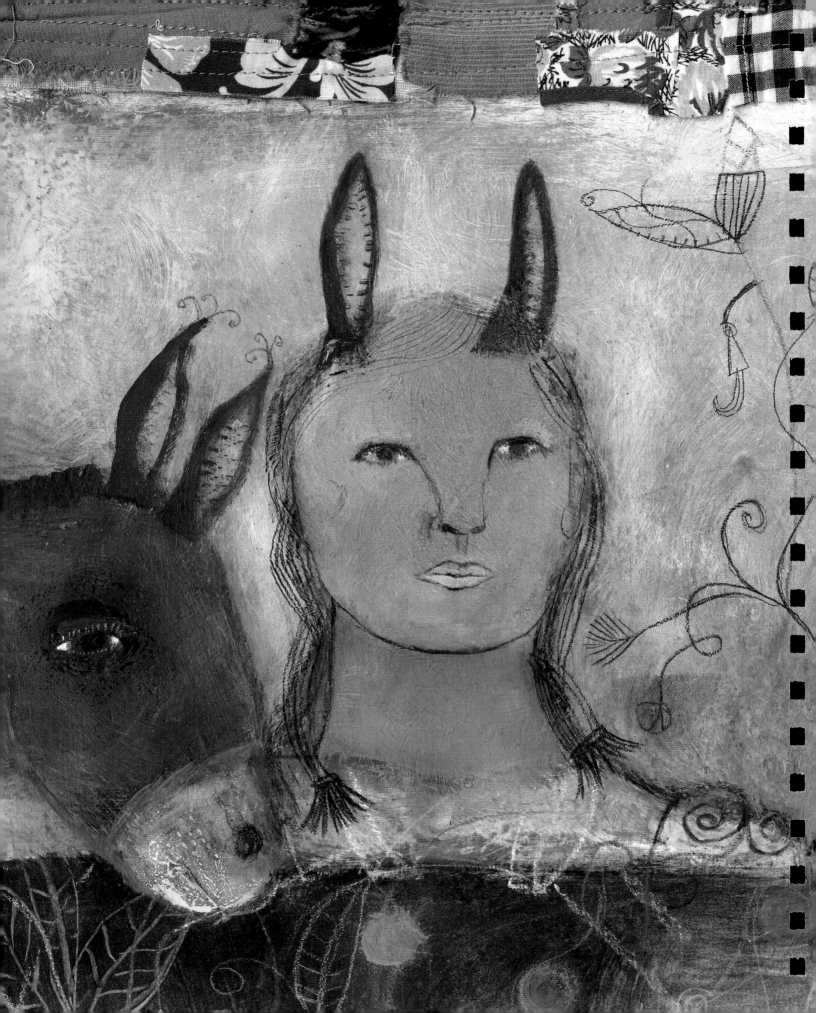

SEW, STAPLE, TAPE, TEAR, HAMMER

Play with different ways to apply items and alter surfaces. This allows shapes, textures, and colors to emerge in your art that you might not have discovered otherwise. Look at the shape of an object and ask yourself what that shape might represent or symbolize in your world. A yellow button becomes a sun, for example.

(Left)

Acrylic and pastel on paper | Scraps of fabric are sewn together and onto the paper surface to create an upper border.

An actual feather is taped to the hat on this piece, created on tissue paper. I had intended to sew it down with invisible thread but liked the splash of green. Be open to the colors and shapes that emerge as you work.

This piece is painted on old barn wood with the original nail holes still visible on the left side. A white button hammered into the surface symbolizes a cloud. A square black bolt is glued to the wood, and the torn papers are collaged to the surface. All the items are whimsical but have symbolic meaning.

Acrylic and collage on newsprint surface | Ripped tissue paper, varnished down on the surface, gives the effect of snowflakes for this holiday image.

MAGAZINE AND PAPER SCRAP

Think back to childhood. Wasn't it fun to look at magazines and cut out pretty colors for doll clothes? So now you're a tad bit older, but magazines are still full of inspiring colors and objects. Cuttings of fabrics, objects, and flowers can add content to your work as well as color and pattern.

Try incorporating images of fabric to create a sense of style and ambiance. Collage items can also help define a country or specific subject. For example, if you were working on a piece about Paris, a collaged image of the Eiffel Tower would give it instant place recognition.

TIP After you complete a day of painting, move the painting to different areas in the house. As you walk around during your day, glance at the painting. For some reason this can help you see the image with fresh eyes and opens you up to making small adjustments, such as adding one collage piece, that inevitably enhance the composition.

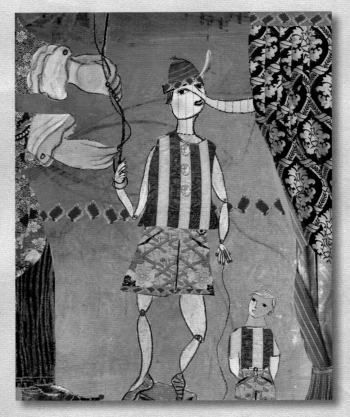

The colors and fabrics of Italy come across in this piece, thanks to collage.

TIP Get your idea on paper first and do some drawing and painting before looking at magazines for collage scrap. If you jump ahead too quickly and start applying scrap before your idea has developed, the piece can suffer.

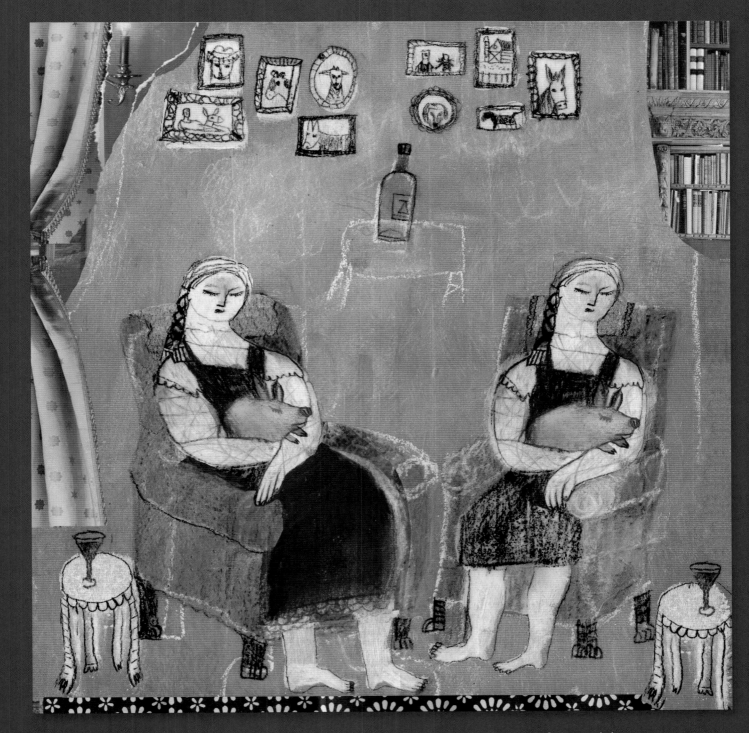

Acrylic and collage on paper | Curtains, bookshelves, and a hint of a candle give this piece a sense of space and elegance. The bottom collaged paper adds a patterned border that feels like carpet.

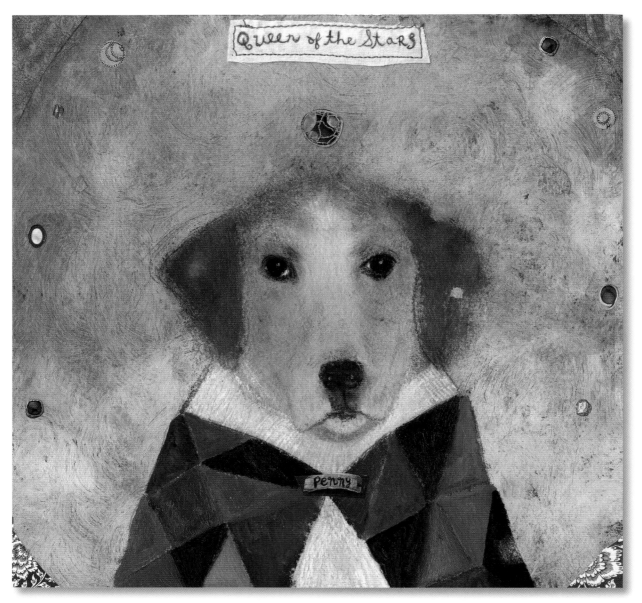

Jewelry images from catalogs, cut out and collaged onto the paper surface of this pet memorial, create a fanciful background of shining stars. The client's dog was an avid stargazer, and this piece wouldn't have been as powerful without the collaged stars. The *Queen of the Stars* title is written on linen and sewn onto the surface.

LAYERING EXERCISE

Create a simple image using magazine scrap and liquid varnish. For this exercise, I am working on 6-inch (15 cm) watercolor paper that had already been primed with a layer of blue acrylic and white gesso.

Even the tiniest bits of magazine scrap can enhance an illustration. Once you complete a piece, walk away from it for an hour or more. Periodically stop and arrange bits of magazine scrap, adjusting them on the surface (without adhering with varnish) to see which pieces speak to you. Sometimes the tiny collage additions at the end of a piece make a huge difference.

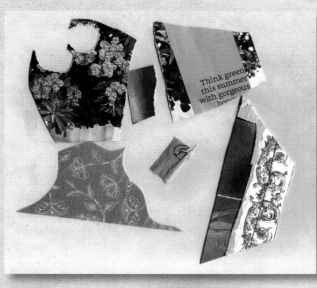

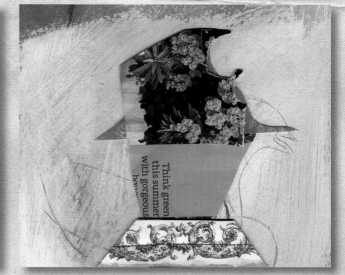
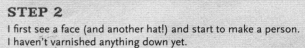

STEP 1

Rip out collage pieces from a magazine. Search for appealing colors or shapes. Spread the pieces on your surface and start to look for shapes and arrangements you like. Don't varnish anything down at this point; just play and have fun.

STEP 2

I first see a face (and another hat!) and start to make a person. I haven't varnished anything down yet.

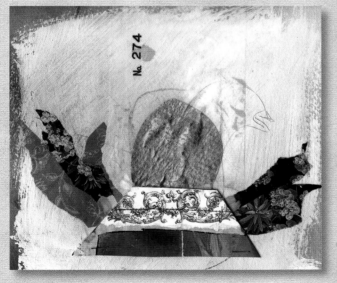

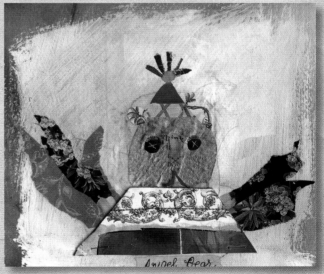

STEP 3

Soon a buglike creature begins to form as I play with the shapes. I add some gold scrap now and some type I like.

STEP 4

What I thought was a bug now feels more like a bear, and he needed a hat. I varnish the pieces to the surface and add the title "Angel Bear" with newsprint scrap. I take the type out above the head.

USING THE COMPUTER TO SCAN AND LAYER YOUR ILLUSTRATIONS

E quipment used for this technique is an Epson scanner, a Mac computer, and Adobe Photoshop. A technique I often use is digital layering. Portions from my originals, magazine clippings, fabric, or natural items are scanned and then layered into a digital Photoshop file. When the image is finished, it is merged to create one seamless digital "original" piece. This digital original can then be made into a print.

Depending on the topic, scanned layers can add content, type, shadows, textures, or drama in a way that I might not be able to achieve through traditional drawing or painting. I will walk you through the steps of several "layered" images.

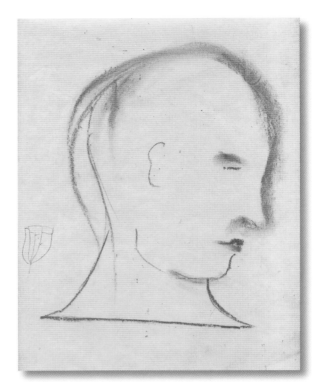

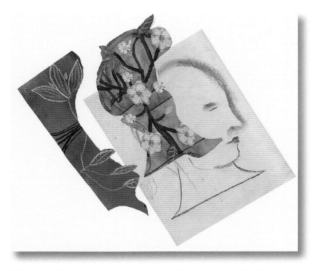

Visualize this technique as an open-faced sandwich. The bottom layer of bread is your background. Each item you add is a layer. The only difference is that all the layers are merged together with the background at the end to make a seamless digital original.

STEP 1:

The concept of this illustration is green eco-friendly shampoos. I begin with a simple sketch of a face, drawn with pastel on tissue paper. This becomes the background.

STEP 2:

I look through the digital scan library of my many originals, looking for green/nature images. I choose the two originals shown on the opposite page.

Photoshop is a good skill to acquire as an artist. It opens up a world of options to manipulate your work.

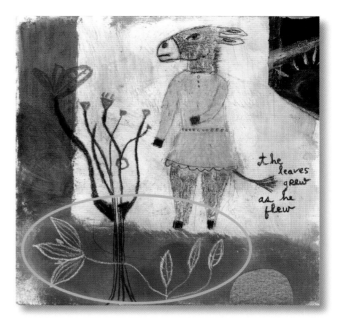

STEP 3:

This is where your skill level comes into play. Using Photoshop, I open up the scan of original, left, above. I outline the area I want, copy it, and paste it in as layer in the image below. I do not merge it yet. I also adjust the color to become even more saturated green.

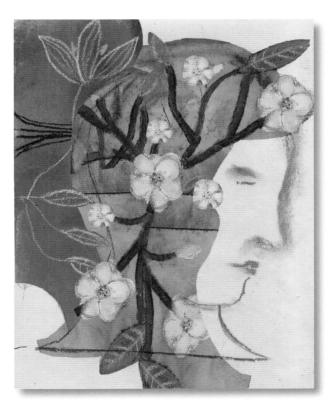

STEP 4:

I open the scan of original (top, right) #2 above. Again I cut and paste the area I want to use, still using Photoshop. And I adjust colors. When I am satisfied with the new images, I "merge" the layers in Photoshop, and I end up with just one digital file.

Here are two good examples of the layering technique.

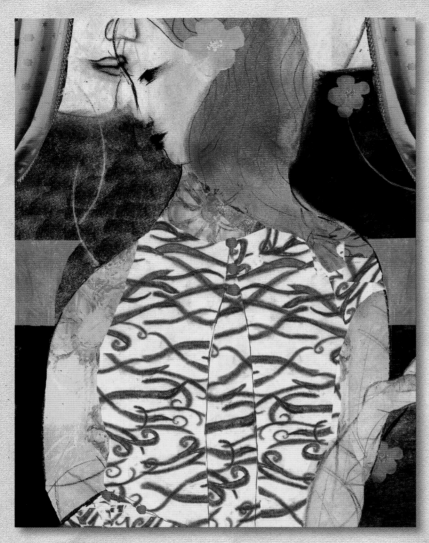

This is a promo image for Mother's Day.

THE BACKGROUND:

Black pastel line drawing of a man and woman created on tissue paper, scanned

LAYER 1:

Created the dress pattern by cutting and pasting the pattern from another original/scan

LAYER 2:

Added a dark background with a scan

LAYER 3:

Added the orange shape from another scanned image

LAYER 4:

Added the pink flowers and curtains by copying from another scanned original

LAYER 5:

Added a hazy pattern over the woman's arms by scanning elsewhere and layering

LAYER 6:

Added small red beads for belt and buttons to balance color

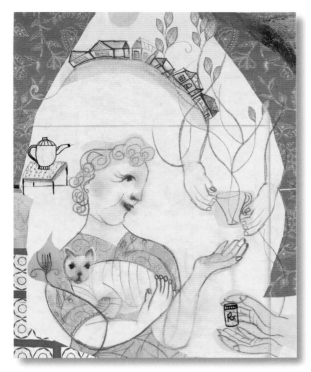

This illustration is for an article in the Los Angeles Times *about helping seniors stay at home as they age.*

THE BACKGROUND:

Pastel line drawing of a woman, drawn on tissue paper

LAYER 1:

Drew arms, hands, cat on another piece of tissue paper, then scanned it

LAYER 2:

Drew houses and teapot on a separate tissue paper and scanned it

LAYER 3:

Added fabric pattern by scanning magazine scrap

LAYER 4:

Drew an organic pattern, scanned it, and layered it on the dress

FINAL TOUCHES:

Scanned and layered in leaves, color tint to hair, flower, and prescription bottle

Digital Options

Think of Photoshop layering as a tool to add to your belt. Digital layering has real benefits, especially to the commercial illustrator. Once you have a library of originals scanned, they provide infinite ways to add color, texture, and content to your pieces. Layering also allows you to make small digital tweaks to a piece without starting all over. For example, I find it challenging to draw hands, so Photoshop allows me to create a separate "layer" of hands; then I can make adjustments to the hands without ruining what I've already done.

An EXERCISE

Find some scrap and found objects.
Make yourself a happy hat.

Her name was Olive Oil, and she was a little sheep. Oh, she was an adult sheep but was very tiny, so instead of being out with the big ewes of the flock, she stayed behind in the barnyard with the younger sheep. But she didn't mind, for she was very happy to spend her day in nature.

Olive Oil especially loved springtime. And every spring she made herself a new hat for the season. She loved hats. Maybe it was because her mother, and her aunties, and her grandmama all wore hats, but whatever the reason, she loved wearing hats and making them. She'd find pretty leaves, chicken feathers, twigs, flower heads, and little bits of this and that, and she'd make a hat. The entire barnyard always knew spring had arrived when Olive Oil paraded around in her new hat.

one needs a
new Hat

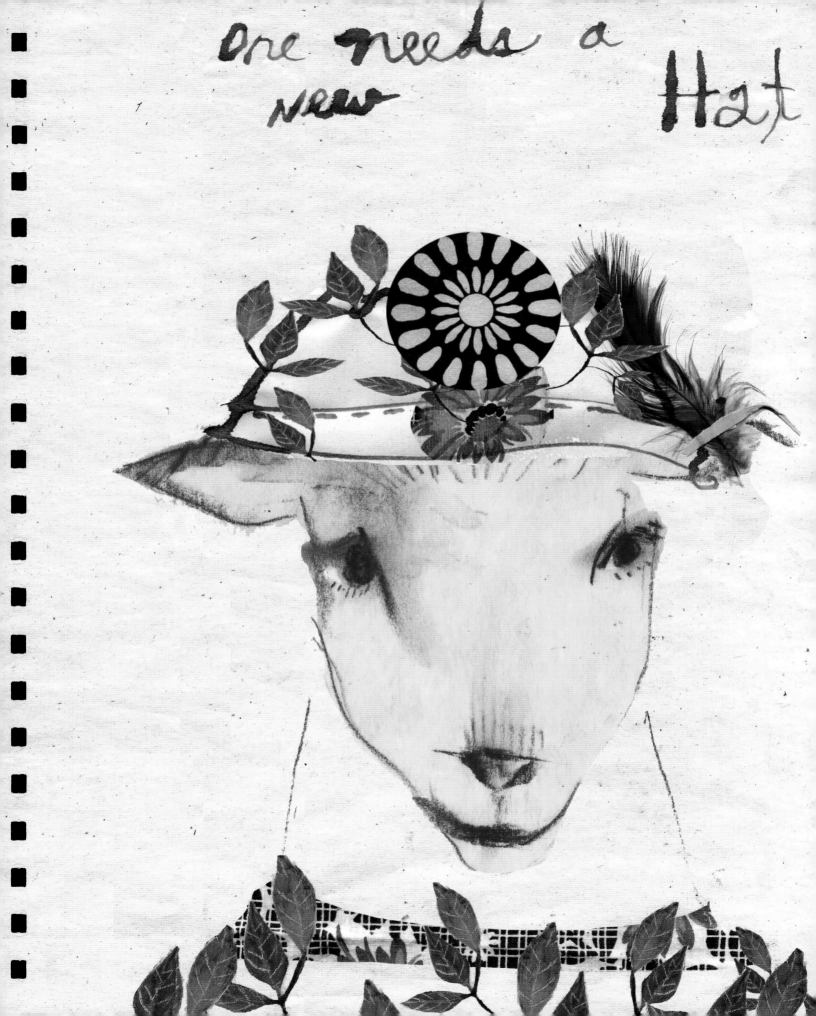

Chapter 6

When

THINGS

aren't

WORKING

Every artist's energy has an ebb and flow, and sometimes the flow stops. But it's usually temporary and can often be a time to simply replenish one's self. Or it might take doing something really drastic ... like making puppets.

In this chapter, we'll look at some simple energy boosters and find inspiration through working three-dimensionally. One important thing to remember: Art is a discipline. You have to work though challenges, and you work through them by actively drawing and painting on a consistent basis. While artists will have periods when they get burned out or are in a rut, you need to continue actively practicing your drawing, art, and storytelling. If you walk away every single time you feel stuck, you won't get anywhere.

Freeing up Creative Time

If you feel you're not accomplishing enough creative work due to family, deadlines, or life's tasks, consider making one small change to your daily routine that would free up one solid hour of time just for you. I often am asked how I get so much art and writing done with so many farm tasks, and the answer is that sometimes I don't get art done! But making one small adjustment can free up time. For example, I vowed to get the majority of my email done by 11 a.m. This allowed me to have four consecutive hours of creative time in the afternoon.

Creative Times in Your Head

When is your creative brainstorming time? Use it to your advantage, even if it's only five minutes. Just because you aren't drawing doesn't mean you aren't percolating stories and ideas in your mind. Give yourself permission to explore this way. For me, it's while I fall asleep or lying in bed early in the morning.

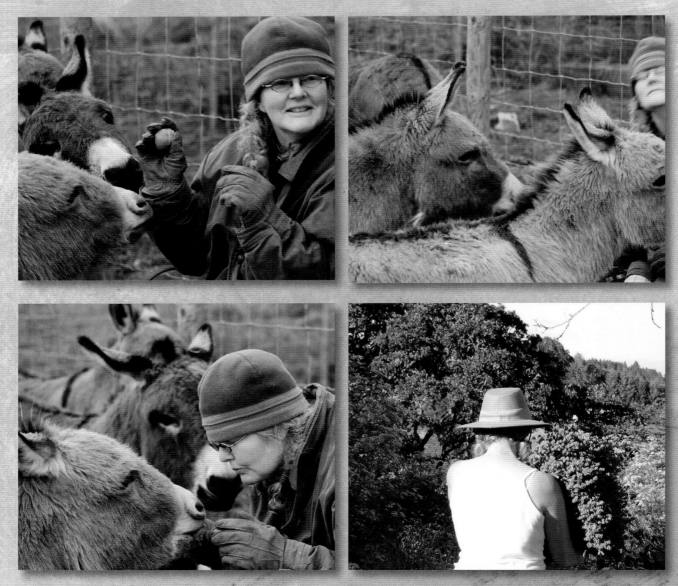

Seek ways to drink in nature's replenishing energy. Here the artist visits with her donkeys and works in her garden.

WORKING THROUGH BLOCK WITH NATURE
and Movement

 n old farmer once told me, "Keep takin' water out of the well, sooner or later it's gonna go dry. You have to walk away; let it fill back up from the earth."

When you first get hit with creative blues, change your immediate environment and look to Mother Nature for an energy tonic. Physical activity and letting your eyes and body experience other natural stimuli help replenish your creative well.

Try taking fifteen-minute sabbaticals from the drawing table. Take a fifteen-minute walk or a break with nature somewhere. No matter where you live, you can commune with the air or sky for fifteen minutes. These breaks give you a fresh perspective when you return to your work.

When creative block first hits, take a break for an hour to indulge in your own preferred "energy drink."

The artist free-form dances in her studio to revitalize her energy during the workday.

My favorite energy booster when I'm feeling drained from work is dancing. Put on some good music and move with whatever beat you feel. That vibration sinks into you, filling up your creative well. Plus—it's fun! Try fifteen-minute physical bursts of walking, jumping rope, or doing yoga—anything that helps you move and breathe.

BE AWARE OF ARTISTIC RUTS

Be aware of getting in a repetitive rut. You unconsciously repeat elements and symbols in your work that become your unique painted language. But if you find yourself saying, "I don't know what to put here, so I'll add a red circle again," consider consciously trying something out of your comfort zone—a new color, shape, or object. It doesn't mean using a red circle is wrong, but it's easy to get lazy and repeat things that are safe because you know they worked well in past images.

Sometimes your creative block requires more than a fifteen-minute walk to jolt you out of it.

In these times, try turning to a completely different medium or art form. Doing so brings you in touch with new textures, new methods, and new ideas. You'll be forced to figure out how the new medium works, and you won't have time to feel blocked.

If you're comfortable drawing on 8-inch (20 cm) paper, paint on a large canvas for a day. If you normally work in color, try producing some images in charcoal or black ink. Usually a painter? Switch to photography for a day or writing poems. Look at switching mediums as a "creative catalyst."

Recognize your own daily energy rhythms. I personally have a hard time painting in the morning. I can write in the morning, but for some reason my painting feels clumsy and blocked. Rather than forcing myself into an unnatural state, I accept this and work around it.

So take note of your natural energy cycles. Are you tired in the afternoon? Then take a nature walk and hit the drawing board afterward. Take time to ask these simple questions: When do my ideas flow freely? When do I feel most open—morning, noon, or evening? While this might seem like an obvious suggestion, many people lead such overfilled lives, they haven't taken the time to ask these simple questions.

"Every wall is a door."
—Ralph Waldo Emerson

Working on a large canvas is a physical experience. Try working as you listen to music, painting to the rhythm and beat. Work abstractly at first to free your mind from details.

Here's an array of the artist's handmade dolls that look they stepped out of her illustrations.

WORKING THREE-DIMENSIONALLY FOR INSPIRATION

Perhaps one of the best things I ever did was to sit down one day and create a sock doll for fun. With no plan or preconception of what the end product would be, I eventually found myself holding a creature that looked like it had stepped out of one of my illustrations. The same two-dimensional creatures that were inspired by my real animals were now inspiring three-dimensional characterizations of themselves.

Once I made my first doll, I made more. I often take breaks from painting or writing just to make dolls. Each doll seems to inspire another doll. I also explored working with needle felting my creatures and their clothes.

Consider creating a doll that represents a character in one of your illustrations. Translate its personality into fabric.

Three-Dimensional Formats to Bring Two-Dimensional Characters to Life

Three-dimensional creatures take on living personalities when you work with them and can inspire characters for your two-dimensional work.

Working in a three-dimensional format you aren't trained in allows you to be a novice. When you've never done something, you seek out ways that work best for you and are more open to taking chances. Working three-dimensionally can lead to techniques that let you apply your style to a whole new body of work.

Once you create your first three-dimensional character or subject, consider moving it around like a prop on a theater set. What stories come from that? That story might just stay in your head, or it might inspire new illustrations.

- Try sculpting figures out of clay.
- Carve items out of soapstone or wood.
- Create a stage scene with paper dolls on sticks.

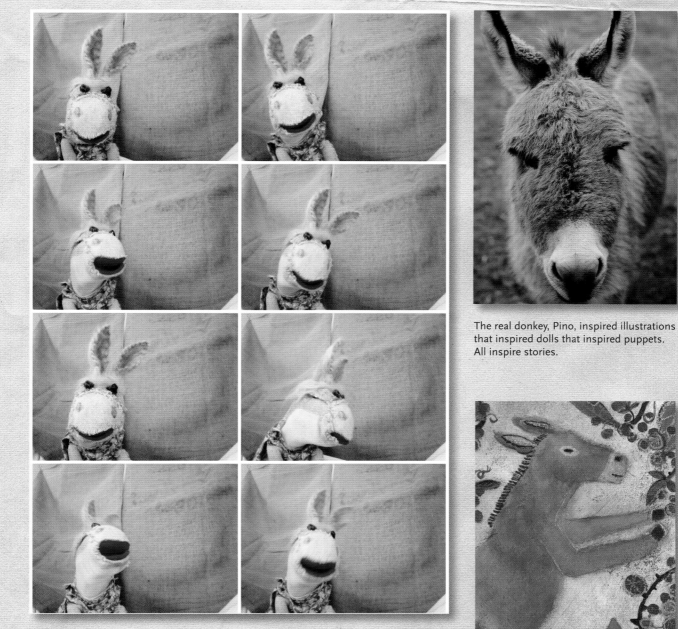

The real donkey, Pino, inspired illustrations that inspired dolls that inspired puppets. All inspire stories.

As I worked with my doll creatures, their voices and thoughts developed in my head. That's when the first puppet of Apifera was born. Do you recognize him? The puppets are just one more vehicle for me to share stories. After I make a new puppet, I create little movies of them having a conversation.

CREATING A SIMPLE PUPPET

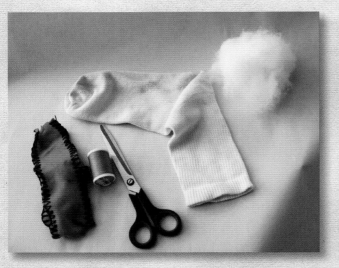

Materials needed: one sock, needle and thread (or sewing machine if available), stiff red fabric such as felt for a mouth, scrap fabric for ears and eyes, and cotton or poly batting to stuff head area (or you can use other cotton scrap.)

STEP 1:

Cut a slit in the toe area of the sock. Take your red felt (or any thicker fabric) and bend it to place it in the slit of the sock. Sew this red mouth into the sock by hand or with a machine. You can use a different color, but red shows up well.

STEP 2:

Put the puppet on your hand and just play with it and imagine what features may emerge. Then begin to make ears and eyes.

STEP 3:

Add your ears and eyes and any embellishments. If you feel the forehead area needs some structure, place stuffing inside the sock at the forehead. You can also wad up old cotton fabric and use it as stuffing.

Puppet making is the antithesis of creative block. —Katherine Dunn

The goat puppet on the left has ears made from an old brown sweater, and the arms are made of old socks. This donkey is more involved. I needle felted the ears separately and sewed them to the head. I also sewed an apron. Your main agenda is to have fun.

"Life's like a movie. Write your own ending. Keep believing, keep pretending." —Jim Henson

Find a sock. Now go bring it to life and share the stories it holds within.

It's been a long time since I've seen daylight. And it sure is nice to get out of that old drawer and look around at all the things going on in this one room. Oh, here she comes again ... she's picking me up. Oh, I feel like I'm ... alive. I have stories to tell! I can hear my voice again! Oh, it's so wonderful to speak again. And feel myself stretch. To come to life after all that time sleeping in that sock drawer. I'm one lucky sock.

Chapter 7

Gallery of

PROJECTS

In the end, it's your work. You make the decisions, or let's say an entire orchestra inside you makes the decisions. Your art and stories aren't here to please everybody. Please yourself first in the art; then put it out there and the right audience will follow.

In this chapter I've showcased an array of finished projects for commercial clients, gallery shows, and personal pieces made for myself. The objective of an illustrator is to convey a story, a message, or an essence in images. It can draw a reader to buy a book or help engage them in a magazine article. A greeting card reaches out to your heart, or the packaging on a box makes you feel happy on a dreary day. While there are always design parameters and client needs in any commissioned project, it can still be completed with your unique view of the subject and your special way of creating a story through images.

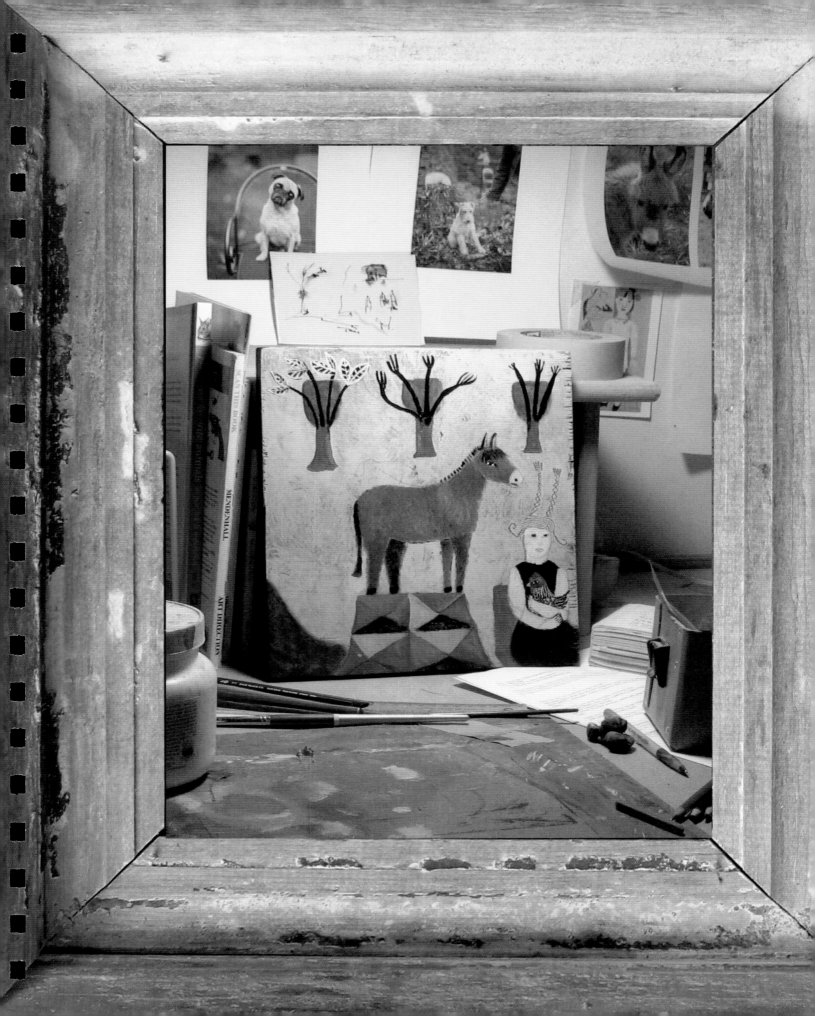

Avoid Painting Just to Sell

One trap that professional artists can fall into (myself included) is unconsciously returning to subjects that sell well. Working artists have to make a living, but sometimes we can get stuck. Accolades are handed out for "how well you paint red flowers," for example, and the day you sit down and don't know what to paint, you end up painting red flowers. This warning doesn't mean that you can't paint red flowers, but check your motives for why you decide to paint them on any given day. Is it for you? Or is it because you just sold two paintings of red flowers? One tip that helps me stay fresh and focused on my own muses is to paint a piece one day that you know is good for selling in the commercial market, i.e. red flowers. The next day, paint only what your internal muses are dictating you to paint, even if you think it won't sell. If your muse tells you to paint about the nightmare you had last night and the colors are dark and ugly, just go with it. Often important work comes from these personal visions.

Fox Guided by Moons (10" x 17" [25.4 x 43.2 cm]). *Acrylic, pastel, and collage on heavy watercolor paper* | When you live in the country on a farm, the creatures of the night become less mysterious because you see and hear them more. Still, the knowledge that they are guided so innately, something we humans have mostly lost, is a constant inspiration to my work. The moon shapes in this piece are collaged magazine scrap, chosen for their color.

(Opposite)

I'm Pretty Sure He's Here Somewhere (13" x 16" [33 x 40.6 cm]). *Acrylic, pastel, and collage on heavy watercolor paper* | Originally created for a gallery show called "Somewhere," this piece has many personal symbols for me, and much of it centers on the process of accepting my father's death. I find much hope and spirit in this piece, from the lone flower bright in the darkness to the stars and energy in the night. The little color specks are all magazine scrap.

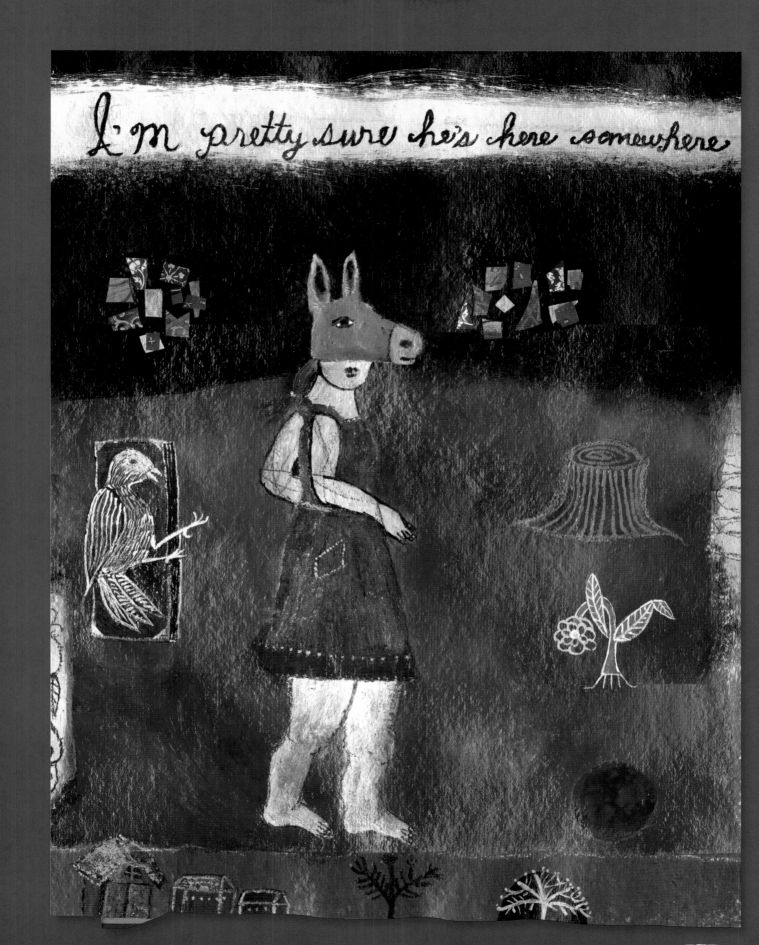

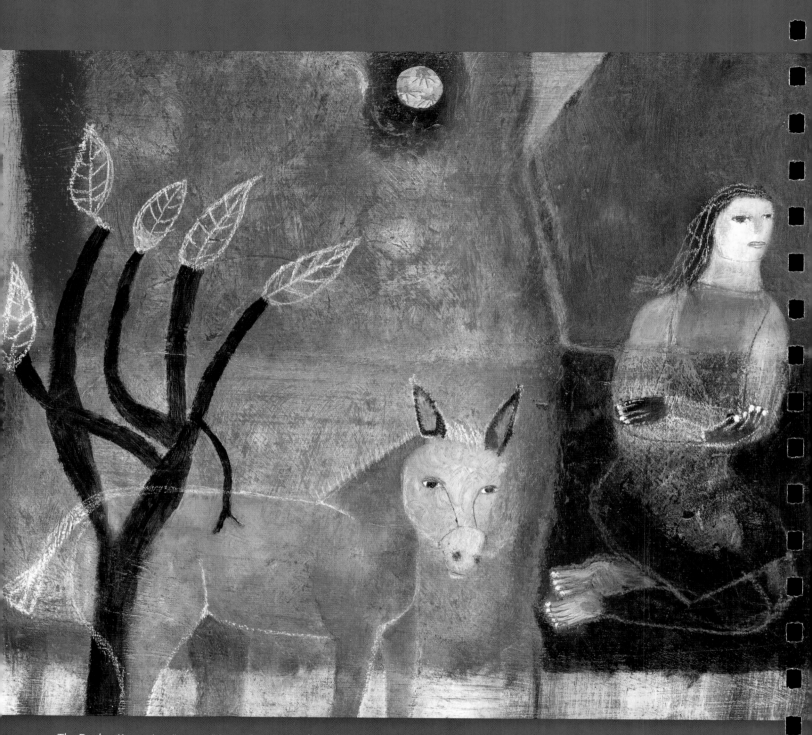

The Donkey Knows (13.5" x 11.25" [33 x 28 cm]). *Acrylic and pastel on pine* | This was originally created for a gallery show called
"*Innate Refuge.*" A person at the opening asked me, "What does the donkey know?" I told him it depended on the donkey.
Seriously, the titles of my personal work come to me after I complete them, sometimes days later. Even I don't always know what
they mean. Years later when I look at old work, I can sometimes recognize what message was in it for me. If I could discuss and
explain every symbol and title in words, I wouldn't have the need or internal urge to paint.

Bird Bike (12" x 15" [30.5 x 38.1 cm]). *Acrylic, collage, and pastel on an old kitchen cupboard door* |
I was asked to partake in a group show that would promote the benefits of commuting by bike
versus by car. The ethereal quality of the background is created by many layers of acrylic washes,
each drying before another is applied. The sun symbol is collaged scrap, and the linear elements
are created with pastel.

I'm Right Over Here in the Corn (11" x 15" [27.9 x 38.1 cm]). This was a private commission for a client's beloved pet, Mose, an old chocolate Lab, who had died months before. I always ask people to write a page about their pet, and then I decide what speaks to me and go from there. After reading through paragraphs about this great old guy, I was drawn to the fact that Mose liked to sneak into the neighbor's field and eat corn. The client left me an emotional message saying that "she just didn't realize Mose was in the corn all this time." This piece is a good example of how you can apply scanned layers of photos and scrap onto an original drawing to create a "digital original." This process is described in chapter 5.

I am often hired to do animal portraits, so I created this composite image of cropped portions of original portraits. Most of the originals of these crops were acrylic, with some collage. For me, the purpose of any portrait is to connect the viewer to the essence of that creature in one quick look. This composite is now sold as an archival print. Proceeds from these prints are donated to help senior creatures at my favorite animal charities.

Commissioned for the *University of Minnesota Alumni Magazine*, this piece accompanied a short, fiction piece entitled "Kalispell," by Jacob Ellsworth. The story is about a woman who was torn between two men: one stable and doting but in her eyes rather boring; and the other a dashing, flamboyant skywriter, who wrote her messages each day in the sky, much to the humiliation of the other suitor. The main composition of the couple was created traditionally with pencil and acrylic. (8½" x 11" [21.6 x 27.9 cm]). Scans of other drawings were added digitally—the sky, the town, and the decorative floral items.

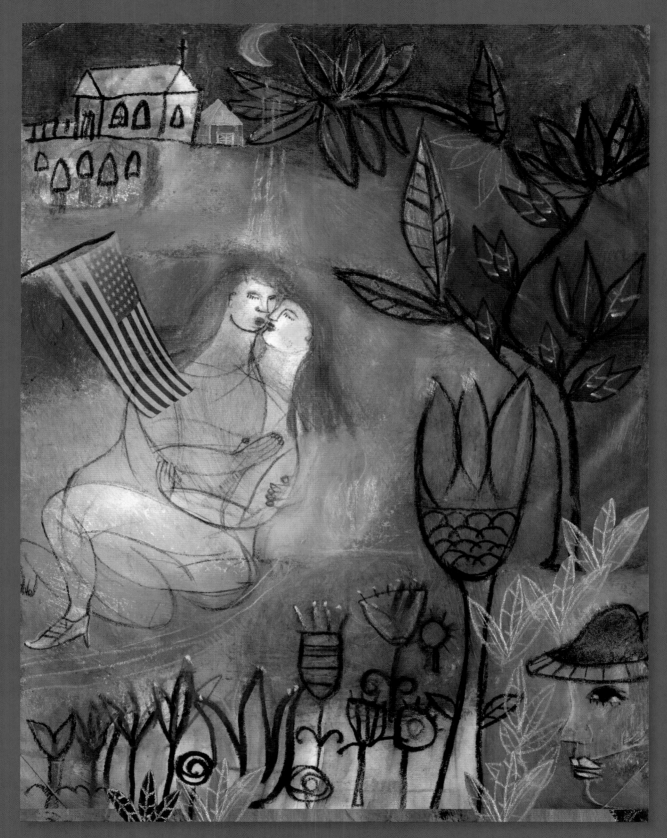

Acrylic on paper. 10" x 14" [25.4 x 35.6 cm]) | This piece was inspired by a story on the radio about two respected, churchgoing women living in small-town America. They had to conceal their lesbianism and their relationship from the small-town conservatives, many of them in their own church. I felt that adding the flag symbol was very important, because so many people were talking about morals and values while brandishing the flag but were unaccepting of perfectly wonderful, caring women in their church.

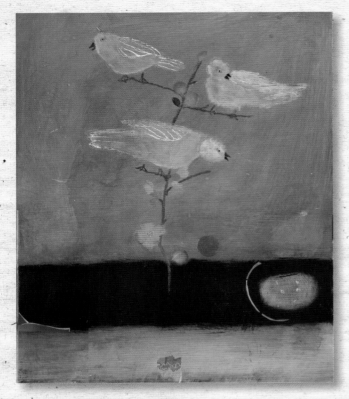

(All three pieces shown)

Originally created for a gallery show called "*Flight*," all these pieces are acrylic with some collage and are approximately (14.5" x 14.5" [35.6 x 36.8 cm]) in size. Long after they were sold, I licensed the images to *Studio Avo* to be used for canvas reproductions. One original can be applicable to a whole array of markets, so my advice is to never, ever sell your copyright on any given piece.

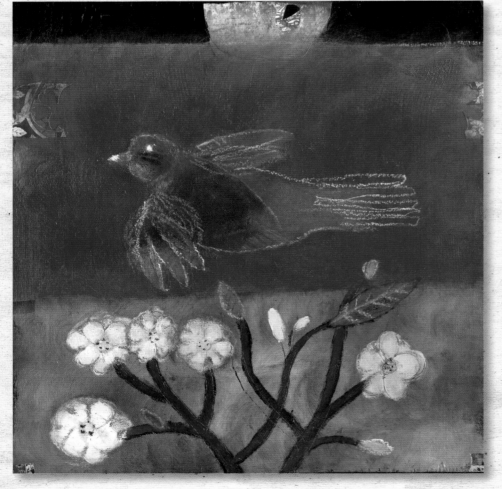

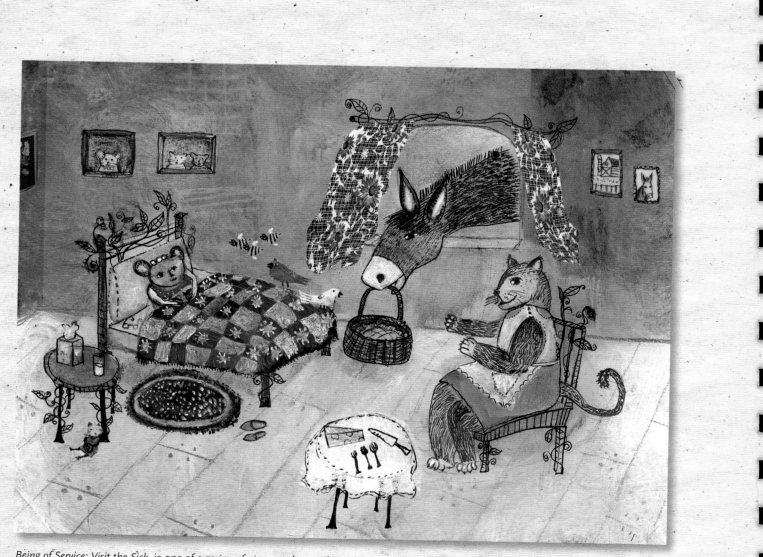

Being of Service: Visit the Sick, is one of a series of pieces to honor the many ways children can help others. Each piece was created on paper, with acrylic, pastel, and ink, (14" x 11" [35.6 x 27.9 cm]). Note that I touched up each piece digitally by scanning items and using Photoshop. This allows me to add important elements such as the floral curtains that can make the ambiance of the room more complete.

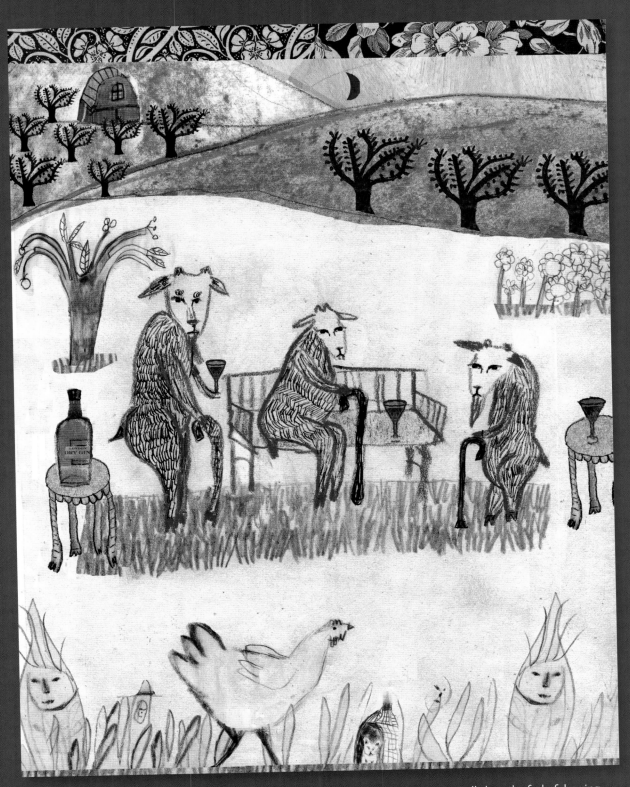

Senior Goat Cocktail Hour was created with conté pencil and acrylic on drafting tissue. I really love the feel of drawing with pastel/conté pencil on tissue; it feels very earthy to me. I drew the goats and animals separately and then gathered scans from other illustrations and merged them into one digital piece (for more on this process, see chapter 5). For example, the trees came from a separate painting. The end result is a print that I send to people who sponsor the farm's three senior pygmy goats.

These three fabric pieces were created by taking my original drawings and uploading them to *Spoonflower*, an online resource that takes your digital file and prints it into fabric (see Resources, page 138). I use the fabric to create pillows and sachets from our farm's lavender buds harvested from 4,000 plants. I've also used the fabric to make three-dimensional items such as stand-up dolls and prayer flags.

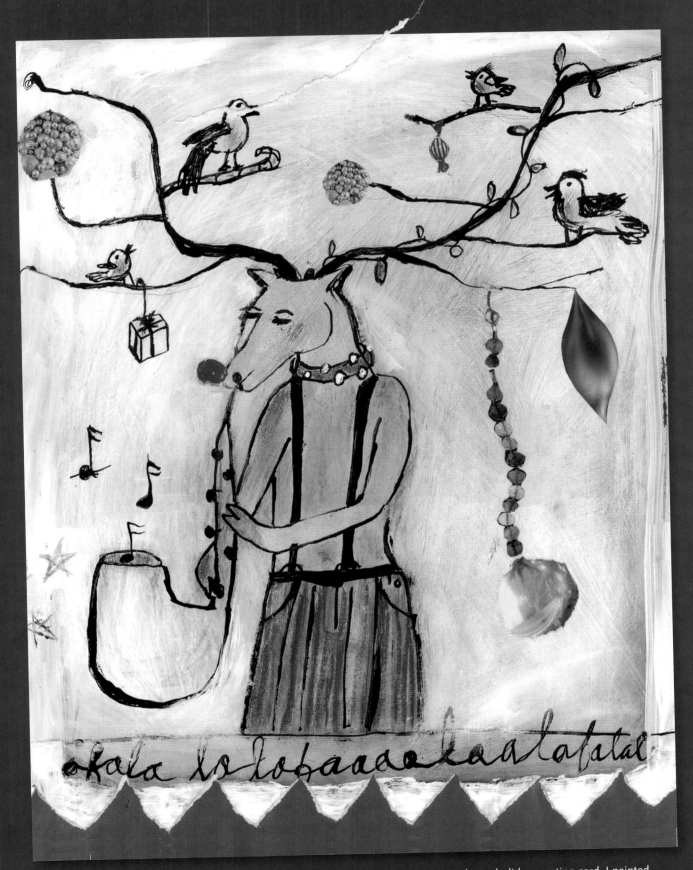

Originally created for *Neiman Marcus*'s holiday issue of *The Book*, the image is now used on a holiday greeting card. I painted gesso on a magazine cover and mainly used ink and pastel to create this piece, along with some collage. The sparkly jewelry is cut from magazine scrap (9" x 12" [22.9 x 30.5 cm]).

Night Swimmer, 12" (30.5 cm) *acrylic pastel on archival inked paper.*

This was inspired by a story about a woman who disappears after swimming in the ocean. It's mainly pastel, with acrylic, created on an already printed (12" x 10.5" [30.5 x 26.7 cm]) archival print that had an eerie blue/black abstract background. I painted an acrylic wash over the dark surface, let it dry, and used mainly pastel for the images. The moon on both pieces is from collage scrap of a photo of the moon that captured the glow better than I felt I could.

New Year's Couple. Acrylic, pastel, and collage | The majority of this image was created traditionally, but elements were brought into the final illustration digitally. I really enjoy making tiny digital additions that mean so much to the final piece, such as the pipe, dog, and bird.

To Title or Not to Title

Should you add a title to your finished piece? There are different opinions on this. Some will tell you that adding a title to your piece is too suggestive and doesn't let the viewers make up their mind about what the piece means. I find that adding a title "completes" the story for me and have often had viewers tell me they like having a title for guidance.

RESOURCES

PAINTS AND MEDIA SUPPLIES

Dick Blick Art Materials
www.dickblick.com

Golden Artist Colors, Inc.
www.goldenpaints.com

Liquitex Paints and Varnishes
www.liquitex.com

Utrecht Art Supplies
www.utrechtart.com

Winsor & Newton
www.winsornewton.com

PINE BOARD / SUPPLIES/ VARNISH BRUSHES

Home Depot
www.homedepot.com

Lowe's
www.lowes.com

CUSTOM FABRIC

Spoonflower, Inc.
www.spoonflower.com

SHIPPING SUPPLIES/CARDBOARD

U.S. Box Packaging
www.usbox.com

FRAMING

United Mfrs. Supplies, Inc.
www.unitedmfrscatalog.com

CAMERAS AND SCANNERS

Canon
www.usa.canon.com

Epson
www.epson.com

HELPFUL INFORMATION FOR ARTISTS

Golden Artist Colors, Inc. Environmental Guidelines
www.goldenpaints.com/healthsafety/environ/index.php

Liquitex Safe Studio Tips
www.liquitex.com/healthsafety/safestudiotips.cfm

Find places to recycle paints and more earth-friendly tips
www.earth911.com

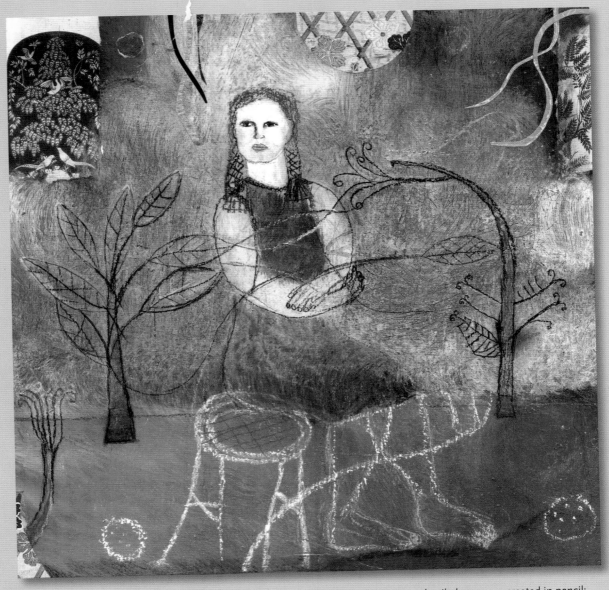

Acrylic, collage, pencil, and pastel on pine board (12" [30.5 cm]) | Note how certain more-detailed areas are created in pencil: the hands, and leaves, the mouth.

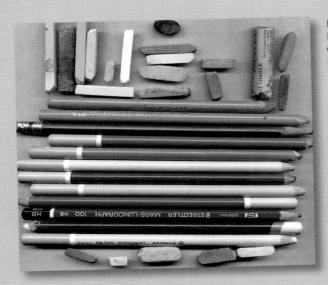

Many brands of pencils and pastels are available. I use Rembrandt pastels, Faber-Castell pencils, and Carrés contés. All can be found online at the stores listed under Paints and Media Supplies, page 138.

ABOUT THE AUTHOR

Artist Katherine Dunn lives on Apifera Farm in Yamhill, Oregon, where she is surrounded by her favorite muses—animals and nature. While her paintings travel internationally to get to their new owners, Katherine takes refuge on her farm, away from the chatter of the world's chaos. Outside her studio she watches a flock of sheep just up the hill from the lavender field. Donkeys bray on a hill, chickens scatter, and an old goat rests in the sun. Her paintings and illustrations tell the stories she sees each day, with an emotive, bittersweet quality.

Raised in Minneapolis in an artistic household, Katherine's tastes for art were flavored by her architect father's travels and her occasional studies abroad. She began painting seriously in her late thirties, choosing to work as a freelance illustrator. Eventually her heart was pulling her west, and she moved to Oregon in 2002, where she eventually met her husband, a landscaper. They established Apifera Farm in 2004.

"Someone recently described my work as a combination of melancholy and hope and I think that is accurate."
—Katherine Dunn

WWW.KATHERINEDUNN.US

WWW.APIFERAFARM.COM

WWW.APIFERAFARM.BLOGSPOT.COM

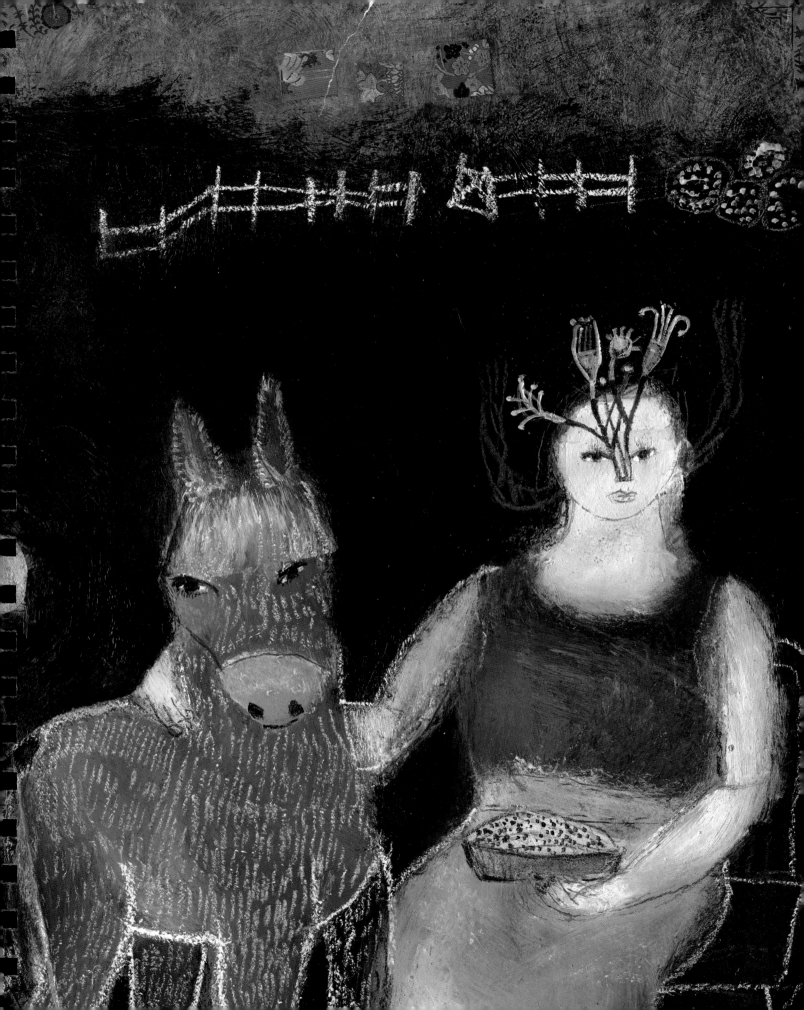

ACKNOWLEDGMENTS

There are many people, creatures, and entities to thank. Fortunately, I have an entire page. First, I'd like to thank my editor, Mary Ann Hall, for the guidance and insights she has given me throughout the book. And thanks also go to Quarry Books for giving me the opportunity to write this book.

Each creature that's come into my life has taught me about the beauty and power of nature. A self-entertaining unit since my first days, nature has always been my muse. I won't name every bird, leaf, tree, or rain shower, for they know who they are.

Thanks to my parents, who encouraged my art. I wish my father could see my first book, and I thank him wherever he is for surrounding me with art books and art supplies when I was young.

Special thanks to my many artist/writer compadrés from all over the continent who share emails, visions, and thoughts as we muddle through life. And thanks to the many followers of my blog, who show love and admiration for Apifera Farm and all its creatures through kind gestures.

To Martyn, my very gentle and loyal dirt farmer—without you, Apifera Farm would fall down. Thank you for watching my puppets sing, cooking meals of nourishment while I write, and chopping the wood to keep us warm.

To the many creatures of this farm—each of you, be it winged, big eared, or one eyed, bring me meaning, nourishment, stories, and companionship. You teach me.

And finally, to this place called Apifera. Do we exist without each other? I think not.

I'd like to thank all the trees too. their leaves know more than I do.

PLEASE DON'T ENTER

CREATIVE ILLUSTRATION WORKSHOP

WORLD STUDIES

THIRD EDITION

Dennis Bollinger, PhD

bju press®

Greenville, South Carolina

Note: The fact that materials produced by other publishers may be referred to in this volume does not constitute an endorsement of the content or theological position of materials produced by such publishers. Any references and ancillary materials are listed as an aid to the student or the teacher and in an attempt to maintain the accepted academic standards of the publishing industry.

WORLD STUDIES Student Activities Answer Key
Third Edition

Dennis Bollinger, PhD

Editor
Grace Zockoll

Project Manager
Dan Berger

Cover & Book Design
Drew Fields

Page Layout
Ealia Padreganda
Dan Van Leeuwen

Permissions
Sylvia Gass

Illustration
Michael Asire
John Cunningham
Preston Gravely Jr.

Photograph Credits
Cover
©iStockphoto.com/sculpies (Pyramids); ©iStockphoto.com/travelphotographer (India); ©iStockphoto.com/sara_winter (Windmills); ©iStockphoto.com/Knighterrant (Tibetan father and son); ©iStockphoto.com/samxmeg (Hong Kong)

Maps (all): Map Resources

Produced in cooperation with the Bob Jones University Division of Social Science of the College of Arts and Science.

© 2011 BJU Press
Greenville, South Carolina 29614

First Edition © 1985 BJU Press
Second Edition © 1998, 2000 BJU Press

ISBN 978-1-59166-978-4

15 14 13 12 11 10 9 8 7 6 5 4

CONTENTS

Unit III Dominant Powers in Europe and Asia: 1450–1750

Unit IV The Revolutionary Age: 1750–1900

Unit V The 20th Century and Beyond: 1900–Present

HOW TO USE THE ACTIVITIES MANUAL

These activities are designed to give you flexibility. We have provided a menu of activities from which you can select the ones that will help you achieve your instructional goals. Before you begin each chapter, look over the activities and decide which ones best meet your students' needs and which ones you want to use. You do not have to use all of them. Determine how you want to assign them. The activity codes at the bottom of each page will help you decide.

ACTIVITY CODES

Each chapter has three to six activities. The activity code tells you which sections of the chapter each activity covers. The code also tells you whether the activity is good for reinforcement, enrichment, or review.

- *Reinforcement* activities are based solely on the information in the textbook. They help students (1) to recognize and recall major terms and concepts in the chapter and (2) to "put it all together." Some reinforcement activities cover the entire chapter. (Students can complete them as they read through the chapter or as they review for tests.) Other reinforcement activities apply to a specific section of the chapter. (Students can complete them as they read that section.)
- *Enrichment* activities go beyond the textbook. They help students (1) to apply information from the chapter, (2) to pursue subjects they find interesting, and (3) to develop special skills. Every student can benefit from these activities, but they are particularly useful for students who need a challenge. Most enrichment activities are related to a specific section in the chapter.
- *Chapter review* activities help students to prepare for the chapter test.

ALTERNATIVE USES OF THE ACTIVITIES

Activities are useful for more than just homework. You can make them an integral part of your classroom discussion. For example, you can complete many of the map activities or primary-source readings together in class as you cover the material in the chapter. Or you can use them as a means of review after you have covered all of the material. Your students will especially appreciate your help in completing the more challenging activities.

- **Homework**—The students complete the activity at home.
- **Class activity**—The students complete the activity in class by themselves or in groups.
- **Class discussion**—You help the class complete the activity together in a classroom discussion.
- **Lecture**—You complete the activity on the board or projector during your lecture, while the students take notes.

The Epic of Gilgamesh

An epic is a long poem that records the adventures of a heroic person. *The Epic of Gilgamesh* is one of the oldest stories in the world. It was written more than two thousand years before the birth of Jesus by an ancient people called the Sumerians.

Answer the questions at the end based on the following excerpts from this ancient story. Compare this pagan account with the biblical account in Genesis 6–8 in order to answer the questions.

The Story of the Flood

The hearts of the Great Gods moved them to inflict the Flood.
Their Father Anu uttered the oath [of secrecy],
Valiant Enlil was their Adviser,
Ninurta was their Chamberlain,
Ennugi was their Minister of Canals.
Ea, the Clever Prince . . . was under oath with them
so he repeated their talk to the reed house:
"Reed house, reed house! Wall, wall!
O man of Shuruppak, son of Ubartutu:
Tear down the house and build a boat!
Abandon wealth and seek living beings!
Spurn possessions and keep alive living beings!
Make all living beings go up into the boat.
The boat which you are to build,
its dimensions must measure equal to each other:
its length must correspond to its width."

The child carried the pitch,
the weak brought whatever else was needed.
On the fifth day I laid out her exterior.
It was a field in area,
its walls were each 10 times 12 cubits in height,
the sides of its top were of equal length, [several] cubits each.

Whatever I had I loaded on it:
whatever silver I had I loaded on it,
whatever gold I had I loaded on it.
All the living beings that I had I loaded on it,
I had all my kith and kin go up into the boat,
all the beasts and animals of the field and the craftsmen I had go up.
Shamash had set a stated time:
"In the morning I will let loaves of bread shower down,
and in the evening a rain of wheat!
Go inside the boat, seal the entry!"

[F]orth went Ninurta and made the dikes overflow.
The Anunnaki lifted up the torches,
setting the land ablaze with their flare.
Stunned shock over Adad's deeds overtook the heavens,
and turned to blackness all that had been light.
The . . . land shattered like a . . . pot.

All day long the South Wind blew . . . ,
blowing fast, submerging the mountain in water,
overwhelming the people like an attack.

. . . .

The gods were frightened by the Flood,
and retreated, ascending to the heaven of Anu.
The gods were cowering like dogs, crouching by the outer wall.

. . . .

When a seventh day arrived
I sent forth a dove and released it.
The dove went off, but came back to me;
no perch was visible so it circled back to me.
I sent forth a swallow and released it.
The swallow went off, but came back to me;
no perch was visible so it circled back to me.
I sent forth a raven and released it.
The raven went off, and saw the waters slither back.
[The raven] eats, it scratches, it bobs, but does not circle back to me.
Then I sent out everything in all directions and sacrificed [an animal].
I offered incense in front of the mountain-ziggurat.

From *The Epic of Gilgamesh*, Tablet XI, http://www.ancienttexts.org/library/
mesopotamian/gilgamesh/tab11.htm

1. What does Gilgamesh (the man of Shuruppak) build to escape the flood? How is this similar to the biblical account (Gen. 6:14–16)? He builds a reed-house boat. Noah built an ark. Both Noah and Gilgamesh put a waterproof material (pitch) on their boats. Gilgamesh's reed-house boat is shaped like a square, and Noah's ark was shaped like a rectangle.

2. What does Gilgamesh take with him on his vessel? Compare and contrast this with the biblical account (Gen. 6:18–21; 7:13–16). Gilgamesh brings silver, gold, family, skilled craftsmen, and many animals. Noah's ark contained his wife, his three sons and their wives, sets of animals, and food for everyone and every animal on the ark.

3. What are some other differences between this epic's account and the biblical account?
Gilgamesh's story speaks of many gods' being involved in the flood, but the Bible shows that only God sent the Flood. The Bible states that God sent the Flood to punish a sinful world (Gen. 6:1-7), but the epic does not show man's sin as the flood's cause. The epic says that the gods were terrified of the flood, but the Bible shows that God was in control the whole time and not afraid of the Flood. The rain in the epic lasts for six days, but the Bible's account speaks of rain lasting for forty days.

4. What three animals does Gilgamesh send out of his boat to see if the water level has lowered? How is this similar to/different from Noah's actions (Gen. 8:5–12)? Gilgamesh sends out a dove, a swallow, and a raven. Noah also sent out a raven and a dove, but not a swallow.

5. What is the first thing that Gilgamesh does after he leaves his boat? What did Noah do after he left the ark (Gen. 8:16–21)? Gilgamesh offers a sacrifice by the mountain-ziggurat, and Noah offered a sacrifice to God.

SKILL: Comprehension, Original Sources

Name _____

CHAPTER 1 ACTIVITY 2

Map Study: Noah's Descendants

Black Sea

Caspian Sea

②

①

⑦

⑤

③

Plain of Shinar

Persian Gulf

④

⑥

Red Sea

The Post-Flood World

Locate the following on the map and place the number in the blank beside the term:

Euphrates River _5_

Ham _6_

Japheth _1_

Mediterranean Sea _4_

Mount Ararat _2_

Shem _3_

Tigris River _7_

WORLD STUDIES

Name _____

CHAPTER 1 ACTIVITY 3

Comparing Covenants

Fill in the blanks on this chart about the various covenants between God and Israel by placing the correct number in each blank. You will find the answers in the Bible passages cited below and between pages 11 and 14 of the student text.

1. Exodus 19:5–6

2. Earliest covenant

3. 2 Samuel 7

4. Promised gift of the Holy Spirit

5. Land

6. Disobedience resulted in punishment

7. Descendant of David will rule in the future

8. Ten Commandments

9. Jeremiah 31:31–34

10. Canaan given to Israel

Covenant	Abrahamic Covenant	Mosaic Covenant	Davidic Covenant	New Covenant
Reference	Genesis 12:1–7	1	3	9
Provisions	Seed 5 Universal blessing	10 Spiritual and economic prosperity	David's kingdom will last forever 7	God will rule the Israelites' hearts 4 Forgiveness of sin
Requirements	To believe	To keep and obey the law found in Exodus, Leviticus, and Deuteronomy		
Penalties		6		
Other	2	8		

SKILL: Charts

Name _____

The City of God

Answer the questions at the end based on the following excerpt from the writings of Augustine:

Are not those very Romans, who were spared by the barbarians through their respect for Christ, become enemies to the name of Christ? The … churches of the apostles bear witness to this; for in the sack of the city they were open sanctuary for all who fled to them, whether Christian or Pagan. To their very threshold the blood-thirsty enemy raged; there his murderous fury owned a limit. [To the church] did such of the enemy as had any pity convey those … whom they had [spared], lest any [more violent barbarians] might fall upon them. And, indeed, when even those murderers who everywhere else showed themselves pitiless came to those spots where that was forbidden which the [rules] of war permitted in every other place, their furious rage for slaughter was [restrained], and their eagerness to take prisoners was quenched…. Escaped multitudes … now reproach the Christian religion, and impute to Christ the ills that have befallen their city; but the preservation of their own life— a [blessing] which they owe to the respect [held] for Christ by the barbarians—they attribute not to our Christ, but to their own good luck. They ought rather, had they any [true understanding], to attribute the severities and hardships inflicted by their enemies, to that divine providence which [seeks] to reform the depraved manners of men by chastisement, and which exercises with similar afflictions the righteous and praiseworthy,—either translating them, when they have passed through the trial, to a better world, or detaining them still on earth for [other] purposes. And they ought to attribute it to the spirit of these Christian times, that, contrary to the custom of war, these bloodthirsty barbarians spared them, and spared them for Christ's sake, whether this mercy was actually shown in [secular] places, or in those places specially dedicated to Christ's name, and of which the very largest were selected as sanctuaries [in order to shelter a large multitude] there. Therefore ought they to give God thanks, and with sincere confession flee for refuge to His name, that so they may escape the punishment of eternal fire—they who with lying lips took upon them this name, that they might escape the punishment of present destruction.

http://www.ccel.org/ccel/schaff/npnf102.iv.ii.ii.html

1. How did the church buildings protect believers and unbelievers alike during Germanic invasions of the Roman Empire? _Believers and unbelievers found refuge in the church buildings._

2. Why were the church buildings considered safe havens? _The invaders would not enter the churches to_ _attack those inside._

3. How did some of the unbelievers who sought refuge in the churches later treat Christians?
 They spoke against the Christians and blamed them for "the ills that [befell] their city."

4. What reason does Augustine give for the assaults of the Germanic tribes on Rome?

God uses hardships and chastening to "reform the depraved manners of men."

5. According to Augustine, what should the Romans do in response to these assaults?

They should thank God and repent so that "they may escape the punishment of eternal fire."

SKILL: Comprehension, Original Sources

St. Patrick

Answer the questions at the end based on the following excerpts from St. Patrick's writings:

I am Patrick, a sinner, most unlearned, the least of all the faithful, and utterly despised by many. My father was Calpornius, a deacon son of Potitus, a priest, of the village Bannavem Taburniae; he had a country seat nearby, and there I was taken captive. I was then about sixteen years of age. I did not know the true God. I was taken into captivity to Ireland with many thousands of people—and deservedly so, because we turned away from God, and did not keep His commandments. . . .

But after I came to Ireland—every day I had to tend sheep, and many times a day I prayed—the love of God and His fear came to me more and more, and my faith was strengthened. And my spirit was moved so that in a single day I would say as many as a hundred prayers. . . . [O]ne night I heard in my sleep a voice saying to me: "it is well that you fast, soon you will go to your own country." . . . I went in the strength of God who directed my way to my good, and I feared nothing until I came to that ship. . . . [With this ship, I returned home.]

Once again, after many years, I fell into captivity. On that first night I stayed with them. I heard a divine message saying to me: "Two months will you be with them." . . . And again after a few years I was in Britain with my people. . . . There I saw in the night the vision of a man, whose name was Victoricus, coming as it were from Ireland, with countless letters. And he gave me one of them, and I read the opening words of the letter, which were: "The voice of the Irish"; and as I read the beginning of the letter I thought that at the same moment I heard their voice—they were those beside the Wood of Voclut, which is near the Western Sea—and thus did they cry out as with one mouth: "We ask thee, boy, come and walk among us once more."

Upon returning to Ireland, Patrick describes how revival broke out among the Irish people.

How did it come to pass in Ireland that those who never had a knowledge of God, but until now always worshipped idols and things impure, have now been made a people of the Lord, and are called sons of God[?]

In Patrick's letter to the Roman soldiers at Coroticus, he indicates the full extent of the Irish revivals but also shows how persecution interrupted evangelistic work.

I Patrick, a sinner, unlearned, resident in Ireland, declare myself to be a bishop. . . . With my own hand I have written and composed these words, to be given, delivered, and sent to the soldiers of Coroticus; I do not say, to my fellow citizens, or to fellow citizens of the holy Romans, but to fellow citizens of the demons, because of their evil works. Like our enemies, they live in death, allies of the Scots and the apostate Picts. Dripping with blood, they welter in the blood of innocent Christians, whom I have begotten into the number for God and confirmed in Christ! The day after the newly baptized, anointed with chrism, in white garments—the fragrance was still on their foreheads when they were butchered and slaughtered with the sword by the above-mentioned people—I sent a letter with a holy presbyter whom I had taught from his childhood, clerics accompanying him, asking them to let us have some of the booty, and of the baptized they had made captives. They only jeered at them.

"The Confession of Patrick" and "Letter to Coroticus" from J. M. Holmes, *The Real St. Patrick* (Greenville, SC: Ambassador Intl, 1997).

1. What happened to Patrick when he was sixteen years old? He was kidnapped and taken to Ireland.

2. What reason does Patrick give for this event? Both he and his people turned away from God and did not keep His commandments.

3. What happened to Patrick while he was in Ireland? He became a shepherd and began praying to God.

4. Why did Patrick return to Ireland? He had a vision of a man who had letters asking Patrick to return to Ireland.

5. According to Patrick's confessions, what was the result of his evangelistic work? Some Irish people became Christians and stopped worshipping idols.

6. What happened to many of Patrick's converts in Ireland? Armies killed them or made them captives.

7. What two groups does Patrick rebuke? The Scots and Picts who persecuted the Christians

SKILL: Comprehension, Original Sources

Name _____

Chapter Review
Make the Statement Correct

Underline the word or phrase that makes the statement correct.

1. The book of (Genesis/Romans) explicitly states that God created the world. (p. 4)

2. Those who were not Greek in culture were called (barbarians/Franks). (p.19)

3. God rejected the sacrifice of (Cain/Abel). (p. 8)

4. Genesis chapter ten contains the (Ten Commandments/Table of Nations). (p. 10)

5. The Romans destroyed (Damascus/Jerusalem) in AD 70. (p. 17)

6. Noah placed a curse on the son of (Shem/Ham). (p. 9)

7. The Flood was (local/universal) in scope. (p. 8)

8. Only (Noah's/David's) family survived the Flood. (p. 8)

9. (Constantine/Nero) blamed the Christians for the fire that destroyed Rome in AD 64. (p. 18)

10. The fall of Babel resulted in the (increase/restraint) of sin. (p. 9)

11. Nero made Christianity a(n) (legal/illegal) religion. (p. 18)

12. The (Coptic/Roman Catholic) Church is the official church of Ethiopia. (p. 21)

13. *Christ* is a Greek term meaning (Forgiver/Anointed One). (p. 15)

14. Constantine changed the name of (Byzantium/Athens) to "New Rome." (p. 19)

Matching Exercise

Place the correct letter in the blank.

A. Covenant C. Divine sovereignty E. Fall

B. Creation Mandate D. Creation

<u>D</u> 15. God spoke the world into existence.
p. 4

<u>C</u> 16. God performs everything according to His will.
p. 4

<u>E</u> 17. The result of Adam's sin
p. 6

<u>A</u> 18. Agreement between two individuals or groups
p. 11

<u>B</u> 19. Man is responsible to take care of God's creation.
p. 5

Short Answer

20. What is the most important turning point in history? <u>The death and Resurrection of Jesus Christ (p. 16)</u>

Do Christians and Muslims Worship the Same God?

You are probably familiar with one of the key verses in the Bible found in the Gospel of John—John 3:16. This verse reveals the heart of God—He loves everyone. Although verses such as Romans 3:23 teach us that everyone has sinned and missed the mark of God's standard (His glory), we can also say that God loves sinners. However, the god revealed in the Qur'an is very different from the God of the Bible.

Answer the questions below based on the following quotations from the Qur'an:

"[Allah] bears no love for the impious and the sinful." (Sura 2:276)

"[Allah] does not love the unbelievers." (Sura 3:32)

"[Allah] loves not the evil-doers." (Sura 3:57)

"[Allah] does not love arrogant and boastful men." (Sura 4:36)

1. What do these statements reveal about the god of Islam? __The god of Islam does not love sinners.__
 __Since everyone is a sinner, the god of Islam does not love man.__

2. What would you say to those who claim that Christians and Muslims worship the same God?
 __This statement denies the truth revealed about God in the Bible. God, unlike Allah, loves sinners.__

A Peaceful Religion?

There is a controversy today about whether or not Islam is a peaceful religion. While many Muslims are peace-loving people, the question about Islam's intentions must still be answered.

Note these statements taken from the Qur'an and answer the questions that follow.

"Fight for the sake of [Allah] those that fight against you. . . . Slay them wherever you catch them. . . . Fight against them until idolatry is no more and [Allah's] religion reigns supreme." (Sura 2:190–93)

"Believers, make war on the infidels who dwell around you. Deal firmly with them. Know that [Allah] is with the righteous." (Sura 9:123)

The Qur'an has special commands for dealing with those who stray from Islam:

"Prophet, make war on the unbelievers and the hypocrites [former Muslims] and deal rigorously with them. Hell shall be their home: an evil fate." (Sura 9:73)

The Koran. Trans. N. J. Dawood (London: Penguin Group, 1956). 41, 45, 47, 65, 29, 146, 141.

3. Do these statements support the claims that Islam is a peaceful religion? __No__

4. What do they reveal about Islam? __They reveal the fact that violence against "unbelievers" (non-Muslims) and__
 __"hypocrites" (those who have forsaken Islam) is supported and commanded in the Qur'an.__

Name _____

Shiite Versus Sunni

Read the following article and fill in the blanks from the information provided.

After Muhammad died in 632, Abu Bakr, an early follower of Muhammad, used military force to become the first caliph, or leader, of Islam. He expanded the empire during his brief reign before dying in 634. Islamic leaders then selected Umar, a skilled Muslim general, to serve as the second caliph. Under his leadership, Islamic forces quickly conquered territories to the north and west.

When Umar was killed by other Muslims in 644, Uthmann, another Muslim general, became the third caliph. However, the violence continued, and Uthmann died at the hands of his own troops in 656.

At this time Islam split into two groups. Uthmann's forces declared that Muhammad had intended Ali, Muhammad's cousin, to rule. Thus they rejected the rule of the first three caliphs. They took the title of Shiite ("follower") because they claimed to be the true followers of Muhammad. The Shiites insisted that the right of rule was limited to members of Muhammad's family. They also believed that their ruler should retain Muhammad's dual role of political and religious leader. The Shiites called this individual their imam ("leader").

The majority of Muslims, however, continued to support the established practice of appointing caliphs. They took the name Sunni ("adherent"). The Sunnis believed that any worthy Muslim could become the ruler of Islam. In addition, they divided leadership between a political leader (caliph) and a local religious leader (imam).

Following a civil war, the Sunni position remained the dominant position in the Muslim world (80–90%). Today the Shiites represent only about 10% of the growing Muslim population. Much Muslim-on-Muslim violence stems from this division between these two interpretations of Islam.

Issue	Shiite	Sunni
Meaning of name	_____Follower_____ (of Muhammad)	_____Adherent_____ (to the customary practice of appointing caliphs)
Successor to Muhammad	Muhammad's cousin _____Ali_____	_____Abu Bakr; caliph_____ appointed to lead
Successors	Members of _____Muhammad's_____ family or tribe	_____Any_____ _____worthy_____ Muslim
Political leader	Leader who holds political and religious authority (_____imam_____)	_____Caliph_____
Religious leader		_____Imam_____
Percentage of Muslims	_____10_____ %	_____80–90_____%

SKILL: Recognition, Comprehension

Map Study: Expansion of Islam

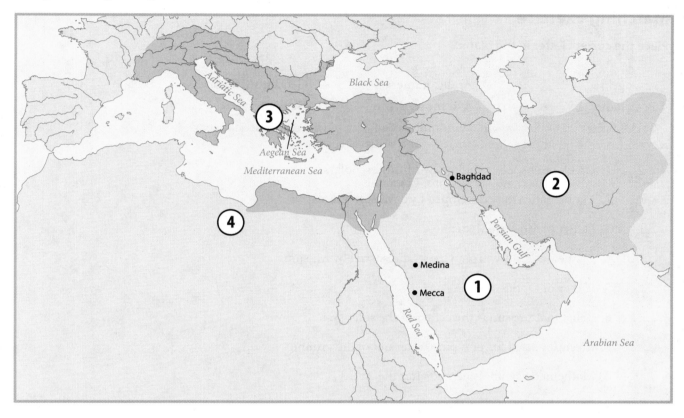

Locate the following on the map and place the number in the blank beside the term:

Arabian Peninsula 1

Byzantine Empire 3

Northern Africa 4

Sassanid Empire 2

Abbassid Contributions to Culture

Matching Exercise

Place the correct letter in the blank.

A. Algebra	D. Arabic numerals	G. Geocentric theory	J. Plato
B. Alhazen	E. Avicenna	H. Geometry	
C. Ali Baba	F. Windmill	I. Heliocentric theory	

J
p. 35 1. Greek philosopher studied by Muslim scholars

A
p. 34 2. Mathematic study developed by a Muslim scholar

E
p. 35 3. Father of Modern Medicine

H
p. 34 4. Mathematic study from Greeks, preserved by Muslims

B
p. 35 5. Father of Optics

I
p. 35 6. Belief that the sun is the center of the solar system

F
p. 36 7. Invention used for pumping water out of the ground

D
p. 34 8. Mathematic symbols named after the Arabs

G
p. 35 9. Belief that the earth is the center of the solar system

C
p. 35 10. Character in *Arabian Nights*

SKILL: Recognition, Comprehension

Chapter Review

Make the Statement Correct

Underline the word or phrase that makes the statement correct.

1. Muslims believe that Jesus was a (real/fictional) person. (p. 29)

2. Islam teaches that the (Bible/Qur'an) is the final revelation of God. (p. 28)

3. According to Islamic tradition, Muhammad received his visions from (Gabriel/Michael). (p. 26)

4. The Qur'an and the Hadith teach (warfare/dialogue) against those who reject Islam. (p. 29)

5. Islam first spread in the (Iberian/Arabian) Peninsula. (p. 27)

6. The Arabs defeated the (Sassanid/Byzantine) Empire in 637. (p. 33)

7. Islam teaches that the (Qur'an/Bible) contains errors and contradictions. (p. 28)

8. The Islamic Golden Age of learning and culture occurred during the (Umayyad/Abbassid) Caliphate. (p. 34)

9. Followers of Islam are (allowed/forbidden) to convert to another religion. (p. 34)

10. The Byzantine Empire used (Greek fire/boiling oil) as a secret weapon to defeat Islamic armies. (p. 37)

11. The (Russians/Franks) in western Europe stopped the spread of Islam in 732. (p. 38)

12. Muslims are required to make a pilgrimage to (Baghdad/Mecca). (p. 28)

13. (*Hegira*/*Caliph*) is derived from the Arabic word for "successor." (p. 27)

14. (Baghdad/Damascus) was the capital of the Umayyad dynasty. (p. 33)

15. The Ka'bah is located in (Medina/Mecca). (p. 31)

Teacher's Choice Teachers, to help the student better prepare for the chapter test, feel free to add questions about other topics you may have covered.

16. Question _____

17. Question _____

18. Question _____

19. Question _____

20. _____

CHAPTER REVIEW: Chapter 2 SKILL: Recognition, Comprehension

The Barozvi Creation Narrative

Use the blanks on the next page to write two paragraphs based on the following story. The first paragraph should note the similarities between the Barozvi creation story and the Genesis account of Creation. The second paragraph should note the differences between the accounts.

In the beginning Nyambi made all things. He made animals, fish, birds. At that time he lived on earth with his wife, Nasilele. One of Nyambi's creatures was different from all the others. His name was Kamonu [man]. Kamonu imitated Nyambi in everything Nyambi did. When Nyambi worked in wood, Kamonu worked in wood; when Nyambi forged iron, Kamonu forged iron.

After a while Nyambi began to fear Kamonu.

Then one day Kamonu forged a spear and killed a male antelope, and he went on killing. Nyambi grew very angry at this.

"Man, you are acting badly," he said to Kamonu. "These are your brothers. Do not kill them."

Nyambi drove Kamonu out into another land. But after a while Kamonu returned. Nyambi allowed him to stay and gave him a garden to cultivate.

It happened that at night buffaloes wandered into Kamonu's garden and he speared them; after that, some [antelopes], and he killed one. After some time Kamonu's dog died; then his pot broke; then his child died. When Kamonu went to Nyambi to tell him what had happened he found his dog and his pot and his child at Nyambi's.

Then Kamonu said to Nyambi, "Give me medicine so that I may keep my things." But Nyambi refused to give him medicine. After this, Nyambi met with his two counselors and said, "How shall we live since Kamonu knows too well the road hither?"

Nyambi tried various means to flee Kamonu. He removed himself and his court to an island across the river. But Kamonu made a raft of reeds and crossed over to Nyambi's island. Then Nyambi piled up a huge mountain and went to live on its peak. Still Nyambi could not get away from man. Kamonu found his way to him. In the meantime men were multiplying and spreading all over the earth.

Finally Nyambi sent birds to go look for a place for Litoma, god's town. But the birds failed to find a place. Nyambi sought counsel from a diviner. The diviner said, "Your life depends on Spider." And Spider went and found an abode for Nyambi and his court in the sky. Then Spider spun a thread from earth to the sky and Nyambi climbed up on the thread. Then the diviner advised Nyambi to put out Spider's eyes so that he could never see the way to heaven again and Nyambi did so.

After Nyambi disappeared into the sky Kamonu gathered some men around him and said, "Let us build a high tower and climb up to Nyambi." They cut down trees and put log on log, higher and higher toward the sky. But the weight was too great and the tower collapsed. So that Kamonu never found his way to Nyambi's home.

But every morning when the sun appeared, Kamonu greeted it, saying, "Here is our king. He has come." And all the other people greeted him shouting and clapping. . . .

"Barozvi Creation Narrative" from *African Intellectual Heritage* edited by Abu S. Abarry and Molefi Kete Asante. Used by permission of Temple University Press. © 1996 by Temple University. All Rights Reserved.

Similarities

Answers will vary but some of the following should be included: As Nyambi "made all things," so God created all things (Gen. 1:1). Both accounts teach that man has unique characteristics from the rest of creation (1:26). They both mention a man's taking care of a garden (1:28–30; 2:15) and attempting to reach God by making a tower to heaven (11:1–9). Each account mentions a growth in population (1:28).

Differences

Answers will vary but some of the following should be included: Nyambi does manual labor on earth, but God made man to do this work (Gen. 1:26). Nyambi fears man, but God does not fear man; rather, man fears God because he has sinned against Him (3:7–10). The Barozvi narrative portrays Nyambi as an equal to man by their doing the same work and by Nyambi's difficulty in running away from man, but God is above man and rules over him (1:1, 26). Nyambi consults a diviner, a person who practices witchcraft, for advice, but God goes to no one for advice; His counsel is only from Himself (1:26; 3:22). Nyambi flees man, but, actually, man flees God (3:8). Nyambi tells man not to kill animals because they are his brothers, but God created man distinct from the animals and told Adam and Eve not to eat the fruit of a certain tree (2:7, 16–17). Nyambi has a wife, but it was Adam (not God) who had a wife (2:21–25).

SKILL: Comprehension, Original Sources

The Yoruba Creation Narrative

Answer the questions following this excerpt from the Yoruba creation narrative.

Obatala [a lesser god under the main god] lived on, with only his black cat for a companion. He thought, "Surely it would be better if many people were living here." He decided to create people. He dug clay from the ground, and out of the clay he shaped human figures which he then laid out to dry in the sun. He worked without resting. He became tired and thirsty. He said to himself, "There should be palm wine in this place to help a person go on working." So he put aside the making of humans and went to the palm trees to draw their inner fluid, out of which he made palm wine. When it was fermented he drank. He drank for a long while. When he felt everything around him softening he put aside his gourd cup and went back to modeling human figures. But because Obatala had drunk so much wine his fingers grew clumsy, and some of the figures were misshapen. Some had crooked backs or crooked legs, or arms that were too short. Some did not have enough fingers, some were bent instead of being straight. Because of the palm wine inside him, Obatala did not notice these things. And when he had made enough figures to begin the populating of Ife [earth] he called out to Olorun the Sky God [the main god], saying, "I have made human beings to live with me here in Ife, but only you can give them the breath of life." Olorun heard Obatala's request, and he put breath in the clay figures. They were no longer clay, but people of blood, sinews, and flesh. They arose and began to do the things that humans do. They built houses for themselves near Obatala's house, and in this way the place Obatala named Ife became the city of Ife.

But when the effects of the palm wine had worn off Obatala saw that some of the humans he had made were misshapen, and remorse filled his heart. He said: "Never again will I drink palm wine. From this time on I will be the special protector of all humans who have deformed limbs or who have otherwise been created imperfectly." Because of Obatala's pledge, humans who later came to serve him also avoided palm wine, and the lame, the blind and those who had no pigment in their skin invoked his help when they were in need.

"The Yoruba Creation Narrative" from *African Intellectual Heritage* edited by Abu S. Abarry and Molefi Kete Asante. Used by permission of Temple University Press. © 1996 by Temple University. All Rights Reserved.

1. List two similarities between this creation account and that found in the book of Genesis.

 Both God and Obatala create man.

 Both God and Obatala form man from the ground.

2. List four differences between this account and the Genesis account.

 Any four of the following:

 Obatala makes many clay figures (rather than one man and one woman).

 Obatala becomes tired and thirsty.

 Obatala drinks palm wine and becomes drunk.

 Obatala makes misshapen people.

 Obatala needs the sky god Olorun to breathe life into the clay figures.

3. In passing down this story, what negative things did the Yoruba admit about their god? (You should be able to find at least three things.) _____

He was not omnipotent. (He needed the help of the sky god to breathe life into his clay figures.)

He made mistakes.

He drank wine and got drunk.

SKILL: Comprehension, Original Sources

Map Study: Africa

Africa

Locate the following on the maps and place the number in the blank beside the term:

Term	
Ethiopia	5
Timbuktu	6
Sahara	1
Nile River	2
Atlantic Ocean	4
Indian Ocean	3
Savannah	8
Sahel	7

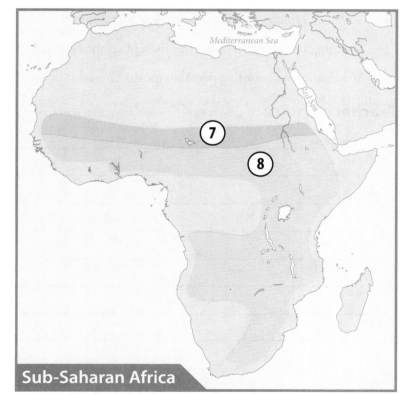

Sub-Saharan Africa

Chapter Review
Make the Statement Correct

Underline the word or phrase that makes the statement correct.

1. The (savannah/Sahel) is a large area of flat grasslands. **(p. 44)**

2. African empires built advanced cities as the (Renaissance/Dark Ages) occurred in Europe. **(p. 41)**

3. Africans grew yams in the (desert/tropical forests). **(p. 44)**

4. The production of (iron/silk) probably developed independently in Africa. **(p. 46)**

5. The (Kikuyu/Bantu) clan believes in one god. **(p. 47)**

6. Coptics believe that the cathedral at Aksum contains the (ark of the covenant/Ten Commandments). **(p. 48)**

7. A number of unusual churches at Lalibela were made by carving into rock (above/below) ground level. **(p. 49)**

8. The rulers of Ghana eventually became (Coptic Christians/Muslims) by the eleventh century. **(p. 50)**

9. African towns traded with merchants from (India/South America). **(pp. 53–54)**

10. "The Conquering Lion of the Tribe of Judah" was the title of the leader of (Ethiopia/Mali). **(p. 48)**

11. Coptic teaching regards Menelik as the offspring of King (David/Solomon). **(p. 48)**

12. The first written history of Africa was penned by (Muslims/the Portuguese). **(pp. 52–53)**

13. (*Cathay*/*Cambay*) was an ancient name for China. **(p. 54)**

14. The kingdom of (Mali/Kush) was located on the Nile River between Egypt and Ethiopia. **(p. 48)**

15. Africans forged (iron/copper) into tools and used it as a form of money. **(p. 46)**

Teacher's Choice
Teachers, to help the student better prepare for the chapter test, feel free to add questions about other topics you may have covered.

16. _Question_ _____

17. _Question_ _____

18. _Question_ _____

19. _Question_ _____

20. _Question_ _____

SKILL: Recognition, Comprehension

Marco Polo's Journals

Answer the questions at the end based on the following excerpts from Marco Polo's writings about these three regions:

[Samarkand] is a noble city, adorned with beautiful gardens, and surrounded by a plain, in which are produced all the fruits that man can desire. The inhabitants, who are partly Christians and partly Mahometans [Muslims], are subject to the dominion of a nephew of the grand khan, with whom, however, he is not upon amicable terms, but on the contrary there is perpetual strife and frequent wars between them. This city lies in the direction of [the] north-west. . . .

In [the] province (of Tenduk) was the principal seat of government of the sovereigns [called] Prester John, when they ruled over the Tartars [Mongols] of this and the neighbouring countries, and which their successors occupy to the present hour. . . . There are two regions in which they exercise dominion. These in our part of the world are named Gog and Magog, but by the natives Ung and Mongul; in each of which there is a distinct race of people. In Ung they are Gog, and in Mongul they are Tartars. Travelling seven days through this province, in an easterly direction, towards Cathay [China], you pass many towns inhabited by idolaters, as well as by Mahometans and Nestorian Christians. They gain their living by trade and manufactures, weaving fine-gold tissues, ornamented with mother-of-pearl, named *nascici*, and silks of different textures and colours, not unlike those of Europe; together with a variety of woollen cloths. These people are all subjects of the grand khan. One of the towns, named Sindichin, is celebrated for the manufacture of all kinds of arms, and every article necessary for the equipment of troops. In the mountainous part of the province there is a place called Idifa, in which is a rich mine of silver, from whence large quantities of that metal are obtained. There are also plenty of birds and beasts. . . .

[Kublai Khan] usually resides during three months of the year, namely, December, January, and February, in the great city of Kanbalu, situated towards the north-eastern extremity of the province of [China]; and here, on the southern side of the new city, is the site of his vast palace, the form and dimensions of which are as follows. In the first place is a square enclosed with a wall and deep ditch; each side of the square being eight miles in length, and having at an equal distance from each extremity an entrance-gate, for the concourse of people resorting thither from all quarters. . . . [T]he bridles, saddles, stirrups, and other furniture serving for the equipment of cavalry, occupy one storehouse; the bows, strings, quivers, arrows, and other articles belonging to archery, occupy another; cuirasses, corselets, and other armour formed of leather, a third storehouse; and so of the rest. Within this walled enclosure there is still another, of great thickness, and its height is full twenty-five feet. The battlements or crenated parapets are all white. This also forms a square four miles in extent, each side being one mile, and it has six gates, disposed like those of the former enclosure. It contains in like manner eight large buildings. . . . The spaces between the one wall and the other are ornamented with many handsome trees, and contain meadows in which are kept various kinds of beasts, such as stags, the animals that yield the musk, roe-bucks, fallow-deer, and others of the same class. Every interval between the walls, not occupied by buildings, is stocked in this manner. The pastures have abundant herbage. . . . The palace contains a number of separate chambers, all highly beautiful, and so admirably disposed that it seems impossible to suggest any improvement to the system of their arrangement. The exterior of the roof is adorned with a variety of colours, red, green, azure, and violet,

and the sort of covering is so strong as to last for many years. The glazing of the windows is so well wrought and so delicate as to have the transparency of crystal. In the rear of the body of the palace there are large buildings containing several apartments, where is deposited the private property of the monarch, or his treasure in gold and silver bullion, precious stones, and pearls, and also his vessels of gold and silver plate.

Marco Polo. *The Travels of Marco Polo*. Trans. William Marsden. Ed. William Marsden and Thomas Wright (London: J. M. Dent, 1946). 93–94, 141–42, 166–69.

1. What important town did Marco Polo visit that he describes as being "surrounded by a plain, in which are produced all the fruits that man can desire"? _Samarkand_____

2. What religious groups did Polo find in this town? _Both Muslims and Christians lived in this town._____
 _(Religious tolerance is implied during this period.)_____

3. In what town did Polo find "every article necessary for the equipment of troops"? _Sindichin_____

4. Besides riches, what objects are located at the Khan's palace? What characteristics of the Mongols do these objects suggest? _"Bridles, saddles, stirrups, and other furniture serving for the equipment of cavalry"; archery_
 equipment and armor. The Mongols were a warring people who relied on their powerful cavalry (horse riders) for
 _victory in conquest._____

5. Using Polo's words, describe Kublai Khan's palace. _Answers may vary. "The exterior of the roof is adorned with a_
 variety of colours, red, green, azure, and violet," and the palace contains "gold and silver bullion, precious stones,
 _and pearls, and . . . vessels of gold and silver plate."_____

6. Imagine that you are living in Europe during Polo's time period. From reading Polo's accounts, how would you picture China? _Answers will vary but might include the following: colorful, wealthy, and luxurious._____

SKILL: Comprehension, Original Sources

Matching Exercise

Place the correct letter in the blank.

Japan

A. Method of suicide

B. Established a new line of rulers in 1192

C. Religion that stresses worship of nature and the emperor

D. Period characterized by loyalty to a local ruler

E. Unwritten military code

F. Dominant clan in the 700s

G. Central leader of Japan ("great general")

H. Member of the warrior class

I. Religion that stresses intense mental concentration

J. Transition from local rule to a central ruler

K. Japan's capital beginning in 1192

L. Dominant clan that moved the capital to Tokyo in 1603

M. Dominant clan in 1336 during the second feudal period

N. Another name for the city of Edo

__M__ p. 65	1.	Ashikaga
__E__ p. 66	2.	Bushido
__D__ p. 65	3.	Feudalism
__F__ p. 65	4.	Fujiwara
__A__ p. 66	5.	Hara-kiri
__K__ p. 65	6.	Kamakura
__H__ p. 66	7.	Samurai
__C__ p. 66	8.	Shintoism
__G__ p. 65	9.	Shogun
__J__ p. 65	10.	Taika
__L__ p. 65	11.	Tokugawa
__N__ p. 65	12.	Tokyo
__B__ p. 65	13.	Yoritomo
__I__ p. 66	14.	Zen Buddhism

Matching Exercise, cont.
Southeast Asia

A. Dai Viet	D. Land influenced by India and China
B. Champa	E. Gained control of Champa in 1471
C. Land that forms the western border of the South China Sea	F. Ancient name for Cambodia

__C__ 15. Vietnam
p. 66

__D__ 16. Cambodia
p. 67

__A__ 17. Northern kingdom
p. 66

__B__ 18. Central and southern kingdom
p. 66

__F__ 19. Angkor
p. 67

__E__ 20. Dai Viet
p. 66

SKILL: Recognition, Comprehension

Mongol Invasion of Japan

Answer the questions at the end based on the following excerpts from Marco Polo's writings:

Zipangu [Japan] is an island in the eastern ocean, situated at the distance of about fifteen hundred miles from the mainland, or coast of Manji [China]. It is of considerable size; its inhabitants have fair complexions, are well made, and are civilized in their manners. Their religion is the worship of idols. They are independent of every foreign power, and governed only by their own kings. They have gold in the greatest abundance, its sources being inexhaustible, but as the king does not allow of its being exported, few merchants visit the country, nor is it frequented by much shipping from other parts. To this circumstance we are to attribute the extraordinary richness of the sovereign's palace, according to what we are told by those who have access to the place. The entire roof is covered with a plating of gold, in the same manner as we cover houses, or more properly churches, with lead. The ceilings of the halls are of the same precious metal; many of the apartments have small tables of pure gold, of considerable thickness; and the windows also have golden ornaments. So vast, indeed, are the riches of the palace, that it is impossible to convey an idea of them. In this island there are pearls also, in large quantities, of a red (pink) colour, round in shape, and of great size, equal in value to, or even exceeding that of the white pearls. . . . There are also found there a number of precious stones.

Of so great celebrity was the wealth of this island, that a desire was excited in the breast of the grand khan Kublaï, now reigning, to make the conquest of it, and to annex it to his dominions. In order to effect this, he fitted out a numerous fleet, and embarked a large body of troops, under the command of two of his principal officers, one of whom was named Abbacatan, and the other Vonsancin. The expedition sailed from the ports of Zai-tun and Kin-sai, and, crossing the intermediate sea, reached the island in safety; but in consequence of a jealousy that arose between the two commanders, one of whom treated the plans of the other with contempt and resisted the execution of his orders, they were unable to gain possession of any city or fortified place, with the exception of one only, which was [taken] by assault, the garrison having refused to surrender. . . . It happened, after some time, that a north wind began to blow with great force, and the ships of the Tartars [Mongols], which lay near the shore of the island, were driven foul of each other. It was determined thereupon, in a council of the officers on board, that they ought to disengage themselves from the land; and accordingly, as soon as the troops were re-embarked, they stood out to sea. The gale, however, increased to so violent a degree that a number of the vessels foundered. The people belonging to them, by floating upon pieces of the wreck, saved themselves upon an island lying about four miles from the coast of Zipangu.

The other ships . . . directed their course homewards, and returned to the grand khan. Those of the Tartars who remained upon the island where they were wrecked, and who amounted to about thirty thousand men, finding themselves left without shipping, abandoned by their leaders, and having neither arms nor provisions, expected nothing less than to become captives or to perish; especially as the island afforded no habitations where they could take shelter and refresh themselves.

As soon as the gale ceased and the sea became smooth and calm, the people from the main island of Zipangu came over with a large force, in numerous boats, in order to make prisoners of these shipwrecked Tartars, and having landed, proceeded in search of them, but in a straggling, disorderly manner. The Tartars, on their part, acted with prudent circumspection [caution], and, being concealed from view by

some high land in the centre of the island, whilst the enemy were hurrying in pursuit of them by one road, made a circuit of the coast by another, which brought them to the place where the fleet of boats was at anchor. Finding these all abandoned, but with their colours flying, they instantly seized them and pushing off from the island, [sailed] for the principal city of Zipangu, into which, from the appearance of the colours, they were suffered to enter unmolested. Here they found few of the inhabitants besides women, whom they retained for their own use, and drove out all others. When the king was apprised of what had taken place, he was much afflicted, and immediately gave directions for a strict blockade of the city, which was so effectual that not any person was suffered to enter or to escape from it, during six months that the siege continued. At the expiration of this time, the Tartars, despairing of succour, surrendered upon the condition of their lives being spared. These events took place in the course of the year 12[8]4.

Marco Polo. *The Travels of Marco Polo.* Trans. William Marsden. Ed. William Marsden and Thomas Wright (London: J. M. Dent, 1946). 323–27.

1. How does Marco Polo describe Japanese religion? _Idol worship_____

2. How does Polo describe the Japanese in appearance and manners? _"Fair complexions," "well made," and_ _"civilized in . . . manners"_____

3. According to Polo, what did the Japanese have in abundance? _Gold and pearls_____

4. What do you conclude from the following remark by Polo: ". . . according to what we are told by those who have access to the place"? _He has never been to the palace. He is writing based on what others have told him._____

5. How do you think a European in the Middle Ages would react after reading about Japan? _Answers will vary. Europeans may have become excited at the thought of Eastern riches._____

6. Why did Kublai Khan want to conquer Japan? _Because he believed it to have great wealth_____

7. Why were the Tartars (Mongols) forced to surrender? _Because of a blockade on the city_____

SKILL: Comprehension, Original Sources

Chapter Review
Make the Statement Correct

Underline the word or phrase that makes the statement correct.

1. A samurai was a (Chinese/<u>Japanese</u>) warrior. (p. 66)

2. (Batu/<u>Chinggis</u>) Khan controlled an empire that included China and Russia. (pp. 68–69)

3. The (<u>Shang</u>/Ming) dynasty was the earliest known dynasty in China. (p. 60)

4. (<u>China</u>/Japan) carried on extensive trade with other nations. (p. 64)

5. The (Mongols/<u>Chinese</u>) developed the production of silk. (p. 62)

6. (Merchants/<u>Scholars</u>) were highly regarded in China. (p. 64)

7. The Japanese borrowed (Hinduism/<u>Buddhism</u>) from China. (p. 66)

8. (<u>Merchants</u>/Scholars) were considered dangerous in China because of their wealth and mobility. (p. 64)

9. Siege warfare was used effectively by the (Japanese/<u>Mongols</u>) in battle. (p. 69)

10. The "Golden Horde" received their name because of their (homes/<u>armor</u>). (p. 71)

11. (Japanese/<u>Mongol</u>) soldiers lived on their horses and even slept on them during marches. (p. 69)

12. (Batu Khan/<u>Tamerlane</u>) demonstrated great brutality and built an empire that collapsed shortly after his death. (p. 73)

13. Chinggis Khan invaded (<u>northern</u>/southern) China. (p. 69)

14. (China/<u>Japan</u>) successfully repelled two Mongol invasions. (p. 70)

15. Cast iron was developed by the (Mongols/<u>Chinese</u>). (p. 63)

16. China was the first nation to use (iron/<u>paper</u>) as a form of money. (p. 62)

Teacher's Choice
Teachers, to help the student better prepare for the chapter test, feel free to add questions about other topics you may have covered.

17. Question _____

18. Question _____

19. Question _____

20. <u>Question</u> _____

SKILL: Recognition, Comprehension

Name _____

The Anglo-Saxon Chronicle

Answer the questions at the end based on the excerpts below.

A.D. 1066

This year came King Harold from York to Westminster, on the Easter [after] the midwinter when the king (Edward) died. Easter was then on the sixteenth day [of April]. Then was over all England such a token seen as no man ever saw before. Some men said that it was the comet-star, which others [call] the long-hair'd star. It appeared first on the eve called "Litania major [Great Litany]", that is, on [April 24]; and so shone all the week. Soon after this came in Earl Tosty from beyond [the] sea into the Isle of Wight, with as large a fleet as he could get; and he was there supplied with money and provisions. Thence he proceeded, and committed outrages every-where by the sea-coast where he could land, until he came to Sandwich. When it was told King Harold, who was in London, that his brother Tosty was come to Sandwich, he gathered so large a force, naval and military, as no king before collected in this land; for it was credibly reported that Earl William from Normandy, King Edward's cousin, would come hither and gain this land; just as it afterwards happened. When Tosty understood that King Harold was on the way to Sandwich, he departed thence, and took some of the boatmen with him, willing and unwilling, and went north into the Humber . . . ; whence he plundered in Lindsey, and there slew many good men. When the Earls Edwin and Morkar understood that, they came hither, and drove him from the land. . . .

Then . . . went [Harald], King of Norway, and Earl Tosty into York with as many followers as they thought fit; and having procured hostages and provisions from the city, they proceeded to their ships, and proclaimed full friendship, on condition that all would go southward with them, and gain this land. In the midst of this came Harold, king of the English, with all his army, on the Sunday, to Tadcaster; where he collected his fleet. Thence he proceeded on Monday throughout York. But Harald, King of Norway, and Earl Tosty, with their forces, were gone from their ships be-yond York to Stanfordbridge; for that it was given them to understand, that hostages would be brought to them there from all the shire. Thither came Harold, king of the English, [and ambushed] them beyond the bridge; and they closed together there, and continued long in the day fighting very severely. There was slain Harald the Fair-hair'd, King of Norway, and Earl Tosty, and a multitude of people with them, both of Normans and English; and the Normans that were left fled from the English, who slew them hotly behind; until some came to their ships, some were drowned, some burned to death, and thus variously destroyed; so that there was little left: and the English gained possession of the field. . . .

. . . William the earl landed at Hastings, on St. Michael's-day: and Harold came from the north, and fought against [William] before all his army had come up: and there [Harold] fell, and his two brothers, Girth and Leofwin; and William subdued this land. And he came to Westminster, and Archbishop Aldred consecrated him king, and men paid him tribute, [gave] him hostages, and afterwards bought their land.

http://avalon.law.yale.edu/medieval/ang11.asp

1. List three English towns that this chronicle mentions. (This shows that they were founded before 1066.)

 Three of the following: York, Westminster, Tadcaster, London, Sandwich, Hastings, Lindsey, and Stanfordbridge

2. King Harold came to Westminster around the time of what religious day? _Easter_

3. What "token" did the English see in the sky? How did the chronicler and the English describe it? _____

 A comet; the "comet-star" and a "long-hair'd star"

4. Who was the ruler of England before the Norman invasion? _Harold_

5. Where did King Harold and his two brothers fall (in death)? _Hastings_

6. At what town was William the Conqueror crowned king? _Westminster_

7. Who consecrated William as the new king of England? _Archbishop Aldred_

8. What did the English bring to William after he became their king? _Tribute and hostages_

9. What did the English buy from William after he became their king? _Their land_

SKILL: Comprehension, Original Sources

The Canterbury Tales

(Excerpt from *The General Prologue*)

Answer the questions at the end based on the following excerpts from Chaucer's work:

With him there rode a gentle pardoner*
Of Rouncival, his friend and his compeer;*
Straight from the court of Rome had journeyed he.
Loudly he sang Come hither, love, to me,
The summoner joining with a burden round;*
[There] never [was a] horn of half so great a sound.
This pardoner had hair as yellow as wax,
But lank* it hung as does a strike* of flax;
In wisps hung down such locks . . . on [his] head,
And with them he his shoulders overspread;
But thin they dropped, and stringy, one by one.
But as to hood, for sport of it, [he'd wear] none,
Though it was packed in [his] wallet all the while.
It seemed to him he went in latest style,
Dishevelled, save for cap, his head all bare.
As shiny eyes he had as has a hare.
He had a fine veronica* sewed to [his] cap.
His wallet lay before him in his lap,
Stuffed full of pardons brought from Rome all hot.
A voice he had that bleated like a goat.

But in his craft, from Berwick unto Ware,
Was no such [other] pardoner in any place.
For in his bag he had a pillowcase
The which, he said, was Our True Lady's veil:
He said he had a piece of the very sail
That good Saint Peter had, what time he went
Upon the sea, till Jesus changed his bent.
He had a latten* cross set full of stones,
And in a bottle had he some pig's bones.
But with these relics, when he came upon
Some simple parson, then this paragon*
In that one day more money stood to gain
Than the poor dupe* in two months could attain.
And thus, with flattery and suchlike japes,*
He made the parson and the rest his apes.*
But yet, to tell the whole truth at the last,
He was, in church, a fine ecclesiast.

pardoner: a person who sells indulgences and other items to raise money for the Roman Church
compeer: companion

burden round: strong bass voice

lank: straight, flat / *strike*: strip

veronica: According to Catholic tradition, Veronica wiped the face of Christ, and an image of His face remained on the cloth.

latten: thin, brass-like metal

this paragon: the Pardoner

the . . . dupe: the parson

japes: tricks

apes: fools

Well could he read a lesson or a story,
But best of all he sang an offertory;
For well he knew that when that song was sung,
Then might he preach, and all with polished tongue.
To win some silver, as he right well could;
Therefore he sang so merrily and so loud.

www.canterburytales.org

1. From where did the Pardoner come (or claim to have come)? __Rome__

2. What objects does he carry in a bottle? __Pig's bones__

3. What other "holy relics" does he bring with him? __A veil belonging to Our True Lady (Mary), a piece of a sail__ __belonging to Peter, and a cross__

4. When he comes to a village, whom does he trick and make like fools? __The parson and "the rest"—those who__ __attend the parson's church__

5. According to the end of the passage, what is the Pardoner's motive for preaching in a village church? __"To win some silver"__

SKILL: Comprehension, Original Sources

Romanesque and Gothic Architecture

Locate the following on the drawings and place the number in the blank beside the term:

Rounded vaults _4_

Romanesque building _3_

Gothic building _1_

Flying buttresses _2_

Matching Exercise

Place the correct letter in the blank.

A. Gothic B. Romanesque

B 1. Thick walls _A_ 5. Warm and bright

A 2. Stained-glass windows _B_ 6. Based on the Roman style

B 3. Dark and cold _A_ 7. Light and airy

A 4. Thin walls

Chapter Review
Make the Statement Correct
Underline the word or phrase that makes the statement correct.

1. (Castles/<u>Towns</u>) grew along trade routes. (p. 82)

2. Europe experienced a warm period that resulted in the growth of (<u>more</u>/less) crops. (p. 82)

3. (<u>Venice</u>/Paris) developed a city-state with a republican form of government. (pp. 85–86)

4. The Crusades (succeeded/<u>failed</u>) in freeing the Holy Land. (p. 86)

5. Chaucer was an (<u>English</u>/Italian) poet. (p. 92)

6. The English used (heavy armor/<u>longbows</u>) to defeat the French in battle. (p. 93)

7. (Romanesque/<u>Gothic</u>) architecture used flying buttresses and stained-glass windows. (p. 92)

8. Bankers issued (interdicts/<u>letters of credit</u>) to traveling merchants. (p. 89)

9. The Roman Church lost credibility when it could not stop the (<u>Black Death</u>/Hundred Years' War). (p. 94)

10. The Knights Templar protected traveling (bankers/<u>pilgrims</u>). (p. 89)

11. (<u>William the Conqueror</u>/Hugh Capet) conquered England and established a new dynasty. (p. 83)

12. Henry II strengthened royal authority in (<u>England</u>/France). (p. 83)

13. (<u>Romanesque</u>/Gothic) architecture was described as dark and cold. (p. 92)

14. The medieval papacy reached its peak under Pope (Gregory VII/<u>Innocent III</u>). (p. 81)

15. The *Reconquista* occurred in (France/<u>Spain</u>). (p. 89)

16. Writing in the common spoken language of the people is known as (<u>*vernacular*</u>/*chivalry*). (p. 92)

Teacher's Choice
Teachers, to help the student better prepare for the chapter test, feel free to add questions about other topics you may have covered.

17. Question _____

18. Question _____

19. Question _____

20. Question _____

SKILL: Recognition, Comprehension

Utopia

Answer the questions below based on the following excerpts from Sir Thomas More's work:

[*On proper punishment*]

I answered, "It seems to me a very unjust thing to take away a man's life for [stealing] a little money, for nothing in the world can be of equal value with a man's life: and if it be said, 'that it is not for the money that one suffers, but for his breaking the law,' I must say, extreme justice is an extreme injury: for we ought not to approve of those terrible laws that make the smallest offences capital, nor of that opinion of the Stoics that makes all crimes equal; as if there were no difference to be made between the killing [of] a man and the taking [of] his purse, between which, if we examine things impartially, there is no likeness nor proportion. God has commanded us not to kill, and shall we kill so easily for a little money? . . . [Since God has] taken from us the right of disposing either of our own or of other people's lives, if it is pretended that the mutual consent of men in making laws can [authorize] manslaughter in cases in which God has given us no example, that it frees people from the obligation of the divine law, and so makes murder a lawful action, what is this, but to give a preference to human laws before the divine? and, if this is once admitted, by the same rule men may, in all other things, put what restrictions they please upon the laws of God."

The Utopia by Sir Thomas More. Public Domain.

1. According to More, what crime should not be punishable by death? _Stealing someone's money_ _____

2. Why is the death penalty too harsh for this crime? _The life of a man is worth more than all the riches in the_ _world. God's law does not require the death penalty for stealing._ _____

3. Does More believe that man has the right to kill himself or anyone else? _No_ _____

[*On the limited rights of kings*]

Now what if, after all these propositions were made, I should rise up and assert that such counsels were both unbecoming a king and [harmful] to him; and that not only his honour, but his safety, consisted more in his people's wealth than in his own; if I should show that they choose a king for their own sake, and not for his; that, by his care and endeavours, they may be both easy and safe; and that, therefore, a prince ought to take more care of his people's happiness than of his own, as a shepherd is to take more care of his flock than of himself? It is also certain that they are much mistaken that think the poverty of a nation is a mean of the public safety. Who quarrel more than beggars? who does more earnestly long for a change than he that is uneasy in his present circumstances? and who run to create confusions with so desperate a boldness as those who, having nothing to lose, hope to gain by them? If a king should fall under such contempt or envy that he could . . . [only] keep his subjects in their duty . . . by oppression and ill usage, and by rendering them poor and miserable, it were certainly better for him to quit his kingdom than to retain it by . . . methods [that] make him, while he keeps the name of authority, lose the majesty due to it. Nor is it so becoming the dignity of a king to reign over beggars as over rich and happy subjects. And therefore Fabricius, a man of a noble and exalted

temper, said "he would rather govern rich men than be rich himself; since for one man to abound in wealth and pleasure when all about him are mourning and groaning, is to be a [jailer] and not a king." He is an [unskillful] physician that cannot cure one disease without casting his patient into another. So he that can find no other way for correcting the errors of his people but by taking from them the conveniences of life, shows that he knows not what it is to govern a free nation. He himself ought rather to shake off his sloth, or to lay down his pride, for the contempt or hatred that his people have for him takes its rise from the vices in himself. Let him live upon what belongs to him without wronging others, and accommodate his expense to his revenue. Let him punish crimes, and, by his wise conduct, let him endeavour to prevent them, rather than be severe when he has [allowed] them to be too common.

The Utopia by Sir Thomas More. Public Domain.

4. More compares the kingship to what three other jobs? Shepherd, jailer, and physician

5. What does More say is the danger of having poor subjects? They quarrel, want change, are willing to rebel,

and have nothing to lose or risk by rebelling.

6. Does More think that it is dangerous for a king to have rich subjects? No

SKILL: Comprehension, Original Sources

Erasmus and Access to Scripture

Answer the questions below based on the following excerpt from the introduction of Erasmus's Greek New Testament:

I strongly dissent from those who are unwilling to have the Scriptures translated into the vernacular and read by the ignorant, as if Christ taught so complicated a doctrine that it can hardly be understood even by a handful of theologians or as if the [mystery] of the Christian religion consisted in its not being known. It is perhaps reasonable to conceal the mysteries of kings, but Christ seeks to divulge his mysteries as much as possible. I should like to have even the most humble women read [the four Gospels] and the Epistles of St. Paul. . . . Would that the plowboy recited something from them at his plowshare, that the weaver sang from them at his shuttle and that the traveler [wiled] away the tedium of his journey with their tales. . . .

To me he is truly a theologian who teaches not with [logic] and [difficult] arguments but . . . who teaches indeed by the example of his own life that riches are to be despised, that the Christian man must not put his faith in the defenses of this world but depend entirely on Heaven . . . [and] that all good men ought to love and cherish each other. . . . If anyone inspired by the spirit of Christ preaches things of this kind . . . then he is a true theologian even if he should be a ditch digger.

Desiderius Erasmus. "The Philosophy of Christ." *The Renaissance: Maker of Modern Man.* Ed. Kenneth M. Setton (Washington: National Geographic Society, 1970). 300–301.

1. How does Erasmus respond to those who opposed the translation of Scripture? He strongly disagrees: the Scriptures are meant to be read and understood by everyone.

2. What does Erasmus imply that the Roman Church teaches about Scripture? That "Christ taught so complicated a doctrine that it can hardly be understood even by a handful of theologians"

3. According to Erasmus, who should be allowed to read the Scriptures? Women, plowboys, weavers, travelers, and ditch diggers

4. What does Erasmus define as a true theologian? He who teaches "by the example of his own life that riches are to be despised, that the Christian man must not put his faith in the defenses of this world but depend entirely on Heaven . . . [and] that all good men ought to love and cherish each other"

5. According to Erasmus, does one have to be extremely educated to be a theologian? Why or why not?
No; anyone (even a ditch digger) "inspired by the spirit of Christ" who "preaches things of this kind" can be a theologian.

"Why Monks Are Shunned"

Answer the questions at the end based on the following excerpt from François Rabelais' work:

"There is nothing truer than that the robe and cowl [clothing worn by monks] draw down upon themselves all sorts of hard feelings, insults, and curses on the part of everybody. . . . The chief reason is that monks feed on . . . human sins, and . . . they are always being driven back . . . to their convents and abbeys, which are isolated from polite intercourse as are the privies of a house. But if you can understand why it is that a pet monkey in a household is always teased and tormented, then you ought to be able to understand why it is that monks are shunned. . . . The monkey does not watch the house, like a dog; he does not haul a cart like the ox; he produces neither milk like the cow nor wool like the sheep; he does not carry burdens like the horse. . . .

"Similarly, a monk—I mean the lazy ones—does not labor, like the peasant; he does not guard the country like the soldier; he does not cure the sick like the doctor; he does not preach to nor teach the world like a good evangelic doctor and pedagogue [schoolmaster]; he does not bring in commodities and public necessities like the merchant. And that is the reason why they are all jeered at and [hated]."

"But . . . don't they pray [to] God for us?"

"They do nothing of the kind," said Gargantua.

"All they do is keep the whole neighborhood awake by jangling their bells."

François Rabelais. "Why Monks Are Shunned." *The Renaissance: Maker of Modern Man.* Ed. Kenneth M. Setton (Washington: National Geographic Society, 1970). 302.

1. What two articles of the monks' clothing attracted "hard feelings [and] insults"? The robe and cowl _____

2. According to Rabelais, on what do monks feed? Human sins _____

3. To what animal does Rabelais compare late medieval monks? A monkey _____

4. What kinds of workers does Rabelais describe as contributors to society? Peasants who work, soldiers _____
who guard the country, doctors who attend the sick, teachers, preachers, and merchants who supply goods

5. Because the monks did not contribute to society, how did the European common people respond to them?
They mocked them and hated them.

6. How did the monks keep neighborhoods awake? By ringing bells _____

SKILL: Comprehension, Original Sources

Luther's Ninety-five Theses

Answer the questions below based on the following excerpts of Luther's writings:

21. Those preachers of indulgences are in error, who say that by the pope's indulgences a man is freed from every penalty and is saved. . . .

27. They preach man-made doctrines who say that so soon as the coin jingles into the money-box, the soul flies out of purgatory.

28. It is certain that when the coin jingles into the money-box, greed and avarice can be increased, but the result of the intercession of the church is in the power of God alone. . . .

32. They will be condemned eternally, together with their teachers, who believe themselves sure of their salvation because they have letters of pardon. . . .

35. They preach no Christian doctrine who teach that contrition [sorrow over sin] is not necessary in those who intend to buy souls out of purgatory or to buy confessional privileges.

36. Every truly repentant Christian has a right to full remission of penalty and guilt, even without letters of pardon.

37. Every true Christian, whether living or dead, has part in all the benefits of Christ and the church; and this is granted to him by God, even without letters of pardon. . . .

43. Christians are to be taught that he who gives to the poor or lends to the needy does a better work than buying pardons. . . .

45. Christians are to be taught that he who sees a man in need and passes him by and gives his money for pardons instead, purchases not the indulgences of the pope, but the indignation [anger] of God. . . .

50. Christians are to be taught that if the pope knew the exactions [excessive demands] of the indulgence preachers, he would rather that St. Peter's church should go to ashes than that it should be built up with the skin, flesh, and bones of his sheep.

51. Christians are to be taught that it would be the pope's wish, as it is his duty, to give of his own money to many of those from whom certain hawkers of pardons cajole money, even though the church of St. Peter might have to be sold. . . .

54. Injury is done to the Word of God when, in the same sermon, an equal or a longer time is spent on pardons than on the Word.

55. It must be the pope's intention that if pardons, which are a very small thing, are celebrated with one bell, single processions, and ceremonies, then the gospel, which is the very greatest thing, should be preached with a hundred bells, a hundred processions, and a hundred ceremonies.

Martin Luther. *Martin Luther's Ninety-five Theses*. Ed. Stephen J. Nichols (Phillipsburg, NJ: P & R Publishing, 2002). 29–37. ISBN 0-87552-557-1

1. According to indulgence-sellers, what happened when money fell into the collection box? (27) They said that when money "[jingled] into the money-box, the soul [flew] out of purgatory."

2. What does Luther say will happen to those who think they are saved because they have "letters of pardon" (indulgences)? (32) "They will be condemned eternally."

3. According to Luther, what is a necessary attitude for those who buy indulgences or confessional privileges?

(35) Sorrow over sin

4. According to Luther, what good work is better than buying pardons for sin? (43) Giving or lending money to the poor

5. How does Luther think the pope should help those who were cheated by indulgence-sellers?

(51) The pope should pay out of his own pocket to help those who were cheated.

6. What two spiritual things are more important than proclaiming and selling indulgences?

(54–55) The Word of God and the gospel

SKILL: Comprehension, Original Sources

Chapter Review
Make the Statement Correct

Underline the word or phrase that makes the statement correct.

1. The Renaissance started in (Spain/<u>Italy</u>). (p. 98)

2. The fall of (Venice/<u>Constantinople</u>) contributed to a revival of learning in Europe. (p. 98)

3. The Bible was first translated into English by (<u>Wycliffe</u>/Luther). (p. 108)

4. The Reformation began in (<u>Germany</u>/Italy). (p. 109)

5. The church court that sought to find and punish heresy was called the (transubstantiation/<u>Inquisition</u>). (p. 105)

6. The Roman Church burned (Wycliffe/<u>Huss</u>) at the stake. (p. 108)

7. Castiglione wrote a book about Renaissance (warfare/<u>manners</u>). (p. 103)

8. Erasmus published a (<u>Greek</u>/German) New Testament. (p. 103)

9. Lorenzo de Medici generously supported the (<u>Renaissance</u>/Reformation). (p. 98)

10. (Machiavelli/<u>Erasmus</u>) exposed corruption in the Roman Church with his work *In Praise of Folly*. (p. 103)

11. Zwingli was a reformer in (Germany/<u>Switzerland</u>). (pp. 109–10)

12. (Zwingli/<u>Luther</u>) was the author of the Ninety-five Theses. (p. 109)

13. (<u>Transubstantiation</u>/Excommunication) is the teaching that the bread and wine in the Lord's Supper change into the actual body and blood of Christ. (p. 105)

14. (Inquisitions/<u>Indulgences</u>) are papers that grant pardon from the punishment of sin. (p. 106)

15. Pope (<u>Leo X</u>/Martin V) authorized the issuing of indulgences to pay for the completion of St. Peter's Basilica. (p. 106)

16. Pope (Gregory VII/<u>Boniface VIII</u>) demanded submission to the pope as a requirement for salvation. (p. 105)

17. (Michelangelo/<u>Leonardo da Vinci</u>) painted *The Last Supper*. (p. 99)

18. (<u>Michelangelo</u>/Gutenberg) painted the ceiling of Rome's Sistine Chapel. (p. 100)

19. (<u>Brunelleschi</u>/Ghiberti) designed the dome of the Cathedral of Florence. (p. 102)

20. (<u>Gutenberg</u>/Erasmus) invented the movable-type printing press. (p. 98)

Name _____

Map Study: Indian Civilizations

Locate the following seven Indian civilizations on the map and place the number in the blank beside the term:

Aztecs	2
Five Civilized Tribes	4
Incas	3
Iroquois Confederacy	6
Mayas	7
Plains Indians	5
Pueblos	1

Letters from Mexico

Answer the questions below based on the following excerpt from Cortés's writings:

[The Aztecs] have their shrines and temples with raised walks which run all around the outside and are very wide: there they keep the idols which they worship, some of stone, some of clay and some of wood, which they honor and serve with such customs and so many ceremonies that many sheets of paper would not suffice to give Your Royal Highnesses a true and detailed account of them all. And the temples where they are kept are the largest and the best and the finest built of all the buildings found in the towns; and they are much adorned with rich hanging cloths and featherwork and other fineries.

Each day before beginning any sort of work they burn incense in these temples and sometimes sacrifice their own persons, some cutting their tongues, others their ears, while there are some who stab their bodies with knives. All the blood which flows from them they offer to those idols, sprinkling it in all parts of the temple, or sometimes throwing it into the air or performing many other ceremonies, so that nothing is begun without sacrifice having first been made. They have a most horrid and abominable custom which truly ought to be punished and which until now we have seen in no other part, and this is that, whenever they wish to ask something of the idols, in order that their plea may find more acceptance, they take many girls and boys and even adults, and in the presence of the idols they open their chests while they are still alive and take out their hearts and [intestines] and burn them before the idols, offering the smoke as sacrifice. Some of us have seen this, and they say it is the most terrible and frightful thing they have ever witnessed.

This these Indians do so frequently that, as we have been informed, and, in part, have seen from our own experience during the short while we have been here, not one year passes in which they do not kill and sacrifice some fifty persons in each temple; and this is done and held as customary from the island of Cozumel to this land where we now have settled. Your Majesties may be most certain that, as this land seems to us to be very large, and to have many temples in it, not one year . . . has passed, as far as we have been able to discover, in which three or four thousand souls have not been sacrificed in this manner.

Hernan Cortez. "The First Letter." *Hernan Cortez: Letters from Mexico*. Trans. and ed. Anthony Pagden. Copyright © 1971 by Anthony Pagden. Revised edition copyright © 1986 by Yale University Press. Reprinted by permission of Yale University Press.

1. Out of what materials did the Aztecs make their gods? What does Psalm 135:15–18 say about gods like these? <u>Stone, clay, and wood. They are the "work of men's hands" and are not living.</u>

2. What did the Aztecs do to their own bodies to worship their gods? How is this similar to the behavior of Baal's worshippers on Mt. Carmel (1 Kings 18:28)? <u>They cut their tongues and ears and stabbed their own bodies. The worshippers of Baal also cut themselves so that Baal would hear them.</u>

3. What Aztec practice does Cortés describe as "a most horrid and abominable custom"? <u>Human sacrifice</u>

4. How often did this ritual occur? <u>Yearly; whenever the Aztecs asked their gods for help</u>

5. According to Cortés, how many people did the Aztecs sacrifice every year? <u>Three to four thousand</u>

SKILL: Comprehension, Original Sources

Christopher Columbus

Answer the questions at the end based on the following excerpts from Columbus's journal:

Friday, 3 August

We set sail on Friday, 3 August 1492, crossing the bar of the Saltés at eight o'clock. Sailed S with a strong, veering wind until sunset, making forty-eight miles, or sixteen leagues; then SW and S by W, on course for the Canaries. . . .

Sunday, 9 September

We sailed sixteen and a half leagues. I have decided to log less than our true run [distance], so that if the voyage is long the crew will not be afraid and lose heart. . . .

Sunday, 16 September

The voyage is growing long, and we are far from home, and the men are beginning to complain about the length of the journey and about me for involving them in it. When they saw these great rafts of weed in the distance they began to be afraid that they were rocks or submerged ground, which made them even more impatient and outspoken in their complaints against me. Having seen the ships sailing through the weed, however, they have lost their fear somewhat, though not entirely. . . .

Wednesday, 26 September

Sailed on course W until after noon, then SW until we found that what we had thought was land was only clouds. Our twenty-four hour run was about thirty-three leagues; I told the men twenty-five and a half. The sea was just like a river, with sweet, gentle breezes. . . .

Saturday, 6 October

Remained on course W. Forty-two and a half leagues in the twenty-four hours; I told the men thirty-five. Martín Alonso said tonight that we would be best to steer SW by W. I think he had the island of Cipango [Japan] in mind when he said this. My own opinion is that if we miss Cipango we shall be a long time in making a landfall, and it is better to strike the mainland first and go to the islands afterwards. . . .

Thursday, 11 October

Course WSW. A heavy sea, the roughest in the whole voyage so far. We saw petrels [sea birds], and a green reed close to the ship, and then a big green fish of a kind which does not stray far from the shoals. On the Pinta they saw a cane and a stick, and they picked up another little piece of wood which seemed to have been worked with an iron tool; also a piece of cane and another plant which grows on land, and a little board. On the Niña too they saw signs of land, and a thorn-branch laden with red fruits, apparently newly cut. We were all filled with joy and relief at these signs. Sailed twenty-eight and a half leagues before sunset. After sunset I resumed our original course westward, sailing at about nine knots. By two o'clock in the morning we had sailed about sixty-eight miles, or twenty-two and a half leagues. . . .

I was on the poop deck at ten o'clock in the evening when I saw a light. It was so indistinct that I could not be sure it was land, but I called Pedro Gutiérrez, the Butler of the King's Table, and told him to look at what I thought was a light. He looked, and saw it. I also told Rodrigo Sánchez de Segovia, Your Majesties' observer on board, but he saw nothing because he was standing in the wrong place. After I had told them, the light appeared once or twice more, like a wax candle rising and falling. Only a few people thought it was a sign of land, but I was sure we were close to a landfall.

Then the Pinta, being faster and in the lead, sighted land and made the signal as I had ordered. The first man to sight land was called Rodrigo de Triana. The land appeared two hours after midnight, about two leagues away. . . .

When we stepped ashore we saw fine green trees, streams everywhere and different kinds of fruit. I called to the two captains to jump ashore with the rest, who included Rodrigo de Escobedo, secretary of the fleet, and Rodrigo Sánchez de Segovia, asking them to bear solemn witness that in the presence of them all I was taking possession of this island for their Lord and Lady the King and Queen, and I made the necessary declarations which are set down at greater length in the written testimonies.

Soon many of the islanders gathered round us. I could see that they were people who would be more easily converted to our Holy Faith by love than by coercion, and wishing them to look on us with friendship I gave some of them red bonnets and glass beads which they hung round their necks, and many other things of small value, at which they were so delighted and so eager to please us that we could not believe it. Later they swam out to the boats to bring us parrots and balls of cotton thread and darts, and many other things, exchanging them for such objects as glass beads and hawk bells. They took anything, and gave willingly whatever they had.

From: *THE VOYAGE OF CHRISTOPHER COLUMBUS: Columbus' Own Journal of Discovery Newly Restored and Translated* by John Cummins, copyright © 1992 by the author and reprinted by permission of St. Martin's Press, LLC. (USA rights.) Copyright © by John Cummins. All rights reserved. First published in London by George Weidenfeld and Nicolson. Used by permission of Orion Publishing Group Ltd. (World rights excluding the USA.)

1. What did Columbus do to keep his men from realizing how far they were traveling? Columbus logged less distance than he had actually traveled so his men wouldn't think they were that far from home.

2. Why were the men afraid of the weeds on the ocean? Answers may vary. They thought the weeds were rocks or "submerged ground" that would sink the ship.

3. What signs showed Columbus and his men that they were close to land? Birds, plants, and certain fish indicated that land was near. They also saw a piece of wood that appeared to have been worked with a tool. In the evening, Columbus saw a light that he believed indicated land nearby.

4. On what day did Columbus and his men experience the roughest weather of the voyage? Thursday, 11 October

5. Why did Columbus give the islanders gifts? He wanted to show them friendship and eventually see them converted to Roman Catholicism.

SKILL: Comprehension, Original Sources

Bartolomé de Las Casas

Answer the questions at the end based on the following excerpts from Las Casas's writings:

The Lucayan Islands on the North Side, adjacent to Hispaniola [Dominican Republic and Haiti] and Cuba, which are Sixty in number, or thereabout, together with . . . those, [commonly] known by the name of the Gigantic Isles, and others, the most infertile whereof, exceeds the Royal Garden of Sevil in fruitfulness, a most Healthful and pleasant Climat[e], is now laid waste and uninhabited; and whereas, when the Spaniards first arriv'd here, about Five Hundred Thousand Men dwelt in it, they are now cut off, some by slaughter, and others ravished away by Force and Violence, to work in the Mines of Hispanioloa, which was destitute of Native Inhabitants: For a certain Vessel, sailing to this Isle, to the end, that the Harvest being over (some good Christian, moved with Piety and Pity, undertook this dangerous Voyage, to convert Souls to Christianity) the remaining gleanings might be gathered up, [found] only . . . Eleven Persons, which I saw with my own Eyes. There are other Islands Thirty in number, and upward bordering upon the Isle of St. John [San Juan, today Puerto Rico], totally unpeopled; all which are above Two Thousand miles in [length], and yet remain without Inhabitants, Native, or People.

As to the firm land, we are certainly satisfied, and assur'd, that the Spaniards by their barbarous and [horrible] Actions have absolutely depopulated Ten Kingdoms, of greater extent than all Spain, together with the Kingdoms of Arragon and Portugal, that is to say, above One Thousand Miles, which now [lie] wast[e] and desolate, and are absolutely ruined, when as formerly no other Country whatsoever was more populous. Nay we dare boldly affirm, that during the Forty Years space, wherein [the Spaniards] exercised their [bloody] and detestable Tyranny in these Regions, above Twelve Millions ([of] Men, Women, and Children) have undeservedly perished; nor do I conceive that I should deviate from the Truth by saying that above Fifty Millions in all paid their last Debt to Nature.

Those that arriv'd at these Islands from the remotest parts of Spain, and who pride themselves in the Name of Christians, steer'd Two courses principally, in order to the [murder], and Exterminating of this People from the face of the Earth. The first whereof was raising an unjust, [bloody], cruel War. The other, by putting them to death, who . . . thirsted after their Liberty, or design'd . . . to recover their [perfect] Freedom, and shake off the Shackles of so injurious a Captivity: For they being taken off in War, none but Women and Children were permitted to enjoy the benefit of that Country-Air, [on] whom they did in succeeding times lay such a heavy [yoke], that the very Brutes [animals] were more happy than they. . . .

Now the ultimate end and scope that incited the Spaniards to endeavor the [killing] and Desolation of this People, was Gold only; that thereby growing opulent [wealthy] in a short time, they might arrive at once at . . . Degrees and Dignities, [that were not] consistent with their Persons.

Finally, in one word, their Ambition and Avarice . . . , and the vast Wealth of those Regions; the Humility and Patience of the Inhabitants (which made their approach to these Lands more . . . [easy]) did much promote the business: Whom they so despicably [hated], that they treated them (I speak of things which I was an Eye Witness of, without the least fallacy) not as Beasts, which I cordially wished they would, but as the most abject dung and filth of the Earth; and so [demanding] they were of their Life and Soul, that the above-mentioned number of People died without understanding the true Faith or Sacraments. And this also is as really true as the [preceding] Narration (which the very Tyrants and cruel Murderers cannot deny

without the stigma of a [lie]) that the Spaniards never received any injury from the Indians, but that [the Indians] rather reverenced them as Persons descended from Heaven, until [the Indians] were compelled to take up Arms, provoked thereunto by repeated Injuries, violent Torments, and [unjust] Butcheries.

A Brief Account of the Destruction of the Indies by Bartolomé de las Casas. Public Domain.

1. Which islands are mentioned in this passage? What are the current names of some of these islands?

 Cuba, Hispaniola, Lucayos, Gigantes, San Juan; (Hispaniola) Dominican Republic and Haiti, (San Juan) Puerto Rico

2. According to Las Casas, how many Indians were killed by the Spanish and made to pay "their last Debt to Nature"? Over fifty million _____

3. Why did the Spanish conquistadors abuse the Indians? How does this illustrate 1 Timothy 6:10?

 They wanted to get much gold and live well. Covetousness and greed for money cause many evils, such as the

 Spanish persecution of the Indians.

4. According to the end of this excerpt, what did the Indians first think of the Spanish?

 They thought they were "Persons descended from Heaven."

SKILL: Comprehension, Original Sources

Chapter Review
Make the Statement Correct

Underline the word or phrase that makes the statement correct.

1. (*Siam*/*Dai Viet*) is the ancient name for Thailand. (p. 132)

2. The (Aztecs/Mayas) stoned adulterers and placed great importance on the family. (p. 124)

3. (Dias/Columbus) was the first explorer to find a way around the tip of Africa. (p. 129)

4. Atahualpa was the last (Mayan/Incan) ruler before the Spanish arrived. (p. 131)

5. (Tenochtitlán/Cuzco) was the capital city of the Aztec Empire. (p. 123)

6. (Cortés/Pizarro) conquered the Incan Empire. (p. 131)

7. Queen (Isabella/Elizabeth) financed Sir Francis Drake's expeditions. (p. 130)

8. The (Spanish/Portuguese) developed a thriving trade with India. (p. 129)

9. The Aztecs expected the return of the god (Cuzco/Quetzalcoatl). (p. 124)

10. Indians in southwest North America lived in villages called (pueblos/effigy mounds). (p. 120)

11. Francis Xavier traveled to (China/Japan) as a missionary. (p. 129)

12. The Iroquois Confederacy was located in the modern state of (Georgia/New York). (p. 121)

13. The American Indians who migrated with the herds and did not build permanent settlements lived on the (East Coast/Great Plains). (p. 121)

14. (Magellan/Dias) gave the Pacific Ocean its name. (p. 130)

15. Sailors used the (astrolabe/compass) to determine direction when plotting a course. (p. 127)

16. Spain and Portugal are located by the (Pacific/Atlantic) Ocean. (p. 128)

Teacher's Choice
Teachers, to help the student better prepare for the chapter test, feel free to add questions about other topics you may have covered.

17. Question _____

18. Question _____

19. Question _____

20. <u>Question</u> _____

SKILL: Recognition, Comprehension

Map Study: South America

Locate the following on the map and place the number in the blank beside the term:

Argentina 4 Ecuador 6

Brazil 7 Peru 5

Chile 3 Venezuela 2

Colombia 1

Map Study: Early American Colonization

Locate the following on the map and place the number in the blank beside the term:

Jamestown	2	Plymouth	4
Lake Erie	6	Quebec	3
Lake Ontario	7	St. Lawrence River	5
Montreal	1		

SKILL: Maps

Why the Pilgrims Left the Netherlands

Answer the questions at the end based on the following excerpt from William Bradford's writings:

After [the Pilgrims] had lived in [Leiden] about some 11 or 12 years, . . . [and after some] of them were taken away by death, and many others began to be well stricken in years, . . . those prudent governors with [various] of the sagest members began both deeply to apprehend [understand] their present dangers, and wisely to foresee the future, and think of timely remedy. In the agitation of their thoughts, and much discourse . . . , at length they began to incline to this conclusion, of removal [departure] to some other place. Not out of any newfangledness, or other such like giddy humor, by which men are oftentimes transported to their great hurt and danger, but for [various] weighty and solid reasons; some of the chief of which I will here briefly touch. [First], they saw and found by experience the hardness of the place and country to be such, [that] few [people] in comparison would come to them, and fewer . . . would [remain], and continue with them. For many that came to them, and many more that desired to be with them, could not endure that great labor and hard fare, with other inconveniences which [the Pilgrims] underwent and were contented with. . . . For many, though they desired to enjoy the ordinances of God in their purity, and the liberty of the gospel with them, yet, alas, they . . . preferred and chose the prisons in England, rather than this liberty in Holland, with these afflictions.

[Secondly]. They saw that though the people generally bore all these difficulties very cheerfully, and with a resolute courage, being in the best and strength of their years, yet old age began to steal on many of them, (and their great and continual labors, with other crosses and sorrows, hastened it before the time,) so [that] it was not only probably thought, but apparently seen, that within a few years more they would be in danger to scatter, by necessities pressing them, or [to] sink under their burdens, or both. . . . Thirdly; as necessity was a taskmaster over them, so they were forced to be such, not only to their servants, but in a sort, to their dearest children; the which greatly [wounded] the tender hearts of many a loving father and mother, [and] produced likewise [various] sad and sorrowful effects. For many of their children, that were of best dispositions and gracious inclinations, having learned to bear the yoke in their youth, and willing to bear part of their parents' burden, were, oftentimes, so oppressed with their heavy labors, that though their minds were free and willing, yet their bodies bowed under the weight of the same, and became [old] in their early youth; the vigor of nature being consumed in the very bud as it were. But that which was more lamentable, and of all sorrows most heavy to be borne, was that many of their children, by these occasions, and the great [immorality] of youth in [the Netherlands], and the manifold temptations of the place, were drawn away by evil examples into [unsuitable] and dangerous courses, getting the reins off their necks, and departing from their parents. Some became soldiers, others took upon them far voyages by sea, and other some worse courses, tending to [sinful living] and the danger of their souls, to the great grief of their parents and dishonor of God. So that they saw their posterity would be in danger to degenerate and be corrupted.

Lastly, (and which was not least,) a great hope and inward zeal they had of laying some good foundation, or at least to make some way thereunto, for the propagating and advancing [of] the gospel of the kingdom of Christ in those remote parts of the world; yea, though they should be but even as stepping-stones unto others for the performing of so great a work.

These, and some other like reasons, moved them to undertake this resolution of their removal; the which they afterward [accomplished] with . . . great difficulties, as by the sequel will appear.

The place they had thoughts on was some of those vast and unpeopled countries of America, which are fruitful and fit for habitation, being devoid of all civil inhabitants, where there are only [savage] and brutish men, which range up and down, little [different] than the wild beasts of the same.

Of Plimouth Plantation by William Bradford. Public Domain.

1. How long did the Pilgrims live in Leiden before they decided to look for a new place to live?
 Eleven to twelve years

2. What condition did some Puritans prefer over liberty with hardship in Holland? To be confined in English
 prisons

3. What happened to some of the Pilgrims' children? Some wore themselves out in helping their parents; others
 became sinful and left their parents.

4. What kind of spiritual influence did the Dutch have on the Pilgrims' children? The children were tempted
 to sin by the "evil examples" of others, as well as by the Netherlands' many places of temptation.

5. What evangelistic motives led the Pilgrims to move to America? They wanted to evangelize in a remote
 place and to start missions work that others could continue.

6. How does Bradford describe America? "Vast and unpeopled" (unpopulated); "fruitful and fit for habitation"

7. How does Bradford describe the Indian civilizations? How correct is this description based on what you
 have read about Indians in the Americas? He describes them as "brutish men" and compares them
 to "wild beasts." This is not an accurate description. Many of the Indians, such as the Mayas, Aztecs, Incas, and
 Iroquois, were capable of forming advanced civilizations, and some, such as the Cherokee, were capable of
 developing peaceful civilizations.

SKILL: Comprehension, Original Sources

Simón Bolívar

Answer the questions at the end based on the following excerpt from Bolívar's writings about South America:

The battle of Leipzig has at last produced the decision of a long-drawn contest in which the larger interests of the continent of Europe and the cause of the Independence of Nations have triumphed over the ambition of Bonaparte, overturning that immense colossus of French power. Of the half million Frenchmen who set out to demolish the coalition of the powers, only fifty thousand have managed to survive. The great army, the invincible eagles, the great marshals have virtually disappeared. The days of October 17, 18, 19, and 20, of the year 1813, will remain the most memorable in all the history of Europe, for during those days was won the liberty of the world, which had been threatened with invasion by the common oppressor [Napoleon].

Let America rejoice in the triumph of the allied armies, which have so gloriously defended the cause of independence. Let her cease to fear plans which Spain is in no position to carry out. The war has exhausted Spain's treasury; and the gains won from the French, while they may increase her territorial possessions, cannot give [Spain] the navy which she lacks and without which her threats against us need not be taken seriously. On the other hand, the [dominance] that the great successes of the Duke of Wellington and of the allies give Great Britain over the affairs of Spain will eventually destroy the latter's schemes against the independence of the New World. Let none fear lest that powerful nation which, even in adversity, has persistently defended the independence of Europe, should fail to defend that of America, if attacked. Let us, on the contrary, rejoice in the irresistible ascendancy that England is about to assume over both hemispheres in guarantee of universal freedom.

Our industry, hitherto of no value, and our lagging agriculture will shake off their apathy in response to the rewards [offered] the farmer by the rise in the prices of the products he cultivates. Once the ports of continental Europe are thrown open to British vessels, our farmers will export our coffee, cacao, indigo, cotton, and the like, which are in great demand. Maritime commerce having been so long suppressed wherever the Napoleonic influence has extended, Europe has suffered the want [lack] of products which have become as primary a necessity for them as their exports are for us. This trade is the foundation for the prosperity of our commerce and agriculture.

The policies and the mercantile interests of England and Spain are . . . opposed with respect to America. Spain, unable to keep us tranquilly enslaved, is now bent upon our destruction; England, favoring our independence, is interested in our prosperity. The northern and southern regions of the New World are determined to maintain their freedom at all costs. Even if Spain were to dispatch the most powerful of armies, only mutual destruction could possibly result, for they could never conquer us. England would not tolerate an [unwanted] and, at best, futile war which, offering no hopes for Spain, could only devastate this fair half of the earth.

Yet, where are those armies? Is Spain perchance anything more than a phantom nation? With what resources can she raise these armies and transport them a distance of two thousand leagues, in order to wage a war as long as it would be hopeless? Spain is even less powerful since she repelled the French. Her efforts were those of a dying man, who, having made them, relapses into greater weakness.

England, appropriately, is today supporting Spain. In England's shadow, America can assert her freedom. England, by her influence over [Spain], ends the plans of vengeance and extermination that inspire it; and, at the same time, by her victories over thwarted France, she eliminates the last of Napoleon's designs against us. With Spain a vassal state, the Emperor of the French would not have renounced the rights that he had claimed over America, a dependency of Spain. On the contrary, his unbounded ambition would have sought . . . dominion over both Spain and America.

Simón Bolívar. *Selected Writings of Bolívar.* Vol. 1. Comp. Vicente Lecuna. Trans. Lewis Bertrand. Ed. Harold A. Bierck, Jr. (New York: The Colonial Press, Inc., 1951). 69–71.

1. In what battle did Europe defeat Napoleon's forces? Battle of Leipzig _____

2. How does Bolívar describe Napoleon throughout this letter? He describes Napoleon as "that immense colossus of French power" and as the ambitious "common oppressor." _____

3. On what memorable days was the "liberty of the world" won? October 17–20, 1813 _____

4. Which nation, because it lacked both a navy and a rich treasury, could not attack South America?
Spain _____

5. Which nation promised "universal freedom" and, as Bolívar expected, would protect liberty in South America? England _____

6. How did the end of Napoleon's power in Europe help commerce and agriculture in South America?
Nations could trade again, and Europeans could buy products that South American farmers grew. _____

7. What South American products were popular and needed in Europe? Coffee, cacao, indigo, and cotton _____

Chapter Review
Make the Statement Correct

Underline the word or phrase that makes the statement correct.

1. The Pilgrims founded the (Massachusetts Bay/<u>Plymouth</u>) Colony. (p. 146)

2. Brazil was colonized by the (<u>Portuguese</u>/Spanish). (p. 139)

3. (<u>Sugar</u>/Tobacco) was an important export of colonial South America. (p. 143)

4. (Spain/<u>Portugal</u>) ruled a colony in South America that was eighty times its size. (pp. 140–41)

5. (Thousands/<u>Millions</u>) of Africans were enslaved and taken to South America. (p. 142)

6. (<u>France</u>/England) was the first European country to colonize modern Canada. (pp. 145–46)

7. (Portugal/<u>Spain</u>) colonized the western regions of South America. (p. 138)

8. (Bolívar/<u>Cartier</u>) discovered the St. Lawrence River. (p. 145)

9. (<u>Antonio José de Sucre</u>/Pedro I) liberated Ecuador. (p. 151)

10. Ecuador was part of the (<u>New</u>/Old) World. (p. 138)

11. Massachusetts Bay Colony was founded by the (Pilgrims/<u>Puritans</u>). (p. 147)

12. A (<u>viceroy</u>/caudillo) was a colonial ruler who represented the king of Spain. (p. 141)

13. (<u>Mestizos</u>/Creoles) were children of Indian and Spanish parents. (p. 142)

14. (<u>Gauchos</u>/Barrios) were Argentinean cowboys. (p. 152)

15. The (Dominican/<u>Jesuit</u>) Catholic order became rich and established monopolies in South America. (p. 142)

16. (<u>Portugal</u>/Spain) bought slaves in Africa and took them to Europe and the New World. (p. 142)

Teacher's Choice Teachers, to help the student better prepare for the chapter test, feel free to add questions about other topics you may have covered.

17. Question _____

18. Question _____

19. Question _____

20.

SKILL: Recognition, Comprehension

The English Bill of Rights

Answer the questions below based on the following excerpt from the English Bill of Rights:

Declarations of the Rights of English Subjects:

That the pretended power of suspending the laws or the execution of laws by regal authority without consent of Parliament is illegal;

That the pretended power of dispensing with laws or the execution of laws by regal authority, as it hath been assumed and exercised of late, is illegal;

That the commission for erecting the late Court of Commissioners for Ecclesiastical Causes, and all other commissions and courts of like nature, are illegal and pernicious [harmful];

That levying money for or to the use of the Crown by pretence of prerogative, without grant of Parliament, for longer time, or in other manner than the same is or shall be granted, is illegal;

That it is the right of the subjects to petition the king, and all commitments [imprisonments] and prosecutions for such petitioning are illegal;

That the raising or keeping [of] a standing army within the kingdom in time of peace, unless it be with consent of Parliament, is against [the] law;

That the subjects which are Protestants may have arms for their defence suitable to their conditions and as allowed by law;

That election of members of Parliament ought to be free;

That the freedom of speech and debates or proceedings in Parliament ought not to be impeached or questioned in any court or place out of Parliament;

That excessive bail ought not to be required, nor excessive fines imposed, nor cruel and unusual punishments inflicted;

That jurors ought to be duly impanelled [selected from a list of eligible citizens] and returned, and jurors which pass upon men in trials for high treason ought to be freeholders;

That all grants and promises [payments] of fines and forfeitures of particular persons before conviction are illegal and void;

And that for redress of all grievances, and for the amending, strengthening and preserving of the laws, Parliaments ought to be held frequently.

http://avalon.law.yale.edu/17th_century/england.asp

1. What did the English oppose the king's "raising or keeping . . . in time of peace"? __A standing army__

2. What were Protestant English citizens allowed to possess in order to defend themselves?

 Arms (weapons)

3. According to this document, what should not be "impeached or questioned" anywhere outside of Parliament? __Freedom of speech, debates, and proceedings in Parliament__

4. Based on this document, could English subjects safely ask the king for help without threat of punishment? Why or why not? _Yes; it was illegal to imprison or prosecute someone for petitioning the king._

5. What limits did the English set on bail, fines, and punishment? _Bail and fines should not be excessive; punishment should not be cruel and unusual._

6. According to this document, should anyone be forced to pay a fine or forfeit his goods before being convicted? _No_

7. Why should Parliaments be held frequently? _For "redress of all grievances, and for the amending, strengthening and preserving of the laws"_

SKILL: Comprehension, Original Sources

Galileo's Observations

Answer the questions at the end based on the following excerpts from the writings of Galileo:

The Starry Messenger

About ten months ago a report reached my ears that a certain Fleming had constructed a spyglass by means of which visible objects, though very distant from the eye of the observer, were distinctly seen as if nearby. Of this truly remarkable effect several experiences were related, to which some persons gave credence while others denied them. A few days later the report was confirmed to me in a letter from a noble Frenchman at Paris, Jacques Badovere, which caused me to apply myself wholeheartedly to inquire into the means by which I might arrive at the invention of a similar instrument. This I did shortly afterwards, my basis being the theory of refraction. First I prepared a tube of lead, at the ends of which I fitted two glass lenses, both plane on one side while on the other side one was spherically convex and the other concave. Then placing my eye near the concave lens I perceived objects satisfactorily large and near, for they appeared three times closer and nine times larger than when seen with the naked eye alone. Next I constructed another one, more accurate, which represented objects as enlarged more than sixty times. Finally, sparing neither labor nor expense, I succeeded in constructing for myself so excellent an instrument that objects seen by means of it appeared nearly one thousand times larger and over thirty times closer than when regarded with our natural vision.

It would be [unnecessary] to enumerate the number and importance of the advantages of such an instrument at sea as well as on land. But forsaking terrestrial [earthly] observations, I turned to celestial [heavenly] ones, and first I saw the moon from as near at hand as if it were scarcely two terrestrial radii away. After that I observed often with wondering delight both the planets and the fixed stars, and since I saw these latter to be very crowded, I began to seek (and eventually found) a method by which I might measure their distances apart. . . .

Now let us review the observations made during the past two months, once more inviting the attention of all who are eager for true philosophy to the first steps of such important contemplations. Let us speak first of that surface of the moon which faces us. For greater clarity I distinguish two parts of this surface, a lighter and a darker; the lighter part seems to surround and to pervade the whole hemisphere, while the darker part discolors the moon's surface like a kind of cloud, and makes it appear covered with spots. Now those spots which are fairly dark and rather large are plain to everyone and have been seen throughout the ages; these I shall call the "large" or "ancient" spots, distinguishing them from others that are smaller in size but so numerous as to occur all over the lunar surface, and especially the lighter part. The latter spots had never been seen by anyone before me. From observations of these spots repeated many times I have been led to the opinion and conviction that the surface of the moon is not smooth, uniform, and precisely spherical as a great number of philosophers believe it (and the other heavenly bodies) to be, but is uneven, rough, and full of cavities and prominences, being not unlike the face of the earth, [containing] chains of mountains and deep valleys. . . .

On the seventh day of January in this present year 1610, at the first hour of night, when I was viewing the heavenly bodies with a telescope, Jupiter presented itself to me; and because I had prepared a very excellent instrument for myself, I perceived (as I had not before, on account of the weakness of my previous instrument) that

beside the planet there were three starlets, small indeed, but very bright. Though I believed them to be among the host of fixed stars, they aroused my curiosity somewhat by appearing to lie in an exact straight line parallel to the ecliptic, and by their being more splendid than others of their size. . . . The most easterly star and the western one appeared larger than the other. I paid no attention to the distances between them and Jupiter, for at the outset I thought them to be fixed stars, as I have said. But returning to the same investigation on January eighth—led by what, I do not know—I found a very different arrangement. The three starlets were now all to the west of Jupiter, closer together, and at equal intervals from one another. . . .

I had now decided beyond all question that there existed in the heavens three stars wandering about Jupiter as do Venus and Mercury about the sun, and this became plainer than daylight from observations on similar occasions which followed. Nor were there just three such stars; four wanderers complete their revolutions about Jupiter, and of their alterations as observed more precisely later on we shall give a description here.

Raymond J. Seeger. *Galileo Galilei: His Life and His Works* (Oxford: Pergamon, 1966). 247–48, 250, 253–54, 255.

1. What invention is Galileo describing in this passage? __A telescope__

2. What two kinds of lenses were included in Galileo's instrument? __Convex and concave__

3. How does Galileo describe the moon's surface? __The moon has lighter and darker parts and is covered with large__ __and small spots. The surface is not smooth but is full of mountains and valleys.__

4. What planet did Galileo find with his instrument? On what day did he find it? __Jupiter; January 7, 1610__

5. What did he find around the planet, and how did he describe them? What would we call these today? (The earth has one.) __He found four "starlets," "wanderers," or "stars." They moved around Jupiter; they sometimes made a__ __straight line and at other times moved in different directions. Today, we call these moons.__

6. What two planets does Galileo mention as revolving around the sun? __Venus and Mercury__

SKILL: Comprehension, Original Sources

Matching Exercise

Place the correct letter in the blank.

A. Circumference of the earth	F. King of France
B. Earth revolves around the sun	G. Optics and astronomy
C. Father of Geometry	H. Protectorate
D. Father of Medicine	I. Set limits on royal power
E. William and Mary	J. Smallpox vaccination

F p. 156	1. Louis XIV	E p. 158	6. Glorious Revolution
D p. 160	2. Hippocrates	I p. 158	7. English Bill of Rights
C p. 160	3. Euclid	A p. 160	8. Eratosthenes
G p. 160	4. Roger Bacon	B p. 161	9. Copernicus
H p. 158	5. Oliver Cromwell	J p. 163	10. Edward Jenner

A. Built a large telescope	F. Human body is made of chemicals
B. Christian chemist	G. Predicted orbits of comets
C. "Experience is the source of knowledge."	H. "Reason is the source of knowledge."
D. Father of Modern Chemistry	I. Demands that religion be excluded
E. Human anatomy	J. Ruler of Russia

D p. 164	11. Antoine Lavoisier	F p. 163	16. Paracelsus
H p. 166	12. Rationalism	E p. 163	17. Andreas Vesalius
I p. 167	13. Secularism	G p. 162	18. Edmond Halley
C p. 166	14. Empiricism	A p. 162	19. Sir William Herschel
B p. 164	15. Robert Boyle	J p. 156	20. Catherine the Great

Chapter Review
Make the Statement Correct

Underline the word or phrase that makes the statement correct.

1. The (Dutch/French) developed an economic empire without the aid of a centralized monarchy. (p. 157)

2. The (Spanish/English) have been ruled by kings of German descent. (p. 159)

3. The (Spanish/English) took the lead in exploring and expanding their empire. (p. 156)

4. (Lavoisier/Paracelsus) believed that the body is made mostly of chemicals and should be treated with chemicals. (p. 163)

5. The vaccine to prevent the spread of smallpox was first developed by (Lavoisier/Jenner). (p. 163)

6. King James II was a strong supporter of the (Roman/Protestant) Church. (p. 158)

7. Catherine the Great continued the development of a strong monarchy in (Russia/England). (p. 156)

8. Hippocrates was known as the Father of (Chemistry/Medicine). (p. 160)

9. (Rationalists/Empiricists) believed that truth could only be discovered through human reason. (p. 166)

10. (Descartes/Locke) insisted that observation, not human reason, is the source of truth. (p. 166)

11. (Lavoisier/Paracelsus) became known as the Father of Modern Chemistry. (p. 164)

12. (Cromwell/Galileo) used a telescope to confirm that the earth revolves around the sun. (p. 162)

13. (Robert Boyle/William Harvey) studied the human circulatory system. (p. 163)

14. (Louis XIV/Charles II) became the model of an absolute monarch. (p. 156)

15. (Eratosthenes/Paracelsus) was the first person to determine lines of latitude and longitude. (p. 160)

16. (Spinoza/Descartes) doubted anything in Scripture that he thought was contrary to reason. (p. 166)

Teacher's Choice
Teachers, to help the student better prepare for the chapter test, feel free to add questions about other topics you may have covered.

17. Question _____

18. Question _____

19. Question _____

20. Question _____

SKILL: Recognition, Comprehension

John G. Paton

Answer the questions below based on the following excerpts from John G. Paton's writings:

. . . [Once,] when Natives in large numbers were assembled at my house, a man furiously rushed on me with his axe; but a Kaserumini Chief snatched a spade with which I had been working, and dexterously [skillfully] defended me from instant death. Life in such circumstances led me to cling very near to the Lord Jesus; I knew not, for one brief hour, when or how attack might be made; and yet, with my trembling hand clasped in the hand [that was] once nailed on Calvary . . . and [is] now swaying the scepter of the Universe, calmness and peace and resignation abode in my soul.

Next day, a wild Chief followed me about for four hours with his loaded musket, and, though [the gun was] often directed towards me, God restrained his hand. I spoke kindly to him, and attended to my work as if he had not been there, fully persuaded that my God had placed me there, and would protect me till my allotted task was finished. Looking up in unceasing prayer to our dear Lord Jesus, I left all in His hands, and felt immortal till my work was done. Trials and hairbreadth [narrow] escapes strengthened my faith, and seemed only to nerve me for more to follow; and they did tread swiftly upon each other's heels. Without that abiding consciousness of the presence and power of my dear Lord and Saviour, nothing else in all the world could have preserved me from losing my reason and perishing miserably. . . .

One evening, I awoke three times to hear a Chief and his men trying to force the door of my house. Though armed with muskets, they had some sense of doing wrong, and were wholesomely afraid of a little retriever dog which had often stood [between] me and death. God restrained them again; and next morning the report went all round the Harbour, that those who tried to shoot me were "smitten weak with fear," and that shooting would not do. A plan was therefore [made] to [burn] the premises, and club us if we attempted to escape. But our Aneityumese Teacher heard of it, and God helped us to frustrate their designs.

John G. Paton. *John G. Paton, Missionary to the New Hebrides: An Autobiography Edited by His Brother.* Ed. James Paton (New York: Fleming H. Revell, 1907). 191–93.

1. What trials does Paton mention at the beginning of the passage? <u>A native attacked him with an axe, and a</u> <u>native chief followed him with a loaded musket.</u>

2. How did Paton respond to these trials? <u>He depended on God, remembered God's promises, and became more</u> <u>aware of God's "presence and power."</u>

3. What animal scared some natives who were trying to force their way into Paton's house?
 <u>"A little retriever dog"</u>

Namuri, one of my Aneityumese Teachers, was placed at our nearest village. There he had built a house for himself and his wife, and there he led amongst the Heathen a pure and humble Christian life. Almost every morning, he came and reported on the state of affairs to me. Without books or a school, he yet instructed the Natives in Divine things, conducted the Worship, and taught them much by his good example. His influence was increasing, when one morning a Sacred Man

threw at him the kawas, or killing stone, a deadly weapon, like a scythe stone in shape and thickness, usually round but sometimes angular, and from eighteen to twenty inches long. . . . The Priest [then] sprang upon [Namuri] with his club and with savage yells. [Namuri] evaded, yet also received, many blows; and, rushing out of their hands, actually reached the Mission House, bleeding, fainting, and pursued by howling murderers. I had been anxiously expecting him, and hearing the noise I ran out with all possible speed.

On seeing me, he sank down by a tree, and cried,—

"Missi, Missi, quick! and escape for your life! They are coming to kill you; they say, they must kill us all to-day, and they have begun with me; for they hate Jehovah and the Worship!"

I hastened to the good Teacher where he lay; I bound up, washed, and dressed his wounds; and God, by the mystery of His own working, kept the infuriated Tannese watching at bay. . . . In three or four weeks, he so far recovered by careful nursing that he was able to walk about again. . . .

One morning during worship, when the good Teacher knelt in prayer, the same savage Priest sprang upon him with his great club and left him for dead, wounded and bleeding and unconscious. The people fled[,] . . . afraid of being mixed up with the murder. The Teacher, recovering a little, crawled to the Mission House, and reached it about mid-day in a dying condition. . . .

To him, Jesus was all and in all; and there were no bands in his death. He passed from us, in the assured hope of entering into the Glory of his Lord. Humble though he may appear in the world's esteem, I knew that a great man had fallen there in the service of Christ, and that he would take rank in the glorious Army of the Martyrs.

John G. Paton. *John G. Paton, Missionary to the New Hebrides: An Autobiography Edited by His Brother.* Ed. James Paton (New York: Fleming H. Revell, 1907). 193–96.

4. Why was Namuri attacked by a priest? _Because he taught the people how to worship Jehovah_

5. What did the priest do to Namuri? _He threw a "killing stone" at Namuri, beat him, and later wounded_ _him so severely that he died._

6. Why did the people flee when their teacher was hurt? _They did not want to be "mixed up with the murder."_

7. To what place did Namuri flee after both attacks? _To the mission house where Paton was living_

Skill: Comprehension, Original Sources

James Chalmers

Answer the questions below based on the following excerpts from Chalmers's writings:

During the last nine years I have seen much of Teava [a native pastor], and learned to admire the man. He lived much in prayer, and in the study of God's Word. At prayer-meetings he was always first there, coming at least half an hour before any one else, so that he might have time to pray and receive a blessing for himself and others before the service began. He was never absent from the deacons' Saturday afternoon prayer-meeting. He was always ready to speak to the church, ever pointing the members to Christ, and warning them against the many evils to which they are exposed. From his long, true, and earnest life he was able to speak to them as only very few could. He spoke very plainly, not at all mincing matters when occasion required. He had great regard for the *Pilgrim's Progress*, and his delight was to have me sit with him and go over a part of Christian's journey to Mount Zion, the heavenly Jerusalem.

From his position in the island he was able to speak faithfully to the chiefs. . . . For five weeks before his death he was unable to attend the services in church, but he welcomed any who could spend a short time with him in prayer in his own house. He told me some days before he died that he was just waiting on; he knew the Master had sent for him. He said he was done with all below, and looked only for Christ's presence. Not in what he had done did he trust, but in the Cross of Christ alone. On March 16 he asked for a little food. It was given him, but he could not eat it; he got up and walked a very short distance in the house, when he said, "I think the messenger has come to fetch me; I shall die." His wife and another woman laid him down on his mat, when he quietly passed away.

What a change! In his youth he was a heathen, had fought with, and had captured men and cooked and helped to eat them. In his manhood he was converted to Christ, became a true soldier of the Cross, and led many to the Saviour. In his death he trusted alone to Christ, conquered death in Christ, and went up to hear Him say, "Well done, good and faithful servant, enter thou into the joy of thy Lord."

Richard Lovett. *James Chalmers: His Autobiography and Letters* (New York: Fleming H. Revell, 1902). 114–15.

1. How did Teava demonstrate his godliness? __He prayed, read his Bible, attended prayer meetings, spoke to his__ __church, and warned against sins.__

2. What book written by John Bunyan did Chalmers read with Teava? __*Pilgrim's Progress*__

3. How does Chalmers describe Teava's reaction to death? __Teava trusted in the cross of Christ alone and was__ __ready for death.__

4. What was Teava like before his conversion? __He was a heathen and a cannibal.__

In 1876 Mr. Royle retired to Sydney. For nearly forty years he and his good wife had laboured on Aitutaki, and only once during all that time had he been away from the island. I [suspect] the missionaries of the past thought more of their work than

the missionaries of the present day. The latter seem to come out for ten years, even if they can stand the work so long, and the years and the months are counted, and often the furlough time is longed for. In 1863, Mr. Royle was induced to leave Aitutaki and pay Sydney a visit. On the way the John Williams [a ship] was wrecked on Danger Island (Pukapuka), and Mr. Royle always afterwards spoke of this as a punishment that befell him for daring to leave his work! When the vessel was nearly on the reef, and all had taken to the boats, Mr. Royle was seen seated calmly on a chair on the [deck]. The mate, Mr. Turpie, who was just getting over the side of the vessel, being the last to leave, noticing him, said, "Mr. Royle, why are not you in one of the boats?" "I must wait orders." "Well, be quick and get out of [the ship]." I know of only one other missionary who stayed so long at work without change, and he laboured for forty years without a break. . . . He knew the native language much better than any native, and was more conversant with the past of the Samoans than any single Samoan.

Richard Lovett. *James Chalmers: His Autobiography and Letters* (New York: Fleming H. Revell, 1902). 118.

5. To what Australian town did Mr. Royle decide to retire? __Sydney_____

6. On what Pacific island did he evangelize the native peoples? How long did he work there? __Aitutaki; almost__
 __forty years_____

7. What happened during Mr. Royle's trip to Sydney? Why did he think this happened? __The ship that he was__
 __sailing on crashed; he thought this happened because he dared to leave his missionary work.____

SKILL: Comprehension, Original Sources

James Cook's Journal

Answer the questions at the end based on the following excerpts from Cook's journal:

Friday, June 22nd, 1770. Some of the people were sent to shoot pigeons, and at their return reported that they had seen an animal as large as a greyhound, of a slender make, a mouse colour, and extremely swift.

June 23rd. This day almost everybody had seen the animal which the pigeon-shooters had brought an account of the day before.

June 24th. As I was walking this morning at a little distance from the ship, I saw myself one of the animals which had been so often described. It was of a light mouse colour, and in size and shape very much resembled a greyhound; it had a long tail also, which it carried like greyhound; and I should have taken it for a wild dog if, instead of running, it had not leapt like a hare or deer. Its legs were said to be very slender, and the print of its foot to be like that of a goat; but where I saw it the grass was so high that the legs were concealed, and the ground was too hard to receive the track. Mr. Banks also had an imperfect view of this animal, and was of [the opinion] that its species was hitherto unknown.

July 8th. In a walk of many miles some of our men saw four animals of the same kind, two of which Mr. Banks' greyhound fairly chased, but they threw him out at a great distance by leaping over the long thick grass, which prevented his running. These animals were observed not to run upon four legs, but to bound or hop forward upon two.

July 14th. Mr. Gore, who went out this day with his gun, had the good fortune to kill one of the animals which had been so much the subject of our speculation. In form it is most like the jerboa [a small jumping rodent that lives in the desert], which it also resembles in its motion, but it greatly differs in size, the jerboa not being larger than a common rat, and this animal, when full grown, being as big as a sheep; this individual was a young one, much under its full growth, weighing only thirty-eight pounds.

The head, neck, and shoulders are very small in proportion to the other parts of the body; the tail is nearly as long as the body, thick near the body, and tapering towards the other end; the fore-legs of this individual were only eight inches long, and the hind-legs two-and-twenty. Its progress is by successive leaps or hops, of a great length, in an erect posture; the fore-legs are kept bent close to the breast, and seemed to be of use only for digging. The skin is covered with a short fur of a dark mouse or gray colour, excepting the head and ears, which bear a slight resemblance to those of a hare.

This animal is called by the natives *Kangaroo*.

The next day our kangaroo was dressed for dinner, and proved most excellent meat. On the 27th Mr. Gore shot a kangaroo which weighed eighty-four pounds. Upon examination, however, we found that this animal was not at its full growth. . . . We dressed it for dinner the next day; but, to our great disappointment, we found it had a much worse flavour than that we had eaten before.

James Cook and C. G. Cash. *The Life and Voyages of Captain James Cook: Selections with Introductions and Notes* (London: Blackie and Son, n. d.). 46–48.

1. What animal did Cook and his crew find? How does Cook describe this animal? Kangaroo; as large as a greyhound or sheep, fast, able to hop, having a long tail, having forelegs for digging, and furry

2. What did this animal do that kept Cook from calling it a wild dog? Instead of running, it leaped like a rabbit or deer.

3. What were the sizes of the animals that Cook and his crew were able to capture? The young kangaroo was thirty-eight pounds, and the other was eighty-four pounds.

4. To what already-known animals does Cook compare this unknown animal? Greyhound, hare (rabbit), deer, goat, jerboa, and sheep

Hitherto we had safely navigated this dangerous coast, where the sea in all parts conceals shoals that suddenly project from the shore, and rocks that rise abruptly like a pyramid from the bottom, for an extent of two-and-twenty degrees of latitude, more than 1300 miles; and therefore hitherto none of the names that distinguish the . . . parts of the country that we saw are memorials of distress; but here we became acquainted with misfortune, and we therefore called the point which we had just seen farthest to the northward Cape Tribulation.

This Cape lies in latitude 16° 6′ south, and longitude 145° 21′ east. We steered along the shore N. by W. at the distance of between three and four leagues, having from fourteen to twelve and ten fathom water. On the night of Sunday, June 10th, 1770, a few minutes before eleven, the water shallowed at once from twenty to seventeen fathom, and before the lead could be cast again the ship struck and remained immovable, except by the heaving of the surge that beat her against the crags of the rock upon which she lay. In a few moments everybody was upon the deck, with countenances which sufficiently expressed the horrors of our situation.

We had stood off the shore three hours and a half with a pleasant breeze, and therefore knew that we could not be very near it; and we had . . . much reason to conclude that we were upon a rock of coral, which is more fatal than any other, because the points of it are sharp, and every part of the surface is so rough as to grind away whatever is rubbed against it even with the gentlest motion. . . . The men were so far impressed with a sense of their situation that not an oath was heard among them, the habit of profaneness, however strong, being instantly subdued by the dread of incurring guilt when death seemed to be so near.

James Cook and C. G. Cash. *The Life and Voyages of Captain James Cook: Selections with Introductions and Notes* (London: Blackie and Son, n. d.). 48–52.

5. What did Cook name the place where he was almost shipwrecked? Cape Tribulation

6. Upon what was the ship stuck? Why was this especially dangerous for the ship? Coral; Coral has sharp points, and its rough surface could grind away at the ship's wooden sides.

7. Why were the sailors not swearing as they normally did? They were afraid of dying and did not want to die guilty.

SKILL: Comprehension, Original Sources

Chapter Review

Make the Statement Correct

Underline the word or phrase that makes the statement correct.

1. The First Fleet sailed to (Hawaii/<u>Australia</u>). (p. 181)

2. (<u>Cook's</u>/Bougainville's) ship was almost sunk when it grounded on the Great Barrier Reef. (p. 179)

3. (Polynesia/<u>Micronesia</u>) means "small islands." (p. 173)

4. Australia is about the size of the (<u>United States</u>/Soviet Union). (p. 180)

5. The didgeridoo is a (<u>musical instrument</u>/crude hut). (p. 180)

6. Thor Heyerdahl sailed on the (First Fleet/<u>Kon-Tiki</u>) expedition. (pp. 173–74)

7. Alvaro de Mendaña explored on behalf of (<u>Spain</u>/England). (p. 175)

8. Captain James Cook died on the (<u>Hawaiian</u>/Solomon) Islands. (p. 179)

9. Louis Bougainville colonized (Australia/<u>Tahiti</u>) for France. (p. 178)

10. (<u>Gregory Blaxland</u>/James Chalmers) discovered a passage through the Great Dividing Range. (p. 183)

11. (Arthur Phillip/<u>James Chalmers</u>) served as a missionary to Papua New Guinea. (p. 174)

12. The (Tasmanians/<u>Maoris</u>) are native peoples who live in New Zealand. (p. 179)

13. Captain Cook fed his crew (tomatoes/<u>sauerkraut</u>) to help prevent scurvy. (p. 179)

14. (<u>Canberra</u>/Sydney) is the capital of Australia. (p. 185)

15. Abel Tasman sailed on behalf of (France/<u>the Netherlands</u>). (pp. 176–77)

16. Spanish exploration ended due to a lack of (<u>funds</u>/captains). (p. 176)

Teacher's Choice
Teachers, to help the student better prepare for the chapter test, feel free to add questions about other topics you may have covered.

17. _Question_ _____

18. _Question_ _____

19. _Question_ _____

20. _Question_ _____

SKILL: Recognition, Comprehension

Name _____

Map Study: Ming China

Locate the following on the map and place the number in the blank beside the term:

Beijing 5

Great Wall 1

Grand Canal 3

Manchuria 2

Pacific Ocean 4

Encounter with a Lion

Answer the questions below based on the following excerpt from Pierre du Jarric's account:

When the summer had come to an end, the King [Akbar] set out on his return journey to Lahor. He had desired . . . Xauier [a Catholic missionary] and his companion to travel with him; but the latter, anxious to avoid the commotion of the court, asked and obtained permission to go on before. On their journey they suffered much from cold and hunger, as well as from the badness of the road; for they had to go by rough paths which were often so narrow that there was room for only a single horseman. They were obliged, therefore, to travel very slowly and to stop frequently. Moreover, the elephant which carried their goods had great difficulty in climbing the mountains. Sometimes, feeling insecure on its feet, owing to the load which it carried, it supported itself with its trunk, making it serve the purpose of a staff.

At length, on the 13th of November, after many hardships, they arrived at Lahor, from whence they had set out on the 15th of May of the same year, 1597. The people of the town exhibited towards the [priest] and his companion a more friendly attitude than was their wont. It had previously been their practice to throw stones at them, and offer them other insults; but on this occasion they displayed neither incivility nor disrespect. The King and the Prince [Salim] arrived some days later, having lost on their way many horses and elephants, and several of their attendants. The Prince, too, had been in great danger of his life. One day, mounted on a female elephant without tusks, he went in pursuit of lions, and in the course of the chase, [encountered] some lion whelps. As these were but half grown, the elephant had no difficulty in killing them with her trunk. The next moment, however, the lioness their mother appeared, and in her rage would have hurled herself upon the Prince, had he not pierced her with an arrow as she was in the act of springing. But the wound was not [fatal], and the infuriated animal still strove to reach him who had struck her, to rend him with her claws and teeth. Again the Prince discharged his arquebus [weapon], piercing her through and through a second time; but the savage beast was not vanquished; and goaded to even greater fury, she sprang upon the elephant, and so nearly reached the Prince that he was splashed with the foam from her mouth. Seeing himself in such danger, he grasped his arquebus like a club, and with the [handle] dealt the lioness so severe a blow on the head, that she fell to the ground stunned. A soldier then came up and killed [the lioness] with his sword; but not before she had avenged herself on her last assailant, whom she tore severely with her claws. Perhaps it was our Saviour's will to save the Prince from this danger in order that the [Catholic] Church might increase, and many souls win salvation, when he came to the throne.

Pierre du Jarric. *Akbar and the Jesuits: An Account of the Jesuit Missions to the Court of Akbar.* Trans. C. H. Payne (New York: Harper and Brothers, 1926). 78–80.

1. What dangers did Xauier and his companion experience in their travels? _Road conditions were difficult, and_
 and the people of Lahor sometimes threw stones at them.

2. What animal attacked Prince Salim? _A female lion_

3. What did Salim do to protect himself? _He shot at the lion, then hit the lion on the head with his weapon._

4. According to Pierre du Jarric, why did God save Salim from danger? _So that the Catholic Church might grow_
 in Asia when Salim became king

Matching Exercise

Place the correct letter in the blank. Answers may be used more than once.

A. Manchu dynasty	D. Ottoman Empire
B. Ming dynasty	E. Safavid Empire
C. Mughal dynasty	F. Yuan dynasty

__F__ p. 190 1. Mongol rule in China

__B__ p. 191 2. Developed long, complex plays

__D__ p. 197 3. Destroyed the Byzantine Empire

__E__ p. 200 4. Shah Ismail I

__B__ p. 192 5. Built the Imperial City in China

__C__ p. 201 6. Babur

__A__ p. 194 7. Seized power in China during the seventeenth century

__B__ p. 191 8. Painted landscapes and perfected porcelain

__E__ p. 201 9. Abbas

__B__ p. 192 10. Restored the Grand Canal

__D__ p. 198 11. Developed a two-dimensional form of government

__B__ p. 194 12. Zheng He

__D__ p. 196 13. Anatolia

__B__ p. 190 14. Seized power in China during the fourteenth century

__C__ p. 202 15. Protected by the British East India Company

Matching Exercise, cont.

___D___ 16. Mehmet II
p. 196

___D___ 17. Welcomed Jews who were expelled from western Europe
p. 198

___C___ 18. Akbar
p. 202

___D___ 19. Istanbul
p. 197

___B___ 20. Taizu
p. 190

SKILL: Recognition, Comprehension

Map Study: Asia Minor

Locate the following on the map and place the number in the blank beside the term:

Anatolia	3
Arabian Sea	5
Constantinople	6
India	4
Mediterranean Sea	1
Safavid Empire	2

WORLD STUDIES

Name _____

CHAPTER 11 ACTIVITY 5

Chapter Review

Make the Statement Correct

Underline the word or phrase that makes the statement correct.

1. The Chinese perfected the production of (leather/<u>porcelain</u>). (pp. 190–91)

2. (India/<u>China</u>) referred to itself as the Middle Kingdom. (p. 190)

3. (Babur/<u>Ismail</u>) founded the Safavid dynasty. (p. 200)

4. (<u>Akbar</u>/Babur) was the most effective Mughal ruler. (p. 202)

5. The (<u>Ottomans</u>/Ming) built a strong empire that endured for six centuries. (p. 197)

6. (<u>Babur</u>/Ismail) was a descendant of Chinggis Khan and Tamerlane. (p. 201)

7. Zheng He sailed on behalf of (India/<u>China</u>). (p. 194)

8. (<u>Manchuria</u>/India) lies north of China. (pp. 190, 195 [see maps on these pages])

9. The (<u>Ming</u>/Manchu) dynasty reconstructed the Grand Canal. (p. 192)

10. The Ottomans were among the first to use (longbows/<u>small cannons</u>) in battle. (p. 197)

11. The Safavid Empire embraced the (<u>Shiite</u>/Sunni) interpretation of Islam. (p. 200)

12. (Turkish/<u>Afghan</u>) forces overthrew the Safavid Empire in 1722. (p. 201)

13. The (<u>Ottoman</u>/Manchu) Empire viewed merchants and artisans as essential to the empire's economic success. (p. 198)

14. The Ottomans destroyed the Byzantine Empire and renamed its capital city (Constantinople/<u>Istanbul</u>). (pp. 196–97)

15. The Ottoman Empire was initially dominated by (<u>Turks</u>/Mongols). (p. 196)

16. (Chengzu/<u>Taizu</u>) founded the Ming dynasty. (p. 190)

Teacher's Choice
Teachers, to help the student better prepare for the chapter test, feel free to add questions about other topics you may have covered.

17. Question _____

18. Question _____

19. Question _____

20. Question _____

SKILL: Recognition, Comprehension

The Three Estates of France

Matching Exercise

Place the correct letter(s) in the blank. Answers will be used more than once, and more than one answer may occasionally be correct.

A. First Estate

B. Second Estate

C. Third Estate

1. __A__ Clergy

2. __B__ Nobility

3. __C__ Merchants

4. __C__ City laborers

5. __C__ Rural laborers

6. __C__ Twenty-four million members

7. __A__ One hundred twenty thousand members

8. __B__ Three hundred fifty thousand members

9. __A__ Controlled vast land estates in France and owned valuable properties in the cities

10. __B__ Owned about twenty percent of the land in France

11. __A__ About half a percent of the French population belonged to this group.

12. __C__ Bore the heaviest tax burden in France

13. __A__ Paid the fewest taxes in France

14. __A & B__ Exempt from most taxes in France

15. __C__ Required to perform feudal obligations

16. __C__ Included the middle class

17. __C__ Forced to pay fees to use mills, wine presses, and bakeries

18. __C__ Formed the National Assembly and signed the Tennis Court Oath

19. __C__ Signed the Declaration of the Rights of Man

20. __A & B__ Received preference when Louis XVI convened the Estates-General

SKILL: Recognition, Comprehension

The Battle of Waterloo

Answer the questions at the end based on the following excerpts from the writings of Captain R. H. Gronow, a British officer:

[June 18, 1815]

. . . On the morning of the 18th the sun shone most gloriously, and so clear was the atmosphere that we could see the long, imposing lines of the enemy most distinctly. Immediately in front of the division to which I belonged, and, I should imagine, about half a mile from us, were posted cavalry and artillery; and to the right and left the French had already engaged us, attacking Huguemont and La Haye Sainte. We heard incessantly [endlessly] the measured boom of artillery, accompanied by the incessant rattling echoes of musketry.

The whole of the British infantry not actually engaged were at that time formed into squares; and as you looked along our lines, it seemed as if we formed a continuous wall of human beings. I recollect distinctly being able to see Bonaparte and his staff; and some of my brother officers using the glass [telescope], exclaimed, "There he is on his white horse." I should not forget to state that when the enemy's artillery began to [fire] on us, we had orders to lie down: we could hear the shot and shell whistling around us, killing and wounding great numbers; then again we were ordered on our knees to receive cavalry. The French artillery, which consisted of three hundred guns,—though we did not muster more than half that number,—committed terrible havoc during the early part of the battle, whilst we were acting on the defensive.

About four P.M. the enemy's artillery in front of us ceased firing all of a sudden, and we saw large masses of cavalry advance: not a man present who survived could have forgotten in [later] life the awful grandeur of that charge. You [perceived] at a distance what appeared to be an overwhelming, long moving line, which, ever advancing, glittered like a stormy wave of the sea when it catches the sunlight. On came the mounted host until they got near enough, [while] the . . . earth seemed to vibrate beneath their thundering tramp. One might suppose that nothing could have resisted the shock of this terrible moving mass. They were the famous cuirassiers, almost all old soldiers, who had distinguished themselves on most of the battle-fields of Europe. In an almost incredibly short period they were within twenty yards of us, shouting "*Vive l'Empereur!*" [When the] word of command, "Prepare to receive cavalry," had been given, every man in the front ranks knelt, and a wall bristling with steel, held together by steady hands, presented itself to the infuriated cuirassiers. . . .

The charge of the French cavalry was gallantly executed; but our well-directed fire brought men and horses down, and ere long the utmost confusion arose in their ranks. The officers were exceedingly brave, and by their gestures and fearless bearing did all in their power to encourage their men to form again and renew the attack. . . .

It was about five o'clock on that memorable day, that we suddenly received orders to retire behind an elevation in our rear. The enemy's artillery had come up [together] within a hundred yards of us. By the time they began to [fire] their guns, however, we were lying down behind the rising ground, and protected by the ridge before referred to. The enemy's cavalry was in the rear of their artillery, in order to be ready to protect it if attacked; but no attempt was made on our part to do so. After they had pounded away at us for about half an hour, they deployed, and up came the whole mass of the Imperial infantry of the Guard, led on by the emperor in person. We had now before us probably about 20,000 of the best soldiers in France,

the heroes of many memorable victories; we saw the bear-skin caps rising higher and higher, as they ascended the ridge of ground which separated us and advanced nearer and nearer to our lines.

It was at this moment that the Duke of Wellington gave his famous order for our bayonet charge, as he rode along the line: these are the precise words he made use of—"Guards, get up and charge!" We were instantly on our legs, and after so many hours of inaction and irritation at maintaining a purely defensive attitude [position],—all the time suffering the loss of comrades and friends,—the spirit which animated officers and men may easily be imagined. After firing a volley as soon as the enemy were within shot, we rushed on with fixed bayonets, and that hearty hurrah peculiar to British soldiers.

Joseph Grego. *The Reminiscences and Recollections of Captain Gronow: Being Anecdotes of the Camp, Court, Clubs, and Society, 1810–1860.* Vol. 1 (London: John C. Nimmo, 1900). 2 vols. 68–70, 73–74.

1. Whom could the British officers see through a telescope? <u>Napoleon Bonaparte and his staff</u>

2. How does Gronow describe the French cavalry charge? <u>The riders were experienced soldiers who formed a</u> <u>"terrible moving mass." Their equipment "glittered like a . . . wave" in the sun, and the force of their charge seemed to</u> <u>make the "earth . . . vibrate."</u>

3. How many French soldiers composed the French Imperial infantry of the Guard? <u>About 20,000</u>

4. Who personally led the French Imperial infantry of the Guard? <u>The emperor (Napoleon)</u>

5. Which British officer gave orders for the bayonet charge? <u>The Duke of Wellington</u>

SKILL: Original Sources, Comprehension

Name _____

Map Study: Europe

Locate the following on the map and place the number in the blank beside the term:

8 Atlantic Ocean

6 Austrian Empire

5 Britain

1 France

3 Germany

4 Italy

7 Mediterranean Sea

2 Russia

Chapter Review
Make the Statement Correct

Underline the word or phrase that makes the statement correct.

1. The First Estate was composed of (merchants/<u>clergy</u>). (p. 210)

2. (<u>France</u>/Germany) endured the Reign of Terror in the eighteenth century. (p. 213)

3. (France/<u>Germany</u>) achieved unification in 1871. (p. 218)

4. France was predominantly a (Protestant/<u>Catholic</u>) nation. (p. 210)

5. The Tennis Court Oath was taken in (<u>France</u>/Germany). (p. 212)

6. Napoleon was forced to retreat and leave most of his army in (<u>Russia</u>/Germany). (p. 215)

7. Count Camillo di Cavour became the prime minister of (England/<u>Sardinia</u>). (p. 220)

8. Marie-Antoinette became the queen of (<u>France</u>/England). (p. 211)

9. (Louis XIV/<u>Louis XVI</u>) was king at the beginning of the French Revolution. (p. 211)

10. (Garibaldi/<u>Mazzini</u>) was an Italian nationalist who formed the group Young Italy. (p. 220)

11. Napoleon was finally defeated at (Leipzig/<u>Waterloo</u>) in 1815. (pp. 215–16)

12. Eastern Poland came under the domination of (<u>Russian</u>/Austrian) forces in the 1820s. (pp. 217–18)

13. (<u>Napoleon</u>/Bismarck) became the First Consul of France. (p. 215)

14. The Belgians revolted and gained their independence from (<u>the Netherlands</u>/Austria). (p. 217)

15. The Zollverein was an economic union that played a role in the unification of (Italy/<u>Germany</u>). (p. 218)

16. Voltaire was an Enlightenment philosopher from (England/<u>France</u>). (p. 210)

Teacher's Choice
Teachers, to help the student better prepare for the chapter test, feel free to add questions about other topics you may have covered.

17. _Question_ _____

18. _Question_ _____

19. _Question_ _____

20. _Question_ _____

Edison, the Inventor

Answer the questions at the end based on the following excerpts from Edison's writings:

I never allow myself to become discouraged under any circumstances. I recall that after we had conducted thousands of experiments on a certain project without solving the problem, one of my associates . . . expressed discouragement and disgust over our having failed "to find out anything." I cheerily assured him that we *had* learned something. For we had learned for a certainty that the thing couldn't be done that way, and that we would have to try some other way. We sometimes learn a lot from our failures if we have put into the effort the best thought and work we are capable of. . . .

Deafness has done many good things for the world. In my own case it has been responsible, I think, for the perfection of the phonograph; and it had something to do with the development of the telephone into usable form. When Bell first worked out his telephone idea I tried it and the sound which came in through the instrument was so weak I couldn't hear it. I started to develop it and kept on until the sounds were audible to me. I sold my improvement, the carbon transmitter, to the Western Union and they sold it to Bell. It made the telephone successful. If I had not been deaf it is possible and even probable that this improvement would not have been made. The telephone as we now know it might have been delayed if a deaf electrician had not undertaken the job of making it a practical thing.

The phonograph never would have been what it now is and for a long time has been if I had not been deaf. Being deaf, my knowledge of sounds had been developed till it was extensive and I knew that I was not [getting overtones] and no one else was getting overtones. Others working in the same field did not realize this imperfection, because they were not deaf. Deafness, pure and simple, was responsible for the experimentation which perfected the machine. It took me twenty years to make a perfect record of piano music because it is full of overtones. I now can do it—just because I'm deaf.

My deafness has been a definite advantage in my business, too, in more ways than one. The fact that I do not rely on verbal agreements and reports is one reason for this. There would be a chance that I might not hear them perfectly. So I have everything set down in black and white. That has saved me certain difficulties which I might have had if I had been acute of hearing. My deafness never has prevented me from making money in a single instance. It has helped me many times. It has been an asset to me always.

Even in my courtship my deafness was a help. In the first place it excused me for getting quite a little nearer to her than I would have dared to if I hadn't had to be quite close in order to hear what she said. If something had not overcome my natural bashfulness I might have been too faint of heart to win. And after things were actually going nicely, I found hearing unnecessary.

My later courtship was carried on by telegraph. I taught the lady of my heart the Morse code, and when she could both send and receive we got along much better than we could have with spoken words by tapping our remarks to one another on our hands. Presently I asked her thus, in Morse code, if she would marry me. The word "Yes" is an easy one to send by telegraphic signals, and she sent it. If she had been obliged to speak it she might have found it harder. Nobody knew anything about many of our conversations on a long drive in the White Mountains. If we had spoken words, others would have heard them. We could use pet names without the

least embarrassment, although there were three other people in the carriage. We still use the telegraphic code at times. When we go to hear a spoken play she keeps her hand upon my knee and telegraphs the words the actors use so that I know some-thing about the drama though I hear nothing of the [dialogue].

Thomas Alva Edison. *The Diary and Sundry Observations of Thomas Alva Edison.* Ed. Dagobert D. Runes (New York: Philosophical Library, 1948). 43, 53–55.

1. How did Edison avoid becoming discouraged? He learned from his failures. _____

2. What disability helped him improve two inventions? He had a hearing disability which he describes as _____ "deafness." _____

3. How did he turn his disability into a business advantage? He had "everything set down in black and white" _____ (in writing). He used his deafness to improve inventions. _____

4. How did Edison communicate with his bride-to-be? He communicated with her using Morse Code. _____

5. How did Edison understand the drama of a spoken play with the help of his wife? She telegraphed the _____ words of the actors (by tapping the words) on his knee. _____

SKILL: Comprehension, Original Sources

The Wright Brothers

Answer the questions at the end based on the following excerpts from the Wright brothers' account:

We began our active experiments . . . in October, 1900, at Kitty Hawk, North Carolina. Our machine [airplane] was designed to be flown as a kite, with a man on board, in winds from 15 to 20 miles an hour. But, upon trial, it was found that much stronger winds were required to lift it. Suitable winds not being plentiful, we found it necessary, in order to test the new balancing system, to fly the machine as a kite without a man on board, operating the levers through cords from the ground. This did not give [us] the practice [we] anticipated, but it inspired confidence in the new system of balance.

In the summer of 1901 we became personally acquainted with Mr. [Octave] Chanute. When he learned that we were interested in flying as a sport, and not with any expectation of recovering the money we were expending on it, he gave us much encouragement. At our invitation, he spent several weeks with us at our camp at Kill Devil Hill, four miles south of Kitty Hawk, during our experiments of that and the two succeeding years. He also witnessed one flight of the power machine near Dayton, Ohio, in October, 1904.

The machine of 1901 was built with the shape of surface used by Lilienthal, curved from front to rear like the segment of a parabola, with a curvature 1/12 the depth of its cord; but to make doubly sure that it would have sufficient lifting capacity when flown as a kite in 15 or 20-mile winds, we increased the [plane's] area from 165 square feet, used in 1900, to 308 square feet—a size much larger than Lilienthal, Pilcher, or Chanute had deemed safe. Upon trial, however, the lifting capacity again fell very far short of calculation, so that the idea of [getting] practice while flying [the plane] as a kite had to be abandoned. Mr. Chanute, who witnessed the experiments, told us that the trouble was not due to poor construction of the machine. We saw only one other explanation—that the tables of air-pressures in general use were incorrect.

We then turned to gliding—coasting downhill on the air—as the only method of getting the desired practice in balancing a machine. After a few minutes' practice we were able to make glides of over 300 feet, and in a few days were safely operating in 27-mile winds. In these experiments we met with several unexpected phenomena. We found that, contrary to the teachings of the books, the center of pressure on a curved surface traveled backward when the surface was inclined, at small angles, more and more edgewise to the wind. We also discovered that in free flight, when the wing on one side of the machine was presented to the wind at a greater angle than the one on the other side, the wing with the greater angle descended, and the machine turned in a direction just the reverse of what we were led to expect when flying the machine as a kite. The larger angle gave more resistance to forward motion, and reduced the speed of the wing on that side. The decrease in speed more than counterbalanced the effect of the larger angle. The addition of a fixed vertical vane in the rear increased the trouble, and made the machine absolutely dangerous. It was some time before a remedy was discovered. This consisted of movable rudders working in conjunction with the twisting of the wings. The details of this arrangement are given in specifications published several years ago.

The Early History of the Airplane by Orville and Wilbur Wright. Public Domain.

1. Where did Orville and Wilbur Wright start actively experimenting with airplanes? _Kitty Hawk, North_ _Carolina_

2. What was the size of the Wrights' plane in square feet? _308 square feet_

3. How far were the Wrights able to fly the airplane? _Over 300 feet_

4. What was the highest wind gust during their experiments? _27 mph_

In September and October, 1902, nearly 1,000 gliding flights were made, several of which covered distances of over 600 feet. Some, made against a wind of 36 miles an hour, gave proof of the effectiveness of the devices for control [steering]. With this machine, in the autumn of 1903, we made a number of flights in which we remained in the air for over a minute, often soaring for a considerable time in one spot, without any descent at all. Little wonder that our unscientific assistant should think the only thing needed to keep it indefinitely in the air would be a coat of feathers to make it light!

The Early History of the Airplane by Orville and Wilbur Wright. Public Domain.

5. What did the flights made in winds of 36 miles per hour allow the Wright brothers to demonstrate?
 The "effectiveness of the devices for control [steering]"

6. According to the Wrights' assistant, what would enable the plane to remain airborne indefinitely?
 "A coat of feathers"

SKILL: Comprehension, Original Sources

"Thoughts upon Slavery"—John Wesley

Answer the questions below based on the following excerpts from Wesley's writings:

That part of Africa whence the Negroes are brought, commonly known by the name of Guinea, extends along the coast, in the whole, between three and four thousand miles. From the river Senegal, seventeen degrees north of the line, to Cape Sierra-Leone, it contains seven hundred miles. Thence it runs eastward about fifteen hundred miles, including the Grain Coast, the Ivory Coast, the Gold Coast, and the Slave Coast, with the large kingdom of Benin. From thence it runs southward, about twelve hundred miles, and contains the kingdoms of Congo and Angola. . . .

Upon the whole, . . . the Negroes who inhabit the coast of Africa, from the river Senegal to the southern bounds of Angola, are so far from being the stupid, senseless, brutish, lazy barbarians, the fierce, cruel, perfidious [deceitful] savages they have been described, that, on the contrary, they are . . . remarkably sensible, considering the few advantages they have for improving their understanding; as industrious to the highest degree, perhaps more so than any other natives of so warm a climate; as fair, just, and honest in all their dealings, unless where white men have taught them to be otherwise; and as far more mild, friendly, and kind to strangers, than any of our forefathers were. *Our forefathers!* Where shall we find at this day, among the fair-faced natives of Europe, a nation generally practicing the justice, mercy, and truth, which are found among these poor Africans? . . . [W]e may leave England and France, to seek genuine honesty in Benin, Congo, or Angola. . . .

Is there a God? You know there is. Is he a just God? Then there must be a state of retribution; a state wherein the just God will reward every man according to his works. Then what reward will he render to you? O think [quickly]! before you drop into eternity! Think now, "He shall have judgment without mercy that showed no mercy."

Are you a man? Then you should have an human heart. But have you indeed? What is your heart made of? Is there no such principle as compassion there? Do you never feel another's pain? Have you no sympathy, no sense of human woe, no pity for the miserable? When you saw the flowing eyes, the heaving breasts, or the bleeding sides and tortured limbs of your fellow-creatures, was you a stone, or a brute? Did you look upon them with the eyes of a tiger? When you squeezed the agonizing creatures down in the ship, or when you threw their poor mangled remains into the sea, had you no relenting? Did not one tear drop from your eye, one sigh escape from your breast? Do you feel no relenting now? If you do not, you must go on, till the measure of your iniquities is full. Then will the great God deal with you as you have dealt with them, and require all their blood at your hands. And at "that day it shall be more tolerable for Sodom and Gomorrah than for you!" But if your heart does relent, though in a small degree, know it is a call from the God of love. And "to-day, if you will hear his voice, harden not your heart." To-day resolve, God being your helper, to escape for your life. . . . Immediately quit the horrid [slave] trade: At all events, be an honest man.

John Wesley. "Thoughts upon Slavery." *The Works of John Wesley*. 3rd ed. Vol. 11 (Grand Rapids, MI: Baker Books, 2007). 14 Vols. 61, 64–65, 76–77.

1. From what African kingdoms and regions were the slaves brought? <u>Benin, Congo, Angola, Guinea,</u>
<u>Sierra-Leone, the Grain Coast, the Ivory Coast, the Gold Coast, the Slave Coast, and Senegal</u>

2. What two countries does Wesley describe as not having genuine honesty when compared with the Africans? _England and France_____

3. What will God do to those who fail to show mercy to others? _He will give them "judgment without mercy."_____

4. According to Wesley, what are two proper human attitudes toward slaves? _Accept any two of the following:_____ _compassion, sympathy, pity, repentance, and mercy._____

5. According to Wesley, what should the British do about the slave trade in order to be honest men? _Quit and end it immediately_____

Liberty is the right of every human creature, as soon as he breathes the vital air; and no human law can deprive him of that right which he derives from the law of nature.

If, therefore, you have any regard to justice, (to say nothing of mercy, nor the revealed law of God,) render unto all their due. Give liberty to whom liberty is due, that is, to every child of man, to every partaker of human nature. Let none serve you but by his own act and deed, by his own voluntary choice. Away with all whips, all chains, all [force]! Be gentle toward all men; and see that you . . . do unto every one as you would he should do unto you. . . .

O thou God of love, thou who art loving to every man, and whose mercy is over all thy works; thou who art the Father of the spirits of all flesh, and who art rich in mercy unto all; thou who hast mingled of one blood all the nations upon earth; have compassion upon these outcasts of men, who are trodden down as dung upon the earth! Arise, and help these that have no helper, whose blood is spilt upon the ground like water! Are not these also the work of thine own hands, the purchase of thy Son's blood? Stir them up to cry unto thee in the land of their captivity; and let their complaint come up before thee; let it enter into thy ears! Make even those that lead them away captive . . . pity them, and turn their captivity as the rivers in the south. O burst thou all their chains in sunder; more especially the chains of their sins! Thou Saviour of all, make them free, that they may be free indeed!

John Wesley. "Thoughts upon Slavery." *The Works of John Wesley.* 3rd ed. Vol. 11 (Grand Rapids, MI: Baker Books, 2007). 14 Vols. 79.

6. What is the right of every human creature? _Liberty_____

7. What characteristics of God are mentioned in Wesley's prayer? _He is loving, compassionate, and merciful to_____ _every man._____

8. What two kinds of freedom does Wesley pray for the Africans to receive? _Freedom from slavery and_____ _freedom from sin_____

SKILL: Comprehension, Original Sources

Letter from John Wesley to William Wilberforce

Answer the questions below based on the following letter by Wesley:

DEAR SIR, LONDON, *February* 26, 1791.

UNLESS the divine power has raised you up to be [one man against the world], I see not how you can go through your glorious enterprise, in opposing that [wickedness], which is the scandal of religion, of England, and of human nature. Unless God has raised you up for this very thing [of ending slavery], you will be worn out by the opposition of men and devils. But, "if God be for you, who can be against you?" Are all of them together stronger than God? O "be not weary in well doing!" Go on, in the name of God and in the power of his might, till even American slavery (the vilest that ever saw the sun) shall vanish away before it.

Reading this morning a tract, wrote by a poor African, I was particularly struck by that circumstance,—that a man who has a black skin, being wronged or outraged by a white man, can have no [justice]; it being a law, in all our colonies, that the oath of a black against a white goes for nothing. What [injustice] is this!

That He who has guided you from your youth up, may continue to strengthen you in this and all things, is the prayer of [John Wesley.]

John Wesley. "Letter to a Friend." *The Works of John Wesley*. 3rd ed. Vol. 13 (Grand Rapids, MI: Baker Books, 2007). 14 Vols. 153.

1. With what scriptural phrases does Wesley encourage Wilberforce? "If God be for you, who can be against you?" and "Be not weary in well doing."

2. According to Wesley, what country practiced "the vilest" form of slavery? America

3. What had Wesley recently read that described the injustices suffered by slaves? A tract written by "a poor African"

4. What did Wesley pray for Wilberforce? That He Who had guided Wilberforce in the past might continue to strengthen him in the future

"On the Horrors of the Slave Trade"

Answer the questions below based on the following speech by William Wilberforce:

[Delivered in the House of Commons on May 12, 1789]

In opening, concerning the nature of the slave trade, I need only observe that it is found by experience to be just such as every man who uses his reason would infallibly conclude it to be. For my own part, so clearly am I convinced of the mischiefs inseparable from it, that I should hardly want any further evidence than my own mind would [provide], by the most simple deductions. Facts, however, are now laid before the House. A report has been made by his majesty's privy council, which, I trust, every gentleman has read, and which [confirms] the slave trade to be just as we know. What should we suppose must naturally be the consequence of our carrying on a slave trade with Africa? With a country vast in its extent, not utterly barbarous, but civilized in a very small degree? Does any one suppose a slave trade would help their civilization? Is it not plain that she must suffer from it; that civilization must be [stopped]; that her barbarous manners must be made more barbarous; and that the happiness of her millions of inhabitants must be [injured by] her [slave trade] with Britain? Does not every one see that a slave trade carried on around her coasts must carry violence and desolation to her very center? That in a continent just emerging from barbarism, if a trade in [slavery] is established, if her men are all converted into goods, and become commodities that can be bartered, [then] they must be subject to [abuse] just as goods are; and this, too, at a period of civilization, when there is no . . . legislature to defend this, their only sort of property, in the same manner as the rights of property are maintained by the legislature of every civilized country. . . .

Sir, the nature and all the circumstances of this trade are now laid open to us; we can no longer plead ignorance, we can not evade it; it is now an object placed before us, we can not pass it; . . . we can not turn aside so as to avoid seeing it; for it is brought now so directly before our eyes that this House must decide . . . the [rightness] of the grounds and principles of their decision.

http://en.wikisource.org/wiki/On_the_Horrors_of_the_Slave_Trade

1. Before what assembly did Wilberforce present this speech? __Britain's House of Commons__

2. According to Wilberforce, what effects would the slave trade have on Africa? __The slave trade would keep__
 Africa's inhabitants from becoming fully civilized, promote violence in the land, and make the Africans nothing more
 than objects for trade.

3. According to Wilberforce, what could Africa have achieved if there had been no slave trade?
 Africa could have emerged from "barbarism" (and become civilized by European standards).

4. According to Wilberforce, what could the British no longer plead regarding the African slave trade?
 Ignorance

SKILL: Comprehension, Original Sources

Chapter Review

Matching Exercise

Place the correct letter in the blank.

A. Cotton gin
B. Entrepreneur
C. Flying shuttle
D. Former slave; abolitionist
E. Former slave-ship captain; abolitionist
F. Great Awakening
G. Methodist leader
H. Newspaper editor; abolitionist

I. Reaping machine
J. Seed drill
K. Spinning jenny
L. Steam engine
M. Steam tractor
N. Threshing machine
O. Worked in Parliament to end slavery

J p. 227 1. Jethro Tull

N p. 227 2. Andrew Meikle

A p. 228 3. Eli Whitney

I p. 228 4. Cyrus McCormick

M p. 229 5. John Fowler

L p. 230 6. James Watt

C p. 230 7. John Kay

K p. 231 8. James Hargreaves

B p. 231 9. Richard Arkwright

G p. 235 10. John Wesley

F p. 236 11. George Whitefield

E p. 237 12. John Newton

O p. 237 13. William Wilberforce

H p. 239 14. William Lloyd Garrison

D p. 239 15. Frederick Douglass

Teacher's Choice
Teachers, to help the student better prepare for the chapter test, feel free to add questions about other topics you may have covered.

16. ___Question___

17. <u>Question</u> _____

18. <u>Question</u> _____

19. <u>Question</u> _____

20. <u>Question</u> _____

SKILL: Recognition, Comprehension

The Dreyfus Affair

Answer the questions at the end based on the following fictionalized account of the Dreyfus Affair:

I can still remember that cold day in January 1894. Having just turned fourteen, I had recently found a job as an apprentice at the town bakery. Rushing to my first day of work, I heard a commotion in the town square. As a crowd grew and the noise swelled, my curiosity overcame my urgency, and I stopped to learn the cause of such a stir in our town. I still remember my shock at the scene. Soldiers were restraining an artillery captain who frantically shouted to them and the gathered citizens.

"I am innocent! *Vive la France!* I am an innocent man!"

Eager to get a better view, I pushed my way through the crowd until I stood just a few feet from the captain and those who held him tightly. Soon an officer stepped forward and proceeded to read a charge of *treason*! As we stood in stunned surprise, a sergeant advanced and ripped the shiny buttons from the captain's uniform, tossing them into the half-frozen mud. I remember flinching at the sound of shredding fabric when he yanked the stripes and other military emblems from the captain's coat and trousers. In a final gesture of utter contempt, the sergeant took the captain's dress sword, snapped it over his knee, and cast the broken weapon aside.

The nervous man, identified as a Captain Dreyfus, continued to declare his innocence, but the crowd soon drowned out his cries with insults and taunts. I must confess that I joined in this chorus and called him names that I now am ashamed to repeat. *But*, I thought, *he must be guilty! Surely the army would not condemn an innocent man.*

To complete the captain's humiliation, the soldiers force-marched him around the square amid the continued outcries of the onlookers. Then they tied his hands and carried him off in a prison wagon.

By this time, I had recollected how angry the baker would be over my late appearance. Dreading a box on the ears, I quickly scurried off to his shop. But upon arriving, I was relieved to find that, save for a sharp rebuke, all of his energy was bent toward finding out the details of the captain's arrest. I retold the story in true sensational fashion for a rapt audience of bakery workers and patrons.

But life continued on and, being preoccupied with our own affairs, I and my neighbors soon forgot about the captain until one day late in the fall. Near closing time, a regular customer excitedly barged into the bakery to announce the conviction of Captain Dreyfus for treason! His sentence (recounted in an ominous tone) was captivity for life in the infamous prison at Devil's Island, French Guiana. I believe all of us shuddered to think of being sent to that place! We later heard that the authorities had even placed him in isolation in a small, cramped cell! I wondered how anyone could long survive such unbearable conditions.

Two years later, the baker moved me to the front of the shop to wait on patrons, giving me many more opportunities to catch the latest gossip. One day, a customer came in with astonishing news. Apparently, the military had discovered the real traitor, but had then covered up the evidence! No one seemed to know the details, but, now uncertain, I paused as memories of my own behavior that day rushed back to haunt me. I felt terrible for the things I had shouted with the crowd. *Surely*, I thought, *the authorities will set the innocent captain free!*

But three more years passed, and Captain Dreyfus continued to languish in prison. By this time, I was nearly twenty years old and still working at the bakery. One mild day at the tail end of summer, the doorbell jingled as one of our regulars entered. As I looked up to greet him, the excitement on his face stopped me. He had visited the bakery to tell us that Captain Dreyfus had finally gained his freedom! Oh, the relief we all felt! Such a thing had weighed heavily on our consciences.

It was not until a few years later that I learned the captain's Jewish heritage was the main motivation behind the false accusations. I still wince at the memory of my disappointment and shame. To know that people in my country would commit such shameful acts against a man simply because of prejudice against his ancestry!

1. What crime was Alfred Dreyfus accused of committing? _Treason_

2. What did Dreyfus shout to the soldiers and the crowd? _"I am innocent! Vive la France! I am an innocent man!"_

3. What did the army do to humiliate him? _They ripped the buttons off his uniform, tore off his military emblems, broke his sword, and made him march in front of a crowd._

4. After convicting him of treason, where did the French government send Dreyfus to serve his sentence? _Devil's Island in French Guiana_

5. How many years did Dreyfus remain in prison before his release? _Five years (The narrator was fourteen when the authorities arrested Dreyfus and nearly twenty when Dreyfus regained his freedom.)_

6. Why did the French government keep Dreyfus in prison after he was proven innocent? _The authorities were prejudiced against his Jewish heritage._

SKILL: Comprehension, Original Sources

Hard Times

Answer the questions at the end based on the following excerpts from Charles Dickens's work:

[from Part I, ch. 11]

The [factories] burst into illumination, before pale morning showed the monstrous serpents of smoke trailing themselves over Coketown. A clattering of clogs [shoes] upon the pavement; a rapid ringing of bells; and all the melancholy mad elephants, polished and oiled up for the day's monotony, were at their heavy exercise again.

Stephen bent over his loom, quiet, watchful, and steady. A special contrast, as every man was in the forest of looms where Stephen worked, to the crashing, smashing, tearing piece of mechanism at which he laboured. . . .

So many hundred Hands [workers] in this Mill; so many hundred horse Steam Power. . . .

The day grew strong, and showed itself outside, even against the flaming lights within. The lights were turned out, and the work went on. The rain fell, and the Smoke-serpents, submissive to the curse of all that tribe, trailed themselves upon the earth. In the waste-yard outside, the steam from the escape pipe, the litter of barrels and old iron, the shining heaps of coals, the ashes everywhere, were shrouded in a veil of mist and rain.

The work went on, until the noon-bell rang. More clattering upon the pavements. The looms, and wheels, and Hands all out of gear for an hour.

Stephen came out of the hot mill into the damp wind and cold wet streets, haggard and worn. He turned from his own class and his own quarter, taking nothing but a little bread as he walked along, towards the hill on which his principal employer lived, in a red house with black outside shutters, green inside blinds, a black street door, up two white steps, BOUNDERBY (in letters very like himself) upon a brazen plate, and a round brazen door-handle underneath it. . . .

[from Part II, ch. 1]

The streets were hot and dusty on the summer day, and the sun was so bright that it even shone through the heavy vapour drooping over Coketown, and could not be looked at steadily. Stokers emerged from low underground doorways into factory yards, and sat on steps, and posts, and palings, wiping their swarthy [faces], and contemplating coals. The whole town seemed to be frying in oil. There was a stifling smell of hot oil everywhere. The steam-engines shone with it, the dresses of the Hands were soiled with it, the mills throughout their many stories oozed and trickled it. The atmosphere of those [factories] was like the breath of the simoom [desert wind]: and their inhabitants, wasting with heat, toiled languidly in the desert. But no temperature made the melancholy mad elephants more mad or more sane. Their wearisome heads went up and down at the same rate, in hot weather and cold, wet weather and dry, fair weather and foul. The measured motion of their shadows on the walls, was the substitute Coketown had to show for the shadows of rustling woods; while, for the summer hum of insects, it could offer, all the year round, from the dawn of Monday to the night of Saturday, the whirr of shafts and wheels.

Drowsily they whirred all through this sunny day, making the passenger more sleepy and more hot as he passed the humming walls of the mills. Sun-blinds, and sprinklings of water, a little cooled the main streets and the shops; but the mills, and

the courts and alleys, baked at a fierce heat. Down upon the river that was black and thick with dye, some Coketown boys who were [playing]—a rare sight there—rowed a crazy boat, which made a spumous [foamy] track upon the water as it jogged along, while every dip of an oar stirred up vile smells. But the sun itself, however beneficent, generally, was less kind to Coketown than hard frost, and rarely looked intently into any of its closer regions without engendering more death than life.

Hard Times by Charles Dickens. Public Domain.

1. The mill in Dickens's story is located in what imaginary city? <u>Coketown</u>

2. To what animal does Dickens compare the large, polished, and oiled machines? <u>An elephant</u>

3. What term does Dickens use in the first paragraph to illustrate that factory work was very boring?
 <u>"Monotony"</u>

4. With what machine is Stephen working? <u>A loom</u>

5. What powers the machines in this story? <u>Steam</u>

SKILL: Comprehension, Original Sources

Charles Darwin

Answer the questions at the end based on the following excerpts from Darwin's autobiography:

. . . After [I had] spent two sessions in Edinburgh, my father perceived, or he heard from my sisters, that I did not like the thought of being a physician, so he proposed that I should become a clergyman [pastor]. He was very properly [set] . . . against my turning into an idle sporting man, which then seemed my probable destination. I asked for some time to consider, as from what little I had heard or thought on the subject I had scruples about declaring my belief in all the dogmas of the Church of England; though otherwise I liked the thought of being a country clergyman. Accordingly I read with care Pearson on the *Creed,* and a few other books on divinity; and as I did not then in the least doubt the strict and literal truth of every word in the Bible, I soon persuaded myself that our Creed must be fully accepted.

Considering how fiercely I have been attacked by the orthodox [Christians], it seems ludicrous that I once intended to be a clergyman. Nor was this intention and my father's wish ever formally given up, but died a natural death when, on leaving Cambridge, I joined the *Beagle* as naturalist. If the phrenologists [those who study the shape and bumps of a person's skull] are to be trusted, I was well fitted in one respect to be a clergyman. A few years ago the secretaries of a German psychological society asked me earnestly by letter for a photograph of myself; and some time afterwards I received the proceedings of one of the meetings, in which it seemed that the shape of my head had been the subject of a public discussion, and one of the speakers declared that I had the bump of reverence developed enough for ten priests.

As it was decided that I should be a clergyman, it was necessary that I should go to one of the English universities and take a degree; but as I had never opened a classical book since leaving school, I found to my dismay, that in the two intervening years I had actually forgotten, incredible as it may appear, almost everything which I had learnt, even to some few of the Greek letters. I did not therefore proceed to Cambridge at the usual time in October, but worked with a private tutor in Shrewsbury, and went to Cambridge after the Christmas vacation, early in 1828. I soon recovered my school standard of knowledge, and could translate easy Greek books, such as Homer and the Greek [New] Testament, with moderate facility [ease]. . . .

During the intervening years, Darwin sailed on the Beagle *(1831–36), became the Secretary of the Geological Society, married Emma Wedgwood, and continued his study of geology and natural selection.*

In September 1858 I set to work by the strong advice of Lyell and Hooker to prepare a volume on the transmutation of species, but was often interrupted by ill-health, and short visits to . . . [the medical] establishment at Moor Park. I [continued to write my manuscript] . . . and completed the volume. . . . It cost me thirteen months and ten days' hard labour. It was published under the title of the *Origin of Species*, in November 1859. Though considerably added to and corrected in the later editions, it has remained substantially the same book.

It is no doubt the chief work of my life. It was [immediately] highly successful. The first small edition of 1250 copies was sold on the day of publication, and a second edition of 3000 copies soon afterwards. Sixteen thousand copies have now (1876) been sold in England; and considering how stiff a book it is, this is a large sale. It has been translated into almost every European tongue, even into such languages as Spanish, Bohemian [Czech or Slovak], Polish, and Russian. . . . Even an

essay in Hebrew has appeared on it, showing that the theory is contained in the Old Testament!

The Autobiography of Charles Darwin by Charles Darwin, edited by Sir Francis Darwin. Public Domain.

1. When Charles Darwin decided that he did not want to be a doctor, what did he consider becoming?
 A clergyman

2. In his early life, what did Darwin think of the Bible? He did not doubt the Bible but rather believed that its
 every word was true and completely accurate.

3. When Darwin was training to be a clergyman and went to school again, what language did he have to
 relearn? Greek

4. How does Darwin describe the *Origin of Species* in relation to his life's work? He calls it his "chief work."

5. How popular was this book when it was published? It was much demanded, sold quickly, and was translated
 into many languages.

6. An unnamed author wrote an essay in Hebrew about Darwin's book. What did the author of this essay
 write about Darwin's theory? The author claimed that Darwin's theory was contained in the Old Testament.

SKILL: Comprehension, Original Sources

Chapter Review
Matching Exercise

Place the correct letter in the blank.

A. Anti-Semitism	I. *Communist Manifesto*
B. Capitalists (middle class)	J. Pogrom
C. Alfred Dreyfus	K. Emphasized emotion
D. Forced the French emperor into exile	L. Privilege to vote
E. Granted suffrage to the middle class	M. Second Republic
F. Laborers	N. Stressed domestic reform
G. Lowered the cost of flour	O. *War and Peace*
H. Opposed the manufacture or sale of alcohol	

I 1. Karl Marx
p. 244

F 2. Proletariat
p. 244

L 3. Suffrage
p. 245

B 4. Bourgeoisie
p. 244

H 5. Temperance movement
pp. 245–46

G 6. Repeal of the Corn Laws
p. 246

E 7. Reform Bill of 1832
p. 246

N 8. William Gladstone
p. 247

M 9. Louis Napoleon Bonaparte
p. 247

D 10. Third Republic
p. 247

A 11. Richard Wagner
pp. 247–48

C 12. Humiliated French artillery captain
p. 248

J 13. Russian anti-Semitism
p. 248

K 14. Romanticism
p. 249

O 15. Leo Tolstoy
p. 250

Matching Exercise, cont.

A. British North America Act

B. Built the first successful airplane

C. Porfirio Diaz

D. Produced its power inside the engine

E. Received its power from outside the engine

<u>E</u> 16. Steam engine
p. 254

<u>B</u> 17. The Wright brothers
p. 254

<u>D</u> 18. Internal combustion engine
p. 254

<u>A</u> 19. Canada
pp. 258–59

<u>C</u> 20. Mexico
p. 258

SKILL: Recognition, Comprehension

David Livingstone

Answer the questions below based on the following excerpts from Livingstone's writings:

. . . I have to offer only a simple account of a mission which, with respect to the objects [goals] proposed to be thereby accomplished, formed a noble contrast to some of the earlier expeditions to Eastern Africa. I believe that the information [my narrative] will give, respecting the people visited and the countries traversed, will not be materially gainsaid [contradicted] by any future commonplace traveler like myself. . . . This account is written in the earnest hope that it may contribute to that information which will yet cause the great and fertile continent of Africa to be no longer kept . . . sealed, but made available as the scene of European enterprise, and will enable its people to take a place among the nations of the earth, thus securing the happiness and prosperity of tribes now sunk in barbarism or debased by slavery; and, above all, I cherish the hope that it may lead to the introduction of the blessings of the Gospel. . . .

The main object of the Zambesi Expedition, as our instructions from her majesty's government explicitly stated, was to extend the knowledge already attained of the geography and mineral and agricultural resources of Eastern and Central Africa—to improve our acquaintance with the inhabitants, and to [encourage] them to apply themselves to industrial pursuits and to the cultivation of their lands, [so that] . . . raw material . . . [could] be exported to England in return for British manufactures; and it was hoped that, by encouraging the natives to occupy themselves in the development of the resources of the country, a considerable advance might be made toward the [ending] of the slave-trade. . . . The Expedition was sent in accordance with the settled policy of the English government. . . .

Our first object was to explore the Zambesi, its mouths and tributaries, with a view to their being used as highways for commerce and Christianity to pass into the vast interior of Africa.

David and Charles Livingstone. *Narrative of an Expedition to the Zambesi and its Tributaries; and of the Discovery of the Lakes Shirwa and Nyassa. 1858–1864* (New York: Harper and Brothers, 1866). 2, 9, 14.

1. What reasons does Livingstone give for writing about his expedition? __That people might know more about__
 __Africa, that Africa might be a place of European commerce, that Africa might become like other nations, and that the__
 __gospel might spread into Africa__

2. According to this excerpt, what European nation sought to establish trade with Africa? __Britain__

3. What trade did Livingstone hope would end when Africa developed its natural resources? __The slave trade__

4. What river did Livingstone hope would be a way for "commerce and Christianity" to enter Africa's
 interior? __The Zambezi__

Both banks are dotted with hippopotamus traps over every track which these animals have made in going up out of the water to graze. The hippopotamus feeds on grass alone, and, where there is any danger, only at night. Its enormous lips act like a

mowing machine, and form a path of short-cropped grass as it feeds. We never saw it eat aquatic [water] plants or reeds. The tusks seem weapons of both offense and defense. The hippopotamus trap consists of a beam five or six feet long, armed with a spear-head or hard-wood spike, covered with poison, and suspended to a forked pole by a cord, which, coming down to the path, is held by a catch, to be set free when the beast treads on it. Being wary [cautious] brutes, they are still very numerous. One got frightened by the ship as [the ship] was steaming close to the bank. In its eager hurry to escape[,] it rushed on shore, and ran directly under a trap, when down came the heavy beam on its back, driving the poisoned spear-head a foot deep into its flesh. In its agony it plunged back into the river, to die in a few hours, and afterward furnished a feast for the natives. The poison on the spear-head does not affect the meat, except the part around the wound, and that is thrown away. In some places the descending beam is weighted with heavy stones, but here the hard heavy wood is sufficient.

David and Charles Livingstone. *Narrative of an Expedition to the Zambesi and its Tributaries; and of the Discovery of the Lakes Shirwa and Nyassa. 1858–1864* (New York: Harper and Brothers, 1866). 106–07.

5. What animal did the natives catch and eat? A hippopotamus

6. What scared the animal out of the river and into the trap? A ship

7. How did the Africans catch this animal? They set a trap. When the hippopotamus walked under the trap, a heavy, poisoned spike impaled the animal.

SKILL: Comprehension, Original Sources

Through the Dark Continent

Answer the questions at the end based on the following excerpts from Henry M. Stanley's writings:

[1876,] *Dec.* 8.—On the 8th of December we moved down river to Unya-N'singé, another large town, a mile in length, on the north side of a creek, about thirty yards wide. On the south side, on the summit of bluffs 125 feet high, was a similar town called Kisui-cha-Uriko.

About four miles up the river from Unya-N'singé, the Lira river entered the Livingstone. At the mouth it was 300 yards wide and 30 feet deep, but two miles above it narrowed to 250 yards of deep and tolerably clear water. A hostile movement on the part of the natives, accompanied by fierce demonstrations on shore, compelled us, however, to [give up] the design of penetrating [exploring] farther up, and to hurry back to camp at Unya-N'singé.

We had not been long there before we heard the war-horns sounding on the right bank, and about 4 P.M. we saw eight large canoes coming up river along the islands in midstream, and six along the left bank. On approaching the camp they formed in line of battle near a small grassy island about four hundred yards from us, and shouted to us to come and meet them in mid-river. Our interpreters were told to tell them that we had but one boat, and five canoes loaded with sick people; and that as we had not come for the purpose of fighting, we would not fight.

A jeering laugh greeted the announcement, and the next minute the fourteen canoes dashed towards us with wild yells. I [arranged] my people along the [river] banks, and waited. When they came within thirty yards, half of the men in each canoe began to shoot their poisoned arrows, while the other half continued to paddle in-shore. Just as they were about to land, the command to fire was given to about thirty muskets, and the savages fell back, retiring to the distance of about a hundred and fifty yards, whence they maintained the fight. Directing the people on shore to keep firing, I chose the boat's crew, including Tippu-Tib and Bwana Abdallah, and dashed out into mid-stream. The savages appeared to be delighted, for they yelled triumphantly as they came towards us; only for a short time, however, for we were now only some fifty yards from them and our guns were doing terrible execution. In about a minute the fight was over, and our wild foes were paddling down river; and we returned to our camp, glad that this first affair with the Wasongora Meno had terminated so quickly. Three of our people had been struck by arrows, but a timely application of caustic neutralized the poison, and, excepting swellings, nothing serious occurred.

Unya-N'singé is in south latitude 2° 49′. Nearly opposite it is Urangi, another series of small villages; while on the north bank of the Lira River, at the confluence, is the village of Uranja, and opposite to it is Kisui Kachamba. The town of Meginna is said to be about twenty miles south-east (magnetic) from Unya-N'singé. All this portion is reported to have been the scene of Muini Muhala's exploits.

Dec. 9, 10, 11— . . . [Our friends] had, it appeared, again gone astray, and had entered Ukusu, where they were again obliged to fight. Four had received grievous wounds, and one had been killed. Three Wanyamwezi, moreover, had died of small-pox *en route* from Ikondu.

This creek, like all the rest in the neighbourhood, was half-choked with . . . [odd] asparagus-like plants [that the Aborigines enclose with logs of wood]. When the log-enclosed spaces are full, the plants are taken out, exposed to the sun until they are

withered, dried, and then burnt. The ashes are collected in pots with punctured bottoms, and the pots [are] filled with water which is left to drip through into shallow basins. After the evaporation by fire of this liquid, a dark grey sediment of a nitrous flavour is left, which, re-cleansed, produces salt.

Henry M. Stanley. *Through the Dark Continent or, The Sources of the Nile Around the Great Lakes of Equatorial Africa and Down the Livingstone River to the Atlantic Ocean.* Vol. 2 (New York: Dover, 1988). 2 vols. 135–37. Reprint.

1. What event prevented Stanley's group from traveling farther up the river? __Attacks by Africans__

2. When the Africans challenged the Europeans to fight, what did the interpreter tell them? __The canoes were__ loaded with sick people, and the explorers had not come to fight.

3. What weapon did the Africans use to attack Stanley's group? __Poisoned arrows__

4. What weapon did the members of Stanley's group use to defend themselves? __Guns (muskets)__

5. What did the explorers do to treat those who had been struck by poisoned arrows? __They quickly__ applied a caustic (a type of antidote) to neutralize the poison.

6. According to Stanley, with what was the creek "half-choked"? __"Asparagus-like plants"__

7. When these were processed by the natives, what was the final product? __Salt__

SKILL: Comprehension, Original Sources

Abuses of Colonialism

Answer the questions at the end based on the following excerpts from the writings of Rev. Robert Bedinger, a missionary to Africa:

Cruelty.—"All the cruelties of Alva in the Lowlands, all the tortures of the Inquisition, all the savagery of the Spanish to the Caribs are as child's play compared with the deeds of the Belgians in the Congo."—Conan Doyle. This is a reference to the atrocities of the Leopoldian regime, happily past. But what can be said for the contempt in which the black man is held by the white? Why does the native still flee into the bush at the approach of the white man? In every way, the native is made to feel his inferiority. He resents being kicked about like a dog. Belgium is not alone in the guilt of cruel and inhuman treatment of natives. "What shall we say of the unjust and cruel wars of suppression in which practically every European power has engaged, of punitive expeditions which have been little better than massacres? The things Europe has done under this category are a disgrace to civilization."—Patton.

Taxation.—The native never stops to think of the benefits of the Government[,] and the fact that he resents the [requirement] of a tax only marks him as human. From his point of view, it is an oppressive measure to tax him for the privilege of living in his own country! Whether the tax be low or high it rankles in his bosom. It is obviously unjust to force lads of fourteen to pay taxes, as is done in the Congo. The tax in the Kasai is $1.20 per [year], the equivalent of one month's pay.

Limitation of Travel.—Although by nature a hunter or a trader, the native finds himself confined to a district and cannot go beyond its borders without a permit which is often hard to obtain. To be taxed is hard enough, but to be limited in travel makes him feel like a slave. In certain districts where forced labor is required, he is a slave. Industrial slavery is often as bad as the old form of slavery.

Diseases of [European] Civilization.—"The history of civilization in Africa may be traced by the diseases which spring up in its track." Rinderpest, tick-fever, east-coast fever—these are the cattle pests. To them must be added certain human ills, like tuberculosis, smallpox, and [other] diseases which are working . . . [very] sad havoc. Tribal and family restraints have been broken down and civilization offers no remedy. Certain tribes are more immoral than before the coming of the white man. In the face of such indictments, what is [European] civilization to say? . . .

The Liquor Problem.—This is an evil against which the natives make no protest. Yet no race is so quickly demoralized by strong drink as the black. Restrictive measures for its sale are enforced in certain quarters, but financial considerations stand in the way of its total prohibition. Holland, England, Germany, and the United States are the greatest sinners. "The British Board of Trade reports that during the year ending in April, 1916, there were imported into British West Africa 3,815,000 gallons of spirits [alcohol]. During 1914–15, from the port of Boston, there were shipped to the west coast of Africa 1,571,353 gallons of rum." To the credit of the Belgian Government, we gladly record that the sale of intoxicating [drinks] to the natives is strictly prohibited. It is unfortunate that the same law does not apply to the whites.

Industrial Centers.—Forty per cent of the world's output of gold comes from "The Rand," in South Africa. It has been estimated that . . . half a million blacks each year come under the influence of this one industrial center. The natives are recruited from every tribe south of the Zambezi. Some 300,000 are steadily employed at Johannesburg, which has been called, not without reason, "a university of crime." These natives are mostly young men from sixteen to twenty-five years old. At the

mines they are [divided] in barracks or compounds, from 2,000 to 6,000 males in each. Those in the city naturally gravitate to the slums. Tribal and family restraints are removed. Some of the worst crooks and criminals of Europe and America descend to the lowest depths in order to [steal] from the native his hard earned cash. "The result is that we find natives [giving in] to drunkenness, gambling, murder, [and other sinful lifestyles]. To the vices of heathenism, the heathen are now adding those of [European] civilization."

Robert Dabney Bedinger. *Triumphs of the Gospel in the Belgian Congo* (Richmond, VA: Presbyterian Committee of Publication, 1920). 184–86.

1–3. List three negative effects of European colonialism in Africa. Three of the following: cruelty, taxation, limitation of travel, diseases of European civilization, alcohol, and industrial centers

4. What were Africans required to carry in order to travel? A permit

5. Name one human disease that European colonists spread to Africa. One of the following: tuberculosis and smallpox

6. How much alcohol did the British bring into Africa from 1915 to 1916? 3,815,000 gallons

7. According to Bedinger, what city in South Africa was noted for its sinfulness and called "a university of crime"? Johannesburg

SKILL: Comprehension, Original Sources

Chapter Review
Make the Statement Correct
Underline the word or phrase that makes the statement correct.

1. The (German/<u>British</u>) navy helped end the African slave trade. (p. 265)

2. (Egypt/<u>Ethiopia</u>) developed a modern army to defend itself against European invasion. (p. 266)

3. Warfare among African tribes generally (<u>decreased</u>/increased) after the slave trade ended. (p. 265)

4. Robert Moffat's daughter married (<u>David Livingstone</u>/Henry Stanley). (pp. 268–69)

5. Oxford University gave (<u>Samuel Ajayi Crowther</u>/John Africanus Horton) an honorary degree for his work in Africa. (p. 269)

6. (Olive/<u>Palm</u>) oil, the leading export of Africa, was used to lubricate machines. (p. 265)

7. European states pressured Africans to sign treaties during phase (<u>one</u>/two) of the Scramble for Africa. (p. 273)

8. (France/<u>Britain</u>) transported about three and one-half million slaves to the New World. (p. 270)

9. The (Horton/<u>Fante</u>) Confederation promoted self-rule and education for African males and females. (pp. 266–67)

10. Menelik ruled (<u>Ethiopia</u>/Algeria) and thwarted Italian efforts to conquer his country. (p. 266)

11. (<u>Leopold</u>/Samori Ture) controlled the International African Association and abused the Africans in the region he colonized. (p. 273)

12. (Russia/<u>France</u>) relentlessly attacked Samori Ture's empire in West Africa. (p. 274)

13. (Henry Stanley/<u>Robert Moffat</u>) served as a missionary in South Africa for fifty-three years. (pp. 268–69)

14. The African scholar (<u>John Africanus Horton</u>/Samuel Ajayi Crowther) disproved the claims that the black man was racially inferior. (pp. 272–73)

15. The British explorer (Richard Burton/<u>David Livingstone</u>) discovered the waterfalls that were later named Victoria Falls. (p. 267)

16. The African ruler (<u>Macemba</u>/Samuel Ajayi Crowther) wrote a letter to the Germans, rejecting their pressure to accept German domination. (p. 273)

Teacher's Choice Teachers, to help the student better prepare for the chapter test, feel free to add questions about other topics you may have covered.

17. Question _____

18. _Question_ _____

19. _Question_ _____

20. _Question_ _____

SKILL: Recognition, Comprehension

Slaughter of the Armenians

Answer the questions below based on the following excerpts from John Adger's writings:

In the year 1895, Messrs. G. P. Putnam's Sons, of New York, published a work entitled *The Armenian Crisis in Turkey, The Massacre of 1894, its Antecedents and Significance,* by Frederick Davis Greene, M. A., for several years a resident of Armenia. A portion of this volume consists of eighteen letters written from the interior of Armenia, before and during and immediately after the massacre. The author of this volume thus introduces them into his volume: "These letters were written by men who subjected themselves to personal danger by putting such statements on paper and sending them through the Turkish mails." . . .

It must be borne in mind that no writer was an eyewitness of the actual massacre; nor could he have been, inasmuch as the whole region was surrounded by a military [blockade] during the massacre, and for months after. The letters are largely based on the testimony of refugees from that region, or of Kurds and soldiers who participated in the butchery, and who had no hesitation in speaking about the affair in public or private until long after, when the [possibility] of a European investigation sealed their lips. Much of the evidence is, therefore, essentially first-hand, having been obtained from eye-witnesses by parties in the vicinity at the time, who are impartial, thoroughly experienced in sifting Oriental testimony, familiar with the Turkish and Armenian languages, and [completely trustworthy]. . . .

There is absolute unanimity [agreement] to this extent, that a gigantic and indescribably horrible massacre of Armenian men, women, and children did actually take place in the Sassoun and neighboring regions about September 1, 1894, . . . at the hands of Kurdish troops armed by the Sultan of Turkey, as well as [at the hands] of regular soldiers sent under orders from the same source. What those orders were will probably never [become known]. That they were [carried out] under the personal direction of high Turkish military officers is clear.

John B. Adger. *My Life and Times: 1810–1899* (Richmond, VA: The Presbyterian Committee of Publication, 1899). 673–74.

1. According to Adger, what group of people was attacked? <u>The Armenians</u>

2. How did the Ottoman attackers make it very difficult for anyone to be an eyewitness of the genocide?
<u>They surrounded the Armenians with a blockade during and after the genocide.</u>

3. How does Adger describe the genocide? <u>As "a gigantic and indescribably horrible massacre"</u>

4. What two groups of Ottomans were responsible for this incident? <u>Kurds and Turks</u>

To give the reader an adequate idea of these unquestionably [accurate] testimonies, I here [attach] extracts from Letter 6 . . . and Letter 9.

FROM LETTER No. 6.

"At first the [Kurds attacked], and the troops kept out of sight. The villagers put to the fight, and thinking they had only the Kourds [Kurds] to do with, repulsed them [drove them away] on several occasions. The Kourds were unwilling to do more unless the troops assisted. Some of the troops assumed Kourdish dress, and helped them in the fight with more success. Small companies of troops entered several villages, saying they had come to protect them as loyal subjects, and were quartered among the houses. In the night they arose and slew the sleeping villagers, man, woman, and child. . . .

No distinctions were made between persons or villages as to whether they were loyal and had paid their taxes or not. The orders were to make a clean sweep. A priest and some leading men from one village went out to meet an officer, taking in their hands their tax receipts, declaring their loyalty, and begging for mercy; but the village was surrounded, and all human beings put to the bayonet." . . .

FROM LETTER No. 9.

"The question arises," continues Frederick Davis Greene, "how did the missionaries feel, and how did they behave through all this period?" I answer with two or three statements as a sample of the whole.

The Rev. C. F. Gates, president of Euphrates College, Harpoot, wrote thus November 13th: "For three days we have looked death in the face hourly. We have passed by the mouth of the bottomless pit, and the flames came out against us, but not one in our company flinched or faltered. We simply trusted in the Lord and went on. . . . Threats abound, and the times are critical, but in all these things we are more than conquerors through him that loved us." . . .

The reader should bear in mind that these Moslem massacres of 1894–'97 are not the only ones recorded in the history of Turkey. Similar atrocities were visited upon the Greeks in 1822; upon the Nestorians in 1850; upon the Syrians in 1860; upon the Cretans in 1867; upon the Bulgarians in 1876; upon the Yezidees in 1892, and the Armenians in 1894. The spirit of Islam is still that of Mohammed, "The Koran or the Sword."

John B. Adger. *My Life and Times: 1810–1899* (Richmond, VA: The Presbyterian Committee of Publication, 1899). 674–75, 678–79, 681.

5. What did the Armenians show to the attackers to prove their own loyalty? Tax receipts _____

6. To what religion did the attackers belong? What motto describes the spirit of this religion? Islam; "The _____
 Koran or the Sword" _____

SKILL: Comprehension, Original Sources

WORLD STUDIES

Name _____

CHAPTER 16 ACTIVITY 2

The Sepoy Mutiny

Answer the questions below based on the following excerpts from William Butler's writings:

The year in which I arrived in India saw the introduction of new arrangements for arming the Sepoy army. Instead of the old "Brown Bess," or regulation musket, with which they had hitherto fought the battles of the British, the rulers of India [decided] to arm their Sepoys with the new Enfield rifle. For this weapon a [unique] cartridge had to be prepared, samples of which had been sent out from England to be manufactured at the arsenal of Dum Dum, eight miles from Calcutta. . . .

Then came the intense excitement about the "greased cartridges" for these guns, the purpose being, I suppose, to lubricate the bore of the rifle. It was given out that this grease was "a compound of hogs' lard and [cows'] fat." Only those who have lived among these people, and realized what a horror the [Muslim] has of the hog [as unclean], and what a reverence the Hindoo has for the cow, can appreciate the storm of excitement and frenzy this simple announcement caused through the whole Bengal army. . . .

It has never been definitely settled whether the charge as to the composition of the [grease] was correct or not. The Government did what it could to [ease] the excitement and fears of the Sepoys, even to the withdrawal of the obnoxious cartridges, offering the men the right to make them up themselves with such grease as was not offensive to them. But it was all too late; midnight meetings now began to be held and plans of resistance discussed, and immediate and open mutiny was proposed.

William Butler. *The Land of the Veda: Being Personal Reminiscences of India—Its People, Castes, Thugs, and Fakirs; Its Religions, Mythology, Principal Monuments, Palaces, and Mausoleums, Together with the Incidents of the Great Sepoy Rebellion* (New York: Eaton and Mains, 1906). 223–24.

1. What new equipment did the British give to the Indian troops? The government gave the Sepoys a new kind of gun that used greased cartridges.

2. What material was supposedly used to grease the new cartridges? Grease made from hog and cow fat

3. Why were these greased cartridges offensive to the Muslims and Hindus? Muslims believe pigs are unclean. Hindus believe cows are sacred.

. . . On Thursday, May 14, the commanding officer kindly sent his Adjutant [assisting officer] over to our house with a serious message. Not knowing what he . . . wanted, we engaged for nearly an hour in religious conversation. But I thought from his manner that he looked [worried]. With gentlemanly delicacy he was unwilling to mention his message before Mrs. Butler, lest it might injuriously affect her, as she was in circumstances where any shock was undesirable. He, accordingly, asked to see me alone, and then communicated the intelligence [message] of the mutiny at Meerut, stating that word had arrived from the Governor that the [mutiny] was spreading to Delhi and other places, and that fears were [rising] as to the intention of the Sepoys at Bareilly. Under those circumstances, the commanding officer felt it his duty to request that all ladies and children should be sent off quietly, but at *once*, to the hills, and also . . . considered it prudent, from the [rumors] concerning us and our objects, that I also should accompany Mrs. B[utler] and the children, as he considered me in rather special danger in the event of a mutiny. . . . As soon as the

© 2011 BJU Press. Reproduction prohibited.

ENRICHMENT: Section III

SKILL: Comprehension, Original Sources 115

Adjutant had gone, I communicated the message to Mrs. Butler. She received it with calmness, and we retired to our room to pray together for divine direction. . . .

. . . We were ready [to leave] when our bearers came at nine o'clock, and I went into my study once more. I looked at my books, etc., and the thought flashed across my mind that perhaps, after all my pains in collecting them, I should never see them again! I took up my Hindustanee Grammar, two volumes of manuscript Theological Lectures, a couple of works on India, my Passport, my Commission, and Letter of Instructions, with my Bible, Hymn Book, and a copy of the Discipline, and sorrowfully turned away, leaving the remainder to their fate. . . .

The rebels went to my house, and expressed great regret at not finding me. They are said to have declared they [especially] wanted me. They then destroyed our little place of worship, and burned my house with its contents. All was lost, save life and the grace of God; but the sympathy and prayers of our beloved Church were still our own, so the loss was not so great after all.

It would be [untrue] if I were to profess that I was unmoved at my loss. So far from it, I felt overwhelmed by it. Every thing was so complete and well arranged for my work. But all was destroyed, and some things gone that could never be restored. All my manuscripts; my library, (about one thousand volumes, the collection of my life, and which, perhaps, I loved too well,) so complete in its Methodistic and [doctrinal] and missionary departments; my globe, maps, microscope; our clothes, furniture, [small organ], buggy, stock of provisions—every thing, gone; and here we were, like shipwrecked mariners, grateful to have escaped with life. But we tried to say, "The Lord gave, and the Lord hath taken away; blessed be the name of the Lord." I had the [comfort] to know that my goods had been sacrificed for Christ's sake.

William Butler. *The Land of the Veda: Being Personal Reminiscences of India—Its People, Castes, Thugs, and Fakirs; Its Religions, Mythology, Principal Monuments, Palaces, and Mausoleums, Together with the Incidents of the Great Sepoy Rebellion* (New York: Eaton and Mains, 1906). 234, 237–38, 249–50.

4. What belongings did William Butler take with him when he fled the Sepoy attacks? His grammar of the
Hindustani language, books about theology and India, passport, commission, letter of instructions, Bible, and
hymn book

5. What did the Sepoys destroy? Butler's house, library, globe, maps, microscope, clothes, furniture, provisions,
buggy, and place of worship

6. What was Butler's reaction to his great loss? He was discouraged but submitted to God and was comforted by
knowing that he suffered for Jesus.

SKILL: Comprehension, Original Sources

The Goforths and the Boxer Rebellion

Answer the questions at the end based on the following excerpts from Rosalind Goforth's writings:

. . . I was seized with an overwhelming fear of what might be awaiting us. It was not the fear of *after* death, but of probable torture, that took such awful hold of me. I thought, "Can this be the Christian courage I have looked for?" I went by myself and prayed for victory, but no help came. Just then some one called us to a room for prayer before getting into our carts. Scarcely able to walk for trembling, and utterly ashamed that others should see my state of panic,—for such it undoubtedly was,—I managed to reach a bench beside which my husband stood. He drew from his pocket a little book, "Clarke's Scripture Promises," and read the verses his eye first fell upon. They were the following:

"The eternal God is thy refuge, and underneath are the everlasting arms: and he shall thrust out the enemy from before thee; and shall say, Destroy them."

"The God of Jacob is our refuge."

"Thou art my help and my deliverer; make no tarrying, O my God."

"I will strengthen thee; yea, I will help thee; yea, I will uphold thee with the right hand of my righteousness. . . . The Lord thy God will hold thy right hand, saying unto thee, Fear not; I will help thee." . . .

After prayer we all got on our carts, and one by one passed out into the densely crowded street. As we approached the city gate we could see that the road was black with crowds awaiting us. I had just remarked to my husband on how well we were getting through the crowds, when our carts passed through the gates. My husband turned pale as he pointed to a group of several hundred men, fully armed, awaiting us. They waited till all the carts had passed through the gate, then hurled down upon us a shower of stones, at the same time rushing forward and maiming or killing some of the animals. Mr. Goforth jumped down from our cart and cried to them, "Take everything, but don't kill." His only answer was a blow. The confusion that followed was so great it would be impossible to describe the escape of each one in detail. Each one later had his or her own testimony of that mighty and merciful deliverance. But I must give the details of Mr. Goforth's experience.

One man struck him a blow on the neck with a great sword wielded with two hands. "Somehow" the blunt edge of the sword struck his neck; the blow left a wide mark almost around his neck, but did no further harm. Had the sharp edge struck his neck he would certainly have been beheaded! . . .

Again he was felled to the ground, with a fearful sword cut, which entered the bone of the skull behind and almost cleft it in two. As he fell he seemed to hear distinctly a voice saying, "Fear not, they are praying for you." Rising from this blow, he was again struck down by a club. As he was falling almost unconscious to the ground he saw a horse coming at full speed toward him; when he became conscious again he found the horse had tripped and fallen (on level ground) so near that its tail almost touched him. The animal, kicking furiously, had served as a barrier between him and his assailants. While [Mr. Goforth was] dazed and not knowing what to do a man came up as if to strike, but whispered, "Leave the carts." By that time the onlookers began to rush forward to get the loot, but the attacking party felt the things were theirs, so desisted in their attack upon us in order to secure their booty.

A word as to myself and the children. Several fierce men with swords jumped on my cart. One struck at the baby, but I [blocked] the blow with a pillow, and the little fellow only received a slight scratch on the forehead. Then they dropped their swords and began tearing at our goods at the back of the cart. Heavy boxes were dragged over us, and everything was taken. Just then a dreadful looking man tried to reach us from the back of the cart with his sword, missing by an inch. I thought he would come to the front and continue his attack, but he did not. I had seen Mr. Goforth sink to the ground covered with blood twice, and had given him up for dead. Just then [my son] Paul, who had been in the last cart, jumped in, wild with delight at what he seemed to think was great fun, for he had run through the thick of the fight, dodging sword thrusts from all sides, and had succeeded in reaching me without a scratch. A moment later my husband came to the edge of the cart scarcely able to stand, saying, "Get down quickly; we must not delay in getting away." As I was getting down one man snatched away my hat, another my shoes; but we were allowed to go. . . .

We soon joined the rest of the party, and by six o'clock that evening we reached the large city of Nang Yang Fu. The city wall was black with people, and as we entered the gate the wild crowds crushed against our carts. Sometimes the animals staggered, and it seemed as if nothing could save the carts from being overturned. Every moment or two a brick or stone would be hurled against the carts, and that cry, "Kill, kill," which can never be forgotten when once heard, was shouted by perhaps hundreds of voices. Yet the Lord brought us through, and "no weapon prospered."

How I Know God Answers Prayer by Rosalind Goforth. Public Domain.

1. About what did Rosalind Goforth have an "overwhelming fear"? __Possible torture_____

2. With what scriptural truths did the Goforths comfort themselves during the Boxer Rebellion?
 __God is our refuge and deliverer; God strengthens us and helps us._____

3. When Mr. Goforth first saw the Chinese attackers, what did he yell to protect himself and those with him?
 __"Take everything, but don't kill."_____

4. How did the fallen horse protect him? __It fell between him and those attacking him._____

5. How did Rosalind Goforth protect her baby? __She blocked a sword thrust with a pillow._____

SKILL: Comprehension, Original Sources

Perry's Expedition to Japan

Answer the questions at the end based on the following excerpts:

From the beginning, the two [Japanese] princes had assumed an air of [stiff] formality which they [kept] during the whole interview, as they never spoke a word, and rose from their seats only at the entrance and exit of the Commodore, when they made a grave and formal bow. Yezaiman and his interpreters acted as masters of ceremony during the occasion. On entering, they took their positions at the upper end of the room, kneeling down beside a large lacquered box of scarlet color, supported by feet, gilt or of brass.

For some time after the Commodore and his suite had taken their seats[,] there was a pause of some minutes, not a word being uttered on either side. Tatznoske, the principal interpreter, was the first to break silence, which he did by asking Mr. Portman, the Dutch interpreter, whether the letters were ready for delivery, and stating that the prince Toda was prepared to receive them; and that the scarlet box at the upper end of the room was prepared as the [place to receive] them. The Commodore, upon this being communicated to him, beckoned to the boys who stood in the lower hall to advance, when they immediately obeyed his summons and came forward, bearing the handsome boxes which contained the President's letter and other documents. . . .

MILLARD FILLMORE, PRESIDENT OF THE UNITED
STATES OF AMERICA, TO HIS IMPERIAL MAJESTY,
THE EMPEROR OF JAPAN

GREAT AND GOOD FRIEND: I send you this public letter by Commodore Matthew C. Perry, an officer of the highest rank in the navy of the United States, and commander of the squadron now visiting your imperial majesty's dominions.

I have directed Commodore Perry to assure your imperial majesty that I [have] the kindest feelings toward your majesty's person and government, and that I have no other object in sending [Commodore Perry] to Japan but to propose to your imperial majesty that the United States and Japan should live in friendship and have commercial intercourse with each other.

The Constitution and laws of the United States forbid all interference with the religious or political concerns of other nations. I have particularly charged Commodore Perry to abstain from every act which could possibly disturb the tranquility of your imperial majesty's dominions.

The United States of America reach from ocean to ocean, and our Territory of Oregon and State of California lie directly opposite to the dominions of your imperial majesty. Our steamships can go from California to Japan in eighteen days.

Our great State of California produces about sixty millions of dollars in gold every year, besides silver, quicksilver [mercury], precious stones, and many other valuable articles. Japan is also a rich and fertile country, and produces many very valuable articles. Your imperial majesty's subjects are skilled in many of the arts. I am desirous that our two countries should trade with each other, for the benefit both of Japan and the United States. . . .

Your good friend,
MILLARD FILLMORE

Harry R. Warfel, et al., eds. *The American Mind: Selections from the Literature of the United States*. Vol. 1 (New York: American Book Company, 1937). 447–48.

1. Why did Commodore Perry come to Japan and give the Japanese emperor this letter? <u>The United States</u> <u>wanted to trade and establish commerce with Japan.</u>

2. According to President Fillmore, what do the Constitution and laws of the United States forbid? <u>"All interference with the religious or political concerns of other nations"</u>

3. In the 1850s, how long did it take for a steamship to travel from America's west coast to Japan? <u>The journey took eighteen days.</u>

4. What did President Fillmore say that California produced in abundance? <u>Gold, silver, quicksilver [mercury],</u> <u>precious stones, and other valuable articles</u>

5. According to President Fillmore, who would benefit from Japan's participating in foreign trade? <u>Japan and the United States</u>

Skill: Comprehension, Original Sources

Map Study: Spread of Imperialism

Locate the following on the map and place the number in the blank beside the term:

Burma _6_

China _1_

Indian Ocean _4_

Japan _2_

Map Study, cont.

Ottoman Empire _5_

Russia _3_

South China Sea _7_

Chapter Review
Make the Statement Correct

Underline the word or phrase that makes the statement correct.

1. The (Balkans/Netherlands) are located in southeastern Europe. (p. 284)

2. (Alexander I/Mahmud II) was the Ottoman ruler who laid the foundation for a modern Turkey. (p. 285)

3. (The Ottoman Empire/Russia) became the largest state in the world in the eighteenth century. (p. 286)

4. (Hong Xiuquan/Michael Bakunin) became known as the Father of Anarchism. (p. 288)

5. (Alexander II/Nicholas II) abolished serfdom in Russia and freed over twenty million peasants. (p. 288)

6. (Robert Clive/Matthew Perry) defeated Indian forces at the Battle of Plassey. (pp. 290–91)

7. The (Charter/Indies Commerce) Act gave the possessions of the East India Company to the British crown. (p. 292)

8. The British produced (opium/cocaine) from poppy plants in India and exported it to China. (p. 293)

9. The (Song/Qing) dynasty weakened as European nations began dominating Asia. (p. 293)

10. Many missionaries and Chinese Christians suffered during the (Boxer/Taiping) Rebellion. (p. 295)

11. (Hong Xiuquan/Guangxu) initiated the Hundred Days' Reform in China. (p. 298)

12. (Japan/India) quickly modernized and remained free of European imperialism. (pp. 300–301)

13. The Meiji Restoration took place in (Japan/India). (p. 301)

14. (Matthew Perry/Leo Tolstoy) pressured Japan to end its isolation and open to trade. (p. 300)

15. The Treaty of (Tokyo/Kanagawa) opened trade between Japan and the rest of the world. (p. 300)

16. (Shintoism/Hinduism) became the state religion of Japan. (p. 301)

Teacher's Choice
Teachers, to help the student better prepare for the chapter test, feel free to add questions about other topics you may have covered.

17. Question _____

18. Question _____

19. <u>Question</u>

20. <u>Question</u>

SKILL: Recognition, Comprehension

Alvin York and His Struggle with War

Answer the questions at the end based on the following excerpts from Sergeant York's writings:

. . . [A]s long as the records remain I will be officially known as a conscientious objector. I was. I couldn't have been anything else nohow.

At first I jes [just] couldn't imagine I would have to fight. The war seemed too far away to be mixing me up in it. And I didn't want to be in it nohow. I never had killed nobody, not even in my bad days, and I didn't want to begin now. I turned my back on all of those rowdy things and found a heap of comfort and happiness in religion. I joined the church. It was the Church of Christ in Christian Union. I had takened its creed and I had takened it without what you might call reservations. I was not a Sunday Christian. I believed in the Bible. And I tried in my own way to live up to it. It was the only creed of my church. To be a member I had to accept the Bible as the inspired word of God. I did. And the Bible said, "Thou shalt not kill." That was so definite a child could understand it. There was no way around or out of it. So you see there were two reasons why I didn't want to go to war. My own experience told me that it weren't right. And the Bible were agin [against] it too.

But Uncle Sam said he wanted me and he wanted me most awful bad. And I had also been brought up to believe in my country. . . . I kinder [kind of] felt that my ancestors would want me to do whatever my country demanded of me.

So you see my religion and my own experience sorter [sort of] told me not to go to war, and the memory of my ancestors jes as plainly . . . told me to get my gun and go and fight. I didn't know what to do. I am a-telling you there was a war going on inside of me and I didn't know which side to lean on. I was a heap bothered. [It] is a most awful thing when the wishes of your God and your country sorter get mixed up and go against each other. . . .

Pastor Pile was the registrar. He had a store and the post office at Pall Mall, and the Government done instructed him to take the registration for the draft. I went to him and we talked it over, and we read the Bible and prayed together. No matter how we looked at it, we always come up against "Thou shalt not kill." That was the word of God and that was how it was revealed in His Holy Book. There was no gitting past that nohow. . . .

York applied for an exemption from fighting in the war but was denied. In boot camp, he proved to be an excellent marksman, although he still struggled with the idea of killing others. When York's commander learned of this inner turmoil, he sent York home on leave to resolve the matter.

. . . I went home [from boot camp] and while I was at home we had several services at Greer's [Chapel], and the Lord blessed us and we had a fine meeting. Rev. R. C. Pile and others were helping, and there were a number of people saved during this little meeting. So the Lord was with us. Bless His holy name.

I knowed now that if I went back and told the Major I was still opposed to fighting he would let me out or have me transferred into another branch of the service where I wouldn't have to kill. . . . I talked to Pastor Pile again and again. But all I got from all of this was to get more and more confused. . . . I jes didn't know what to do; whether to want war or peace; and I didn't know which [God] wanted me to do.

So I went out on the mountainside and asked Him sorter straight out from the shoulder. I went off to a quiet place not far from my home. I knelt down and I prayed

and I prayed all the afternoon, through the night and through part of the next day. I asked Him to have pity on me and show me the light. I begged Him to comfort me if it was His will and tell me what to do. And as I prayed there alone a great peace kinder come into my soul and a great calm come over me and I received my assurance. He heard my prayer and He come to me on the mountainside. I didn't see Him, of course, but He was there jes the same. I knowed He was there. He understood that I didn't want to be a fighter or a killin' man, that I didn't want to go to war and hurt nobody nohow. And yet I wanted to do what my country wanted me to do. I wanted to serve God and my country, too. . . .

So He took pity on me and He gave me the assurance I needed. I didn't understand everything. I didn't understand how He could let me go to war and even kill and yet not hold it agin me. I didn't even want to understand. It was His will and that was enough for me. So at last I begun to see the light. I begun to understand that no matter what a man is forced to do, so long as he is right in his own soul he remains a righteous man. I knowed I would go to war. I knowed I would be protected from all harm, and that so long as I believed in [God] He would not allow even a hair of my head to be harmed.

I arose and thanked Him and went home over the mountains, singing a hymn.

I told my little old mother I was going and not to worry. I was coming back safe and sound. I told my brothers and sisters and I told Pastor Pile.

Alvin York. *Sergeant York and the Great War: His Own Life Story and War Diary.* Ed. Richard Wheeler (Boerne, TX: Mantle Ministries, 1998). 67–69, 84–85.

1. Why did Alvin York hesitate to enter the army during World War I? _The Bible says, "Thou shalt not kill."_
 He wanted to follow peace, and war would require killing.

2. What church did York join? _The Church of Christ in Christian Union_

3. Who owned a store and post office in town and served as York's advisor? _Pastor Pile_

4. What did York do to determine whether he should fight in the war? _He prayed on a mountainside and asked_
 God to show him what to do.

5. What was his final decision? With whom did he share this decision? _He decided to participate in the war._
 He told his family and pastor.

SKILL: Comprehension, Original Sources

Sergeant York

Answer the questions at the end based on the following excerpts from Sergeant York's diary:

October 8, 1917

Argonne Forest, France

So the morning of the 8th just before daylight we started for the hill at Chatel Chehery. So before we got there it got light and the [Germans] sent over a heavy Barrage and also gas and we put on our gas mask and just Pressed right on through those shells . . . to the top of hill 223 to where we was to start over the top at 6:10 A.M.

All day long on October 7th we laid out there in the rain and the mud along the main army road running from Varennes to Fleville, and watching the attack of the First Battalion, which takened Hill 223 in the afternoon. Shells were bursting all around and a whole heap of stray bullets were buzzing through the air. Airplanes were fighting overhead. It was all most awful. . . .

The noise were worse than ever, and everybody was shouting through the dark, and nobody seemed to be able to hear what anybody else said. We should have reached the hill before daybreak. But we didn't. It weren't nobody's fault. The going was too tough. So as soon as they were able to see[,] the German artillery lit into us with a heap of big stuff. One of their shells bust plumb in the middle of one of our squads, and wounded or killed every man. They done laid down the meanest kind of a barrage too, and the air was jes [just] full of gas. But we put on our masks and kept plugging and slipping and sliding, or falling into holes and tripping over all sorts of things and getting up again and stumbling on for a few yards and then going down again, until we done reached the hill. The First Battalion had takened it the day before, but they hadn't mopped it up. And there were some snipers and German machine guns left there hidden in the brush and in fox holes. . . .

Well, at the zero hour, which was 6:10 A.M., with fixed bayonets, we done, went over the, top, as ordered. Our boys was to give us a Barrage. So the time came and no Barrage and we had to go with out one. So we started over the top at 6:10 A.M. and the [Germans] was Putting their machine guns to working all over the hill in front of us and on our left and right. So I was in [support] and I could see my pals getting picked off. . . .

I don't know what happened to our artillery support, but we didn't get none nohow, except from a lieutenant from the Third Battalion. He done stood near six-foot-six tall. And he come up on top of the hill, dragging what looked like a toy cannon with him. It was a trench mortar. He did the best he could with it, but it didn't help much nohow. The Germans met our charge across the valley with a regular sleet storm of bullets. I'm a-telling you that-there valley was a death trap. It was a triangular-shaped valley with steep ridges covered with brush, and swarming with machine guns on all sides. I guess our two waves got about halfway across and then jes couldn't get no further nohow. The Germans done got us and they done got us right smart. They jes stopped us in our tracks. Their machine guns were up there on the heights overlooking us and well hidden. . . .

So you see there were just seventeen of us Boys went around on the left flank to see if we couldn't put those guns out of action.

According to orders, we got around on the left and in single file advanced forward through the brush towards where we could hear the machine-gun fire. We, done went very quietly and quickly. We had to. We kept well to the left and deep in

the brush. At first we didn't see any Germans and we were not under heavy fire. Jes a few stray bullets. Without any loss and in right-smart time we done skirted the left side of the valley and were over on the hill somewhere near where the German machine guns were placed. The heavy brush and the hilly nature of the country hid us from the enemy. We were now nearly three hundred yards to the left and in front of our own front line. When we figured out that we were right on the ridge that the Germans were on, we [briefly] stopped. . . . We had now sorter encircled the German left end and were going away in deep behind them without them knowing anything about it.

So when we went a round and fell in Behind those guns we first seen [two Germans] with a Red Cross Band on their arm. So we ask them to stop and they did not so some one of the Boys shot at them and they run Back to our right. So we all run after them. They jumped out of the brush in front of us and run like two scared rabbits. We called to them to surrender, and one of our boys done fired and missed. And they kept on a-going. And we kept on after them. We wanted to capture them before they gave the alarm. . . . We then jumped across a little stream of water that was there[, and] they was a Bout 15 or 20 Germans jumped up and threwed up their hands and said Comrade[.] So the one in charge of us Boys told us not to shoot [because] they was going to give up any way.

It was headquarters. There were orderlies, stretcher bearers, runners, a major and two officers sitting or standing around a sort of small wooden shack. They seemed to be having a . . . conference. And they done jes had breakfast too. And there was a mess of beefsteaks, jellies, jams, and loaf bread around. . . . By the way they were going on we knowed they never even dreamed that there were any Americans near them.

Sergeant Early, who was in command of us, told us to hold our fire, [because] we had them, but to keep them covered and to hurry up and search and line them up. [J]ust as he was turning around from giving this order and we were moving forward to obey, some machine guns up on the hill in front of us and between us and the American lines, suddenly turned around and opened fire on us. . . .

. . . [T]hey killed 6 and wounded 3. So that just left 8. . . . I had no time nohow to do nothing but watch them there German machine gunners and give them the best I had. Every time I seed [saw] a German I jes teched [touched] him off. At first I was shooting from a prone position; that is lying down; jes like we often shoot at the targets in the shooting matches in the mountains of Tennessee; and it was jes about the same distance. But the targets here were bigger. I jes couldn't miss a German's head or body at that distance. And I didn't. Besides, it weren't no time to miss nohow. I knowed that in order to shoot me the Germans would have to get their heads up to see where I was lying. And I knowed that my only chance was to keep their heads down. And I done done it. I covered their positions and let fly every time I seed anything to shoot at. Every time a head come up I done knocked it down. . . .

Of course, all of this only took a few minutes. As soon as I was able I stood up and begun to shoot offhand, which is my favourite position. I was still sharpshooting with that-there old army rifle. I used up several clips. The barrel was getting hot and my rifle ammunition was running low, or was where it was hard for me to get at it quickly. But I had to keep on shooting jes the same.

In the middle of the fight a German officer and five men done jumped out of a trench and charged me with fixed bayonets. They had about twenty-five yards to come and they were coming right smart. I only had about half a clip left in my rifle; but I had my pistol ready. I done flipped it out fast and teched them off, too.

I teched off the sixth man first; then the fifth; then the fourth; then the third; and so on. That's the way we shoot wild-turkeys at home. You see we don't want the front ones to know that we're getting the back ones, and then they keep on coming until we get them all. Of course, I hadn't time to think of that. I guess I jes naturally did

Skill: Comprehension, Original Sources

it. I knowed, too, that if the front ones wavered, or if I stopped them the rear ones would drop down and pump a volley into me and get me.

Then I returned to the rifle, and kept right on after those machine guns. I knowed now that if I done kept my head and didn't run out of ammunition I had them. So I done hollered to them to come down and give up. I didn't want to kill any more'n I had to. I [would] tech a, couple of them off and holler again.

But I guess they couldn't understand my language, or else they couldn't hear me in the awful racket that was going on. . . . Over twenty Germans were killed by this time. I got hold of a [German major] and he told me if I wouldn't kill any more of them he would make them quit firing. So I told him alright if he would do it now. [S]o he blew a little whistle and they quit shooting and come down and give up. . . .

We ended up with about 80 or 90 Germans there disarmed and had another line of Germans to go through to get out. So I called for my men and one of them answered from behind a big oak tree and the others were on my right in the brush so I said lets get these [Germans] out of here. So one of my men said it is impossible so I said no lets get them out. So when my men said that this [German major] said how many have you got and I said I have got a plenty and pointed my pistol at him all the time-in this battle I was using a rifle or a 45 Colts automatic pistol. So I lined the [Germans] up in a line of twos and got between the ones in front and I had the [German major] before me. So I marched them straight into those other machine guns and I got them. . . .

There was considerably over a hundred prisoners now. It was a problem to get them back safely to our own lines. There was so many of them there was danger of our own artillery mistaking us for a German counter-attack and opening up on us. I sure was relieved when we run into the relief squads that had been sent forward through the brush to help us.

Alvin York. *Sergeant York and the Great War: His Own Life Story and War Diary*. Ed. Richard Wheeler (Boerne, TX: Mantle Ministries, 1998). 150, 152, 154, 157–63, 165.

1. What weapons were the Germans using against the American soldiers? They used machine guns, shells, bayonets, and gas.

2. How many American soldiers sneaked around the Germans and caught them by surprise? Seventeen

3. What were the Germans doing at their headquarters when York and the other soldiers took them by surprise? They were having a meeting after breakfast.

4. In what southern state did York compete in shooting matches that prepared him for this battle? Tennessee

5. York compares combat to hunting what animal? Wild turkeys

6. According to the very end of the passage, how many German prisoners did York help to capture? Over one hundred

World War I Review

Matching Exercise

Place the correct letter in the blank. Some answers will be used more than once.

A. Balkans
B. Britain
C. France
D. Germany
E. Russia
F. Stalemate
G. Total war
H. Treaty of Versailles
I. Triple Entente

__A__
p. 310 1. "Powder keg" of Europe

__I__
p. 310 2. British, French, and Russian alliance

__D__
p. 311 3. This country invaded neutral Belgium

__D__
p. 311 4. Advanced by using the Schlieffen Plan

__C__
p. 312 5. Country where troops arrived in taxicabs

__E__
p. 314 6. Vladimir Lenin

__E__
p. 316 7. Nicholas II

__G__
p. 314 8. Results in many civilian deaths

__F__
p. 312 9. Neither side can prevail over the other

__H__
p. 315 10. Agreement between the Allies and the Germans

__B__
p. 308 11. Sought to remain neutral

__D__
p. 314 12. Used zeppelins to bomb the enemy

__B__
p. 312 13. Invented the tank

__B__
p. 313 14. Enjoyed naval superiority

__D__
p. 313 15. Used submarines

__E__
p. 312 16. Attacked Germany on the eastern front

__D__
p. 312 17. General Paul von Hindenburg

Short Answer

18–20. List the three key members of the Central Powers. Germany, Austria-Hungary, and the Ottoman
Empire (p. 310)

"The Only Thing We Have to Fear . . ."

Answer the questions at the end based on the following excerpts from Franklin D. Roosevelt's inaugural speech:

[March 4, 1933]

I am certain that my fellow Americans expect that on my [entrance] into the Presidency I will address them with a candor and a [firmness] which the present situation of our Nation [demands]. This is . . . the time to speak the truth, the whole truth, frankly and boldly. Nor need we shrink from honestly facing conditions in our country today. This great Nation will endure as it has endured, will revive and will prosper. So, first of all, let me assert my firm belief that the only thing we have to fear is fear itself—nameless, unreasoning, unjustified terror which paralyzes needed efforts to convert retreat into advance. In every dark hour of our national life a leadership of frankness and vigor has met with that understanding and support of the people themselves which is essential to victory. I am convinced that you will again give that support to leadership in these critical days.

In such a spirit on my part and on yours we face our common difficulties. They concern . . . only material things. Values have shrunken to fantastic levels; taxes have risen; our ability to pay has fallen; government of all kinds is faced by serious [shortage] of income; the means of exchange are frozen in the currents of trade; the withered leaves of industrial enterprise lie on every side; farmers find no markets for their produce; the savings of many years in thousands of families are gone.

More important, a host of unemployed citizens face the grim problem of existence, and an equally great number toil with little return. Only a foolish optimist can deny the dark realities of the moment.

Yet our distress comes from no failure of [resources]. We are stricken by no plague of locusts. Compared with the perils which our forefathers conquered[,] . . . we have still much to be thankful for. Nature still offers her bounty and human efforts have multiplied it. Plenty is at our doorstep, but a generous use of it languishes in the very sight of the supply. Primarily this is because rulers of the exchange of mankind's goods [business leaders] have failed through their own stubbornness and their own incompetence, have admitted their failure, and have abdicated. Practices of the [dishonest] money changers [bankers] stand indicted in the court of public opinion, rejected by the hearts and minds of men.

True they have tried, but their efforts have been cast in [outdated methods]. Faced by failure of credit they have proposed only the lending of more money. Stripped of the lure of profit by which to [persuade] our people to follow their false leadership, they have resorted to . . . pleading tearfully for restored confidence. They know only the rules of a generation of self-seekers. They have no vision, and when there is no vision the people perish. . . .

Happiness lies not in the mere possession of money; it lies in the joy of achievement, in the thrill of creative effort. The joy and moral stimulation of work no longer must be forgotten in the mad chase of . . . profits. These dark days will be worth all they cost us if they teach us that our true destiny is not to be ministered unto but to minister to ourselves and to our fellow men. . . .

We face the [difficult] days that lie before us in the warm courage of national unity; with the clear consciousness of seeking old and precious moral values; with the clean satisfaction that comes from the stern performance of duty by old and young alike. We aim at the assurance of a [balanced] and permanent national life.

We do not distrust the future of essential democracy. The people of the United States have not failed. In their need they [desire] . . . direct, vigorous action. They have asked for discipline and direction under leadership. They have made me the present instrument of their wishes. In the spirit of the gift I take it.

In this dedication of a Nation we humbly ask the blessing of God. May He protect each and every one of us. May He guide me in the days to come.

http://en.wikisource.org/wiki/Franklin_Roosevelt%27s_First_Inaugural_Address

1. What did Roosevelt say America had to fear? _Nothing but fear itself_____

2. According to Roosevelt, what group's practices stood accused "in the court of public opinion"?
 _"Money changers" (bankers)_____

3. In what did Roosevelt say happiness lies, rather than in owning money? _In hard work and creativity_

4. What did the president say was the "true destiny" of Americans? _To minister to themselves and to each other_

5. Upon whom did Roosevelt call for blessing, protection, and guidance? _God_____

SKILL: Comprehension, Original Sources

Chapter Review
Make the Statement Correct
Underline the word or phrase that makes the statement correct.

1. The Schlieffen Plan called for the German army to first attack (<u>Belgium</u>/Russia). (p. 311)

2. (Stalin/<u>Lenin</u>) signed a treaty with the Germans and took Russia out of World War I. (p. 314)

3. (<u>Total</u>/Offensive) war is a war in which all the resources of a country are devoted to destroying the enemy. (p. 314)

4. The (Bolsheviks/<u>Mensheviks</u>) were a Russian political party that sought change through peaceful methods. (p. 316)

5. German delegates at (Berlin/<u>Weimar</u>) formed a new government after the war. (p. 317)

6. Benito Mussolini was a (<u>fascist</u>/Communist) leader in Italy. (p. 318)

7. The Lateran Treaties were agreements between Mussolini and the (Eastern Orthodox/<u>Catholic</u>) Church. (p. 318)

8. President (Herbert Hoover/<u>Woodrow Wilson</u>) led in the formation of the League of Nations. (p. 319)

9. The Washington Naval Conference did not prevent (<u>Japan</u>/China) from building more warships. (p. 319)

10. Germany agreed to recognize France's and Belgium's borders in the (Versailles/<u>Locarno</u>) Pact. (p. 319)

11. Those who signed the (<u>Kellogg-Briand</u>/Lateran) Pact agreed to settle their disputes by negotiation rather than by force. (p. 319)

12. (<u>Chiang Kai-shek</u>/Mao Zedong) became the leader of the Kuomintang Party after the death of Sun Yat-Sen. (p. 320)

13. During World War I, (Pan-Ottomanism/<u>Pan-Arabism</u>) began to seek a united state that would spread over the Islamic world. (p. 321)

14. Pierre and Marie Curie pioneered work in (electric/<u>radioactive</u>) matter. (p. 322)

15. Post-war literature was largely (<u>despairing</u>/hopeful). (p. 323)

16. President (<u>Franklin D. Roosevelt</u>/Calvin Coolidge) promoted a dramatic growth of the federal government during his time in office. (p. 326)

Teacher's Choice
Teachers, to help the student better prepare for the chapter test, feel free to add questions about other topics you may have covered.

17. Question _____

18. _Question_ _____

19. _Question_ _____

20. _Question_ _____

SKILL: Recognition, Comprehension

The Bombing of Rotterdam

Answer the questions at the end based on the following fictionalized account of the bombing of this Dutch city:

May 21, 1947

Although the war has ended, and my country is rebuilding, I am still haunted by the memory of the German invasion of our peaceful nation. Our family lived in the beautiful city of Rotterdam in the Netherlands. My father owned a successful manufacturing company, and our family of five (I have two older sisters) lived in a large house overlooking one of the canals that crisscrossed our city. We often enjoyed watching the boats sail up and down the waterways.

In the spring of 1940, I had just turned thirteen and had no idea that our lives were about to be turned upside down. We overheard neighbors discussing rumors about a possible war with Germany. However, most people believed the government's assurances that war could be avoided.

My sisters and I began to suspect that all was not well when Father, after much prayer, arranged for Mother and us children to take an extended trip to the country. Our uncle and his family had a farm a few miles south of our city. Without telling us of the danger he anticipated, Father sent us to visit our relatives on May 1, 1940, while he remained in Rotterdam to oversee his business.

Despite Mother's encouragement, I was sure that life on the farm would be boring, and I resented being separated from my friends back in the city. However, within a few days we began to hear troubling reports on the radio of German threats against our land. Then, all of our fears seemed to melt away on May 9 when the prime minister announced that an agreement had been reached with Germany. He assured the Dutch people that their nation would be preserved from war. We went to bed believing that all was well. However, we awoke to the dreadful news that Germany had indeed attacked our country, and we were at war!

Over the next five days, my mother tried to contact my father. We worried as we heard the radio reports of German bombers attacking key targets. Mother feared that Father might be injured or killed if Rotterdam should be bombed.

On May 14 the Germans issued a demand that our country surrender immediately. Otherwise, they would bomb Rotterdam and destroy it! This news sent shivers down my spine, and I worried that my father might be killed. However, our concern soon turned to relief as we heard that the Dutch government had quickly surrendered. Dutch officials believed that this action would prevent a terrible loss of life and property. Again, we went to bed with some assurance that the worst might be over and that our beloved city would be spared.

Imagine our horror the next morning when we heard that, despite our country's surrender, the German air force had bombed Rotterdam! Over the next several days we learned that the bombing had destroyed the heart of the city. The resulting fires had consumed thousands of buildings and killed hundreds of people. Although it seemed like an eternity, in less than a week we received confirmation that Father had survived the attack and would soon come to stay with us in the country. Even though the assault had destroyed our home, we were thrilled to discover that Father was safe.

Gradually we received news that over eighty thousand people had lost their homes. *Where would they live? How would they survive?* I wondered. My heart sank

as I pondered these troubling questions, but my initial resentment soon turned to gratitude that God had given Father the wisdom to send us out of the city. The farm suddenly seemed a wonderful place to live, now that so many people in our country no longer had a home.

1. In this story, where does the father send his family to protect them? _To a family member's farm south of_ _Rotterdam_

2. What Dutch city did the Germans bomb on May 14, 1940? _Rotterdam_

3. What action did the Dutch government take on this day, trying to prevent the bombing? _They surrendered_ _to the Germans._

4. What additional damage resulted from the fires following the bombing? _Thousands of buildings were_ _destroyed; hundreds of people were killed._

5. How many people lost their homes? _Over eighty thousand people_

6. What fears and questions might have troubled the Dutch people after the German attack? _Answers will_ _vary but could include the following: they would have feared that family and friends were dead and_ _wondered where they would live and how they would survive._

7. How does the narrator's attitude change by the end of the story? _His resentment turns to gratitude for the_ _wisdom that God gave his father._

Churchill's Inspiring Words

Answer the questions below based on the following excerpts from Winston Churchill's writings:

[June 4, 1940]

. . . I have, myself, full confidence that if all do their duty, if nothing is neglected, and if the best arrangements are made, as they are being made, we shall prove ourselves once again able to defend our Island home, to ride out the storm of war, and to outlive the menace of tyranny, if necessary for years, if necessary alone. At any rate, that is what we are going to try to do. That is the resolve of His Majesty's Government—every man of them. That is the will of Parliament and the nation. The British Empire and the French Republic, linked together in their cause and in their need, will defend to the death their native soil, aiding each other like good comrades to the utmost of their strength. Even though large tracts of Europe and many old and famous States have fallen or may fall into the grip of the Gestapo and all the odious apparatus of Nazi rule, we shall not flag [slow] or fail. We shall go on to the end, we shall fight in France, we shall fight on the seas and oceans, we shall fight with growing confidence and growing strength in the air, we shall defend our Island, whatever the cost may be, we shall fight on the beaches, we shall fight on the landing grounds, we shall fight in the fields and in the streets, we shall fight in the hills; we shall never surrender, and even if, which I do not for a moment believe, this Island or a large part of it were subjugated and starving, then our Empire beyond the seas, armed and guarded by the British Fleet, would carry on the struggle, until, in God's good time, the New World, with all its power and might, steps forth to the rescue and the liberation of the old.

Winston Churchill. *Never Give In! The Best of Winston Churchill's Speeches*. Ed. Winston S. Churchill (New York: Hyperion, 2003). 218. Reproduced with permission of Curtis Brown Ltd, London on behalf of The Estate of Winston Churchill. Copyright © Winston S. Churchill.

1. What did Churchill believe would be the ultimate outcome of World War II? He believed that the British would ultimately defend their land and "ride out the storm of war."

2. In what places did Churchill say the British would fight the Germans? In France, on the seas and oceans, in the air, on the beaches, on the landing grounds, in the fields, in the streets, and in the hills

3. In the event that Britain fell to the enemy, what region of the world did Churchill expect to ultimately save Europe? The New World

[June 18, 1940]

. . . What General Weygand called the Battle of France is over. I expect that the Battle of Britain is about to begin. Upon this battle depends the survival of . . . our own British life, and the long continuity of our institutions and our Empire. The whole fury and might of the enemy must very soon be turned on us. Hitler knows that he will have to break us in this Island or lose the war. If we can stand up to him, all Europe may be free and the life of the world may move forward into broad, sunlit uplands. But if we fail, then the whole world, including the United States, including all that we have known and cared for, will sink into the abyss of a new Dark Age

made more sinister, and perhaps more protracted [lengthy], by the lights of perverted science. Let us therefore brace ourselves to our duties, and so bear ourselves that, if the British Empire and its Commonwealth last for a thousand years, men will still say, "*This* was their finest hour."

Winston Churchill. *Never Give In! The Best of Winston Churchill's Speeches*. Ed. Winston S. Churchill (New York: Hyperion, 2003). 229. Reproduced with permission of Curtis Brown Ltd, London on behalf of The Estate of Winston Churchill. Copyright © Winston S. Churchill.

4. According to Churchill, which country would stand up to Hitler, allowing all of Europe to regain its freedom? _Britain_____

5. In the event that Germany defeated the British, what might happen to the United States and the rest of the world? _They might experience a new Dark Age._____

6. What did Churchill hope future generations would say about the British who lived during World War II? _"*This* was their finest hour."_____

SKILL: Comprehension, Original Sources

The Iron Curtain

Answer the questions at the end based on the following excerpts from Winston Churchill's speech at Westminster College in Fulton, Missouri:

[March 5, 1946]

I am glad to come to Westminster College this afternoon, and am complimented that you should give me a degree. The name "Westminster" is somehow familiar to me. I seem to have heard of it before. Indeed, it was at Westminster that I received a very large part of my education. . . .

It is also an honour, perhaps almost unique, for a private visitor to be introduced to an academic audience by the President of the United States. Amid his heavy burdens, duties, and responsibilities—unsought but not recoiled from—the President has traveled a thousand miles to dignify and magnify our meeting here today and to give me an opportunity of addressing this kindred nation, as well as my own countrymen across the ocean, and perhaps some other countries too. The President has told you that it is his wish, as I am sure it is yours, that I should have full liberty to give my true and faithful counsel in these anxious and baffling times. . . .

The United States stands at this time at the pinnacle of world power. It is a solemn moment for the American Democracy. For with primacy in power is also joined an awe-inspiring accountability to the future. If you look around you, you must feel not only the sense of duty done but also you must feel anxiety lest you fall below the level of achievement. Opportunity is here now, clear and shining for both our countries. To reject it or ignore it or fritter it away will bring upon us all the long reproaches of the after-time. . . .

A shadow has fallen upon the scenes so lately lighted by the Allied victory. Nobody knows what Soviet Russia and its Communist international [organization] intends to do in the immediate future, or what are the limits, if any, to their expansive and proselytizing tendencies. I have a strong admiration and regard for the valiant Russian people and for my wartime comrade, Marshal Stalin. There is deep sympathy and goodwill in Britain—and I doubt not here also—towards the peoples of all the Russias and a resolve to persevere through many differences and rebuffs in establishing lasting friendships. We understand the Russian need to be secure on her western frontiers by removal of all possibility of German aggression. We welcome Russia to her rightful place among the leading nations of the world. We welcome her flag upon the seas. Above all, we welcome constant, frequent and growing contacts between the Russian people and our own people on both sides of the Atlantic. It is my duty however, for I am sure you would wish me to state the facts as I see them to you, to place before you certain facts about the present position in Europe.

From Stettin in the Baltic to Trieste in the Adriatic, an iron curtain has descended across the Continent. Behind that line lie all the capitals of the ancient states of Central and Eastern Europe. Warsaw, Berlin, Prague, Vienna, Budapest, Belgrade, Bucharest and Sofia, all these famous cities and the populations around them lie in what I must call the Soviet sphere, and all are subject in one form or another, not only to Soviet influence but to a very high and, in many cases, increasing measure of control from Moscow. Athens alone—Greece with its immortal glories—is free to decide its future at an election under British, American and French observation. The Russian-dominated Polish Government has been encouraged to make enormous and wrongful inroads upon Germany, and mass expulsions of millions of Germans on a scale grievous and undreamed-of are now taking place. The Communist parties,

which were very small in all these Eastern States of Europe, have been raised to preeminence and power far beyond their numbers and are seeking everywhere to obtain totalitarian [government-dominated] control. Police governments are prevailing in nearly every case, and so far, except in Czechoslovakia, there is no true democracy.

Winston Churchill. *Never Give In! The Best of Winston Churchill's Speeches*. Ed. Winston S. Churchill (New York: Hyperion, 2003). 414, 420. Reproduced with permission of Curtis Brown Ltd, London on behalf of The Estate of Winston Churchill. Copyright © Winston S. Churchill.

1. Who introduced Winston Churchill to the students at Westminster College? <u>The President of the United States (Truman)</u>

2. According to Churchill, what country stood at the "pinnacle of world power" after World War II? <u>The United States</u>

3. How did Churchill describe his attitude toward the Russian people and Joseph Stalin? <u>He had "a strong admiration and regard" for them.</u>

4. According to Churchill, what had descended across the European continent? <u>"An iron curtain"</u>

5. What country did Churchill cite as being able to "decide its future . . . under British, American and French observation"? <u>Greece</u>

6. What country had Russia dominated and encouraged to expel millions of Germans? <u>Poland</u>

7. What type of government was gaining control all over Eastern Europe? <u>"Police governments"</u>

8. What did Churchill describe as the single true democracy in Eastern Europe? <u>Czechoslovakia</u>

SKILL: Comprehension, Original Sources

Name _____

Chapter Review
Make the Statement Correct

Underline the word or phrase that makes the statement correct.

1. (<u>Franco</u>/Mussolini) was a fascist dictator in Spain. (p. 330)

2. Hirohito was a Japanese (<u>emperor</u>/general) during World War II. (p. 330)

3. Mussolini sent Italy's modern army into (Egypt/<u>Ethiopia</u>) and quickly conquered this African country. (p. 331)

4. The (<u>Anti-Comintern</u>/Berlin Axis) Pact allied Germany and Japan against Communist Russia. (p. 333)

5. Nearly two million German soldiers invaded Poland on (May 8, 1945/<u>September 1, 1939</u>). (p. 333)

6. The Japanese attacked America's naval base at Pearl Harbor on (June 22, 1941/<u>December 7, 1941</u>). (p. 334)

7. General Bernard L. Montgomery defeated German forces in (Britain/<u>Africa</u>). (p. 337)

8. General Erwin Rommel fought in (Russia/<u>North Africa</u>). (p. 336)

9. (<u>Douglas MacArthur</u>/Dwight D. Eisenhower) became the supreme Allied commander in the Pacific. (p. 337)

10. June 6, 1944 is often referred to as (<u>D-day</u>/V-E Day). (p. 338)

11. Hitler tried to break through the Allied line at the Battle of the (Midway/<u>Bulge</u>). (p. 339)

12. President Truman ordered atomic bombs to be dropped on Hiroshima and (<u>Nagasaki</u>/Tokyo). (p. 340)

13. The Soviet Union seized most of (China/<u>Eastern Europe</u>) after the war. (p. 341)

14. Political rivalry that stops short of actual war is called a (total/<u>cold</u>) war. (p. 342)

15. Jackson Pollock developed a form of painting called (<u>abstract expressionism</u>/existentialism). (p. 342)

16. Post-war art and literature were characterized by (positive reconstruction/<u>hopelessness</u>). (p. 342)

Teacher's Choice
Teachers, to help the student better prepare for the chapter test, feel free to add questions about other topics you may have covered.

17. Question _____

18. Question _____

19. Question

20. Question

SKILL: Recognition, Comprehension

UN Charter

Answer the questions at the end based on the following excerpts from the UN Charter:

Chapter 1, Article 1 of the UN Charter states—

The Purposes of the United Nations are

1. To maintain international peace and security, to take effective collective measures for the prevention and removal of threats to the peace, and for the suppression of acts of aggression or other breaches of the peace, and to bring about by peaceful means, and in conformity with the principles of justice and international law, adjustment or settlement of international disputes or situations which might lead to a breach of the peace;

2. To develop friendly relations among nations based on respect for the principle of equal rights and self-determination [freedom] of peoples, and to take other appropriate measures to strengthen universal peace;

3. To achieve international co-operation in solving international problems of an economic, social, cultural, or humanitarian character, and in promoting and encouraging respect for human rights and for fundamental freedoms for all without distinction as to race, sex, language, or religion; and

4. To be a center for harmonizing the actions of nations in the attainment of these common ends.

Chapter 1, Article 2 of the UN Charter states—

The Organization and its Members, in pursuit of the Purposes stated in Article 1, shall act in accordance with the following Principles:

1. The Organization is based on the principle of the sovereign equality of all its Members.

2. All Members, in order to ensure to all of them the rights and benefits resulting from membership, shall fulfill in good faith [their] obligations . . . in accordance with the present Charter.

3. All Members shall settle their international disputes by peaceful means in such a manner that international peace and security, and justice, are not endangered.

4. All Members shall refrain in their international relations from the threat or use of force against the territorial integrity or political independence of any state, or in any other manner inconsistent with the Purposes of the United Nations.

5. All Members shall give the United Nations every assistance in any action it takes in accordance with the present Charter, and shall refrain from giving assistance to any state against which the United Nations is taking preventive or enforcement action.

6. The Organization shall ensure that states which are not Members of the United Nations act in accordance with these Principles so far as may be necessary for the maintenance of international peace and security.

7. Nothing contained in the present Charter shall authorize the United Nations to intervene in matters which are essentially within the domestic jurisdiction of any state or shall require the Members to submit such matters to settlement under the present Charter; but this principle shall not prejudice [hinder] the application of enforcement measures under Chapter VII.

http://en.wikipedia.org/wiki/United_Nations_Charter

1–3. Briefly list three purposes for the United Nations. _Any three of the following: "To maintain international_ _peace and security"; "to develop friendly relations among nations"; "to achieve international co-operation in solving_ _international problems"; "to be a center for harmonizing the actions of nations"_

4. What is the principle on which the United Nations is based? _"The principle of the sovereign equality of all its_ _Members"_

5. How are member states expected to settle their disputes? _"By peaceful means"_

6. From what are member nations to refrain? _"Threat or use of force . . . in any . . . manner inconsistent with the_ _Purposes of the United Nations"_

7. Based on the third chapter of Romans, what does the UN Charter fail to take into account? _Answers will_ _vary, but biblical principles in Romans 3:10–18, 23 should be referenced._

"Ich Bin Ein Berliner . . ."

Answer the questions at the end based on the following excerpts from President Kennedy's speech:

[June 26, 1963]

I am proud to come to this city as the guest of your distinguished Mayor, who has symbolized throughout the world the fighting spirit of West Berlin. And I am proud to visit the Federal Republic with your distinguished Chancellor who for so many years has committed Germany to democracy and freedom and progress, and to come here in the company of my fellow American, General Clay, who has been in this city during its great moments of crisis and will come again if ever needed.

Two thousand years ago the proudest boast was "civis Romanus sum [I am a Roman citizen]." Today, in the world of freedom, the proudest boast is "Ich bin ein Berliner [I am a Berliner]." . . .

There are many people in the world who really don't understand, or say they don't, what is the great issue between the free world and the Communist world. Let them come to Berlin. There are some who say that communism is the wave of the future. Let them come to Berlin. And there are some who say in Europe and elsewhere we can work with the Communists. Let them come to Berlin. And there are even a few who say that it is true that communism is an evil system, but it permits us to make economic progress. . . . Let them come to Berlin.

Freedom has many difficulties and democracy is not perfect, but we have never had to put a wall up to keep our people in, to prevent them from leaving us. I want to say, on behalf of my countrymen, who live many miles away on the other side of the Atlantic, who are far distant from you, that they take the greatest pride that they have been able to share with you, even from a distance, the story of the last 18 years. I know of no town, no city, that has been besieged for 18 years that still lives with the vitality and the force, and the hope and the determination of the city of West Berlin. While the [Berlin] wall is the most obvious and vivid demonstration of the failures of the Communist system, for all the world to see, we take no satisfaction in it, for it is, as your Mayor has said, an offense not only against history but an offense against humanity, separating families, dividing husbands and wives and brothers and sisters, and dividing a people who wish to be joined together.

What is true of this city is true of Germany—real, lasting peace in Europe can never be assured as long as one German out of four is denied the elementary right of free men, and that is to make a free choice. In 18 years of peace and good faith, this generation of Germans has earned the right to be free, including the right to unite their families and their nation in lasting peace, with good will to all people. You live in a defended island of freedom, but your life is part of the [mainland]. So let me ask you as I close, to lift your eyes beyond the dangers of today, to the hopes of tomorrow, beyond the freedom merely of this city of Berlin, or your country of Germany, to the advance of freedom everywhere, beyond the wall to the day of peace with justice, beyond yourselves and ourselves to all mankind.

Freedom is indivisible, and when one man is enslaved, all are not free. When all are free, then we can look forward to that day when this city will be joined as one and this country and this great Continent of Europe in a peaceful and hopeful globe. When that day finally comes, as it will, the people of West Berlin can take sober satisfaction in the fact that they were in the front lines for almost two decades.

All free men, wherever they may live, are citizens of Berlin, and, therefore, as a free man, I take pride in the words "Ich bin ein Berliner."

http://en.wikisource.org/wiki/Ich_bin_ein_Berliner

1. What city was President Kennedy visiting when he made this speech? ___West Berlin, Germany___

2. For how many years had this city been besieged when President Kennedy gave this speech? _____
 Eighteen years

3. What did President Kennedy say was the proudest boast in the free world? ___"Ich bin ein Berliner." (I am a___ Berliner.)

4. What structure did President Kennedy refer to as the most obvious sign of communism's failure to grant peace and freedom? ___The Berlin Wall___

5. According to President Kennedy, what could never be assured as long as one fourth of the German people were denied freedom? ___"Lasting peace in Europe"___

6. What did President Kennedy say about those who believed that communism was the "wave of the future"?
 "Let them come to Berlin."

SKILL: Comprehension, Original Sources

Children of the Storm

Answer the questions below based on the following excerpts from Natasha Vins's work:

. . . A friend from Moscow had brought the news that Papa had been arrested two days earlier. Even though he had already been in hiding for three years and we had known that he could be arrested at any moment [for being a Christian leader], this news was sudden and brought a stab of pain. . . .

The next day, our Sunday worship service in the forest was brutally disrupted. Policemen beat the men and twisted their arms. They pushed around women and children. With my own eyes, I saw seventy-five-year[-]old Fanya Andreevna get shoved so hard that her cane went flying to the side and she fell down. I ran to help her get up, but she could not because she was badly injured. Many believers were arrested that day and sentenced to fifteen days in jail.

At our home the police conducted another house search. They officially informed us that Papa had been arrested and that while his case was being prepared for trial he would be held in Lefortovo Prison in Moscow. The prosecutor in Moscow assigned an investigator in Kiev to question family members.

One day at [my brother] Peter's school his third-grade teacher was told to send him to the principal's office. Peter figured out that he was going to be interrogated. So instead of going to the principal's office, he ran out of school, got on a bus, and went to the home of relatives who lived across town. Mama happened to be there and decided not to bring Peter home, but to send him to a village to stay with a Christian family in order to protect him from interrogation.

I did not succeed in evading interrogation. When the investigator came to my school, the teacher personally took me to the principal's office. The investigator started to question me about Papa, but I refused to answer his questions. He got angry and shouted at me as did the principal, but they were unable to get any information from me. . . .

[Several months later,] we went to see Papa at Lefortovo Prison. All five of us—Mama, Babushka, Peter, Lisa, and I—were allowed in. At the prison entrance the guards checked our passports and birth certificates. Mama showed the notice from the judge allowing us a visit. All the documents were in order so we were permitted to enter.

A guard led us into a large room that had no other furniture except for a table and several chairs. He ordered us to sit on one side of the table. The chair reserved for Papa was on the opposite side. . . . [W]e were allowed a thirty-minute visit. . . . As we said our last good-byes, the guard entered, announcing, "It's over. Time to leave!"

We left the prison gates and walked to the bus stop through the snowy streets of Moscow. The day was December 2, 1966. We had to get to the train station and return home to Kiev. There was nothing left to be done that would keep us in Moscow. As for Papa, he would soon be on his way to a prison camp in the Ural Mountains.

Natasha Vins. *Children of the Storm: The Autobiography of Natasha Vins.* Trans. Jane Vins Comden (Greenville, SC: BJU Press, 2002). 21–24.

1. Why was Natasha's father arrested? __He was a Christian leader._____

2. Where were the believers holding their worship service? __In the forest_____

3. How did the police treat the women and children? _They pushed them around._____

4. What did Natasha learn about her father when authorities searched her house? _He would be held in_
 _Lefortovo Prison in Moscow._____

5. Why did Peter leave the school and go to the home of relatives? _He believed that the authorities were going_
 _to interrogate him._____

6. When Natasha refused to provide the investigator and the principal with information about her father, how
 did they respond? _They got angry and shouted at her._____

7. According to the end of the account, where was Natasha's father to be sent? _A prison camp in the Ural_
 _Mountains_____

SKILL: Comprehension, Original Sources

"Tear Down This Wall!"

Answer the questions at the end based on the following excerpts from President Reagan's speech:

[June 12, 1987]

. . . We come to Berlin, we American presidents, because it's our duty to speak, in this place, of freedom. But I must confess, we're drawn here by other things as well: by the feeling of history in this city, more than 500 years older than our own nation; by the beauty of the Grunewald and the Tiergarten; most of all, by your courage and determination. Perhaps the composer Paul Lincke understood something about American presidents. You see, like so many presidents before me, I come here today because wherever I go, whatever I do: Ich hab noch einen Koffer in Berlin. [I still have a suitcase in Berlin.] Our gathering today is being broadcast throughout Western Europe and North America. I understand that it is being seen and heard as well in the East. To those listening throughout Eastern Europe, a special word: Although I cannot be with you, I address my remarks to you just as surely as to those standing here before me. For I join you, as I join your fellow countrymen in the West, in this firm, this unalterable belief: Es gibt nur ein Berlin. [There is only one Berlin.]

Behind me stands a wall that encircles the free sectors of this city, part of a vast system of barriers that divides the entire continent of Europe. From the Baltic, south, those barriers cut across Germany in a gash of barbed wire, concrete, dog runs, and guard towers. Farther south, there may be no visible, no obvious wall. But there remain armed guards and checkpoints all the same—still a restriction on the right to travel, still an instrument to impose upon ordinary men and women the will of a totalitarian state. Yet it is here in Berlin where the wall emerges most clearly; here, cutting across your city, where the news photo and the television screen have imprinted this brutal division of a continent upon the mind of the world. Standing before the Brandenburg Gate, every man is a German, separated from his fellow men. Every man is a Berliner, forced to look upon a scar. President von Weizsacker has said, "The German question is open as long as the Brandenburg Gate is closed." Today I say: As long as the gate is closed, as long as this scar of a wall is permitted to stand, it is not the German question alone that remains open, but the question of freedom for all mankind. Yet I do not come here to lament. For I find in Berlin a message of hope, even in the shadow of this wall, a message of triumph. . . .

And now the Soviets themselves may, in a limited way, be coming to understand the importance of freedom. We hear much from Moscow about a new policy of reform and openness. Some political prisoners have been released. Certain foreign news broadcasts are no longer being jammed. Some economic enterprises have been permitted to operate with greater freedom from state control. Are these the beginnings of profound changes in the Soviet state? Or are they token gestures, intended to raise false hopes in the West, or to strengthen the Soviet system without changing it? We welcome change and openness; for we believe that freedom and security go together, that the advance of human liberty can only strengthen the cause of world peace. There is one sign the Soviets can make that would be unmistakable, that would advance dramatically the cause of freedom and peace.

General Secretary Gorbachev, if you seek peace, if you seek prosperity for the Soviet Union and Eastern Europe, if you seek liberalization: Come here to this gate! Mr. Gorbachev, open this gate! **Mr. Gorbachev, tear down this wall!** . . .

And I invite Mr. Gorbachev: Let us work to bring the Eastern and Western parts of the city closer together, so that all the inhabitants of all Berlin can enjoy the benefits that come with life in one of the great cities of the world. To open Berlin still further to all Europe, East and West, let us expand the vital air access to this city, finding ways of making commercial air service to Berlin more convenient, more comfortable, and more economical. We look to the day when West Berlin can become one of the chief aviation hubs in all central Europe. . . .

. . . Yes, across Europe, this wall will fall. For it cannot withstand faith; it cannot withstand truth. The wall cannot withstand freedom. . . .

http://en.wikisource.org/wiki/Ronald_Reagan's_Berlin_Wall_Speech

1. What American president had visited Berlin and made a famous speech twenty-four years before President Reagan's speech? _John F. Kennedy_____

2. How many years older is the city of Berlin than the United States? _More than 500 years_____

3. By what historic gate did Reagan give this speech? _The Brandenburg Gate_____

4. Who was the General Secretary of the Soviet Union during this period? _Gorbachev_____

5. What did President Reagan challenge this Soviet leader to do in order to seek peace and prosperity for the Soviet Union? _To tear down the Berlin Wall_____

SKILL: Comprehension, Original Sources

Chapter Review

Make the Statement Correct

Underline the word or phrase that makes the statement correct.

1. Konrad Adenauer quickly improved the economy of (France/<u>Germany</u>) with a free market. (p. 350)

2. The (MacArthur/<u>Marshall</u>) Plan helped western European nations recover from World War II by pouring over twelve billion dollars into their economies. (p. 351)

3. (Communism/<u>Democracy</u>) stresses the individual's role in government and allows the operation of privately owned businesses. (p. 353)

4. Chiang Kai-shek founded the Republic of China in (Beijing/<u>Taiwan</u>). (pp. 353–54)

5. The (<u>Great Leap Forward</u>/Cultural Revolution) sought to improve agricultural production but failed and caused famine in China. (p. 354)

6. UN forces fought the North (<u>Koreans</u>/Vietnamese) at Inchon. (pp. 355–56)

7. Ho Chi Minh declared Vietnam independent from (England/<u>France</u>). (p. 356)

8. *Sputnik* was the first man-made (<u>satellite</u>/space defense weapon). (p. 358)

9. Mohandas Gandhi used (anarchy/<u>passive resistance</u>) to achieve Indian independence from Britain. (pp. 359–60)

10. The British partitioned the sub-continent of India into India and (Afghanistan/<u>Pakistan</u>). (p. 360)

11. The (Tel Aviv/<u>Balfour</u>) Declaration acknowledged Israel's need for a homeland. (p. 362)

12. The (<u>Six-Day</u>/Cold) War resulted from an Arab attempt to invade Israel. (p. 363)

13. The Soviets invaded Czechoslovakia in 1968 because (Wałęsa/<u>Dubček</u>) was restoring rights to the Czechs. (pp. 363–64)

14. The (Chinese/<u>Soviets</u>) invaded Afghanistan in 1979 but could not conquer the country. (p. 364)

15. The Solidarity movement in Poland became an (anti-American/<u>anti-Communist</u>) effort to oppose foreign domination. (p. 365)

16. Mikhail Gorbachev became the first (<u>president</u>/chancellor) of the Soviet Union. (p. 366)

Teacher's Choice
Teachers, to help the student better prepare for the chapter test, feel free to add questions about other topics you may have covered.

17. Question _____

18. Question _____

19. Question _____

20. Question _____

Skill: Recognition, Comprehension

Name _____

Map Study: European Union

Member Countries of the European Union

Locate the following on the map and place the number in the blank beside the term:

Czech Republic 2

France 5

Germany 1

Greece 6

Ireland 10

Italy 9

Map Study, cont.

Poland _7_

Spain _4_

Sweden _8_

United Kingdom _3_

Name _____

CHAPTER 20 ACTIVITY 2

Stem Cell Research

Answer the questions at the end based on the following excerpts from the fourth edition of *BIOLOGY*:

Stem cell technology holds much promise in the treatment of disease and the repair of injuries. But what exactly are stem cells, and where do they come from? Stem cells are cells that have the ability to divide almost indefinitely and to give rise to, or differentiate [modify] into, specialized cells. For example, a stem cell in the tip of a plant root can become any of the types of cells found in plants. Due to environmental and hormonal cues, the cell develops into a particular type of cell; it becomes differentiated [modified] or specialized. Similarly, animal embryos contain stem cells that differentiate to become the various tissues and organs of the animal. The same is true for human embryos. Since much of the controversy regarding stem cells relates to using human stem cells, that context is used in this section. . . .

When a sperm cell fertilizes an ovum, a zygote is formed. That one cell has the potential to give rise to all of the cell types in the human body. . . . When the zygote divides into two cells, each of these cells can also become any of the cell types in the body. If these two cells should separate and continue to grow separately, they would form identical twins.

As the zygote [grows] by cell division, the cells begin to differentiate into the parts of the early embryo. They can give rise to many, but not all, cell types. . . . In other words, these cells have lost some of their potential to specialize. As these . . . cells continue to divide, they form stem cells that will give rise to particular tissues such as blood and skin. Now they are committed to a specific type of tissue but still are not fully specialized. For example, bone marrow stem cells can still give rise to all of the various types of human blood cells. . . .

The larger controversy over stem cells is not whether scientists should be performing stem cell research but rather concerns the source of the stem cells used in research. There are two basic sources for stem cells—embryonic and adult.

As the name states, human embryonic stem cells . . . come from human embryos. In order to obtain embryonic stem cells, the embryo is destroyed. Since life begins at conception[,] . . . human lives are killed in order to harvest embryonic stem cells for research (Ps. 51:5; 139:13–16). . . .

. . . [A]dult stem cells . . . are obtained from the differentiated somatic, or body, tissue of adults or children. Bone marrow stem cells have been successfully used for more than thirty years in the treatment of leukemia. More recently, scientists have isolated somatic [adult] stem cells in a variety of tissues, such as nerves, skin, and blood vessels. Although [these stem cells] are more specialized than embryonic stem cells, researchers are finding that somatic stem cells can be made to differentiate into many types of tissue cells. . . .

Scientists are looking to stem cells for new treatments and cures for many diseases and disorders. For example, in insulin-dependent diabetes, researchers theorize that if stem cells can be harvested, differentiated into the proper kind of pancreatic cells, and then transplanted into the diabetic's pancreas, the newly differentiated cells will continue to grow and produce insulin. If [this procedure is] successful, the person would no longer need to inject insulin to treat his diabetes. Many other conditions are being studied to determine whether they can be successfully treated with stem cells.

At this time, only somatic stem cells have been used to successfully treat human diseases. In fact, somatic stem cells are already being used to treat over 70 different diseases, including diabetes, Parkinson disease, and several forms of cancer. Recent studies continue to find that somatic stem cells can be differentiated into many cell types and have some advantages over embryonic stem cells. Somatic stem cells are easier to grow and to differentiate into specific cell types. . . .

The most important advantage of somatic stem cells is that no embryo is killed to harvest the cells. If researchers should ever determine that embryonic stem cells are superior to somatic stem cells, would that justify their use? Those who support embryonic stem cell research argue that it is acceptable to sacrifice human embryos to advance scientific and medical knowledge for the benefit of all humanity. They refuse to accept that human embryos are human beings from the moment of conception, created in the image of God.

The use of the knowledge that God has allowed man to discover must always be guided by scriptural principles. The Bible states that killing an innocent person is never justified (Gen. 9:6). Doing evil so that some good might result is also condemned (Rom. 3:8). Therefore, even if all of humanity's suffering could be relieved, Christians must stand against all research and treatments that are in opposition to scriptural principles.

Brad R. Batdorf and Elizabeth Lacy. *Biology*. 4th ed (Greenville, SC: BJU Press, 2011). 158–61.

1. What are stem cells? "Cells that have the ability to divide almost indefinitely and to give rise to, or differentiate [modify] into, specialized cells"

2–3. What are two basic types of stem cells? Embryonic and adult (somatic)

4. Which of the two types requires the destruction of human life in order to obtain the stem cells?
The embryonic type

5. Which of the two types of stem cells has been used successfully to treat human diseases?
Adult (somatic)

6. Is killing an innocent person ever justifiable? No

SKILL: Comprehension, Original Sources

Chapter Review

Make the Statement Correct

Underline the word or phrase that makes the statement correct.

1. (Al Gore/Václav Klaus) insists that man is causing climate change and that dire consequences are just over the horizon. (p. 374)

2. The European Union is an economic and political alliance of nearly (twenty/thirty) nations across Europe. (p. 376)

3. Conflict between El Salvador and (Nicaragua/Honduras) has posed a threat to the Central American Common Market. (p. 377)

4. No technological development has had more impact on daily living than (the Internet/the radio). (p. 378)

5. (Embryonic/Adult) stem cell research does not pose a moral dilemma and is currently used to treat diseases. (p. 379)

6. The Twin Towers and the (Capitol/Pentagon) were attacked on September 11, 2001. (p. 380)

7. (Osama bin Laden/Saddam Hussein) became the dictator of Iraq. (p. 381)

8. Afghanistan came under the control of a radical Muslim group called the (Madrassas/Taliban). (p. 381)

9. Wang Mingdao was a Christian leader in (China/India). (p. 384)

10. The (Taliban/Wahhabists) gained control of Saudi Arabia and have spread the literal application of Islam to other countries. (p. 383)

11. Biblical Christianity is spreading rapidly in regions known as the global (south/west). (p. 383)

12. Iran and (India/Afghanistan) are nations that support terrorism. (p. 381)

13. (Saudi Arabia/Iraq) invaded Kuwait in 1990 and seized its oil reserves. (p. 381)

14. Eight West African states currently form a union to promote (military/economic) cooperation. (p. 377)

15. Trade provides an opportunity for Christians to evangelize, helping them to fulfill the (Creation Mandate/Great Commission). (p. 378)

16. The (Iraqi/American) government tried and executed Saddam Hussein. (p. 381)

Teacher's Choice
Teachers, to help the student better prepare for the chapter test, feel free to add questions about other topics you may have covered.

17. _Question_ _____

18. _Question_ _____

19. _Question_ _____

20. _Question_ _____

SKILL: Recognition, Comprehension